WATTEAU

Editorial director: PAUL ANDRÉ
English translation : Josephine Bacon

Printed by Sézanne at Bron
for Parkstone Press
ISBN 1 85995 183

WATTEAU

Introduction

Yuri Zolotov

Catalogue of paintings

Inna Nemilova
Irina Kuznetsova
Tatiana Kamenskaya
Vera Alexeyeva

PARKSTONE PRESS, BOURNEMOUTH
AURORA ART EDITIONS, ST. PÉTERSBURG

CONTENTS

The Life and Work of
WATTEAU

When Watteau was admitted to the Académie Royale de Peinture et de Sculpture in 1717, the painting he presented, Le Pélerinage à l'île de Cythère (The Embarkation for Cythera), caused him to be dubbed with the official title of "peintre de fêtes galantes", the painter of courtly festivities. In later years, Watteau's "fêtes galantes", scenes of courtly love amid a rural setting were often regarded as sophisticated trifles. Diderot was to remark: "Talent imitates nature; taste inspires its choice; yet I prefer simplicity to affectation; and I would give ten Watteaus for one Teniers."[1]

Yet the eighteenth century produced few painters whose gift can compare with Watteau's deep sensitivity and lyrical qualities. Modern studies show that Rodin misinterpreted the Embarkation.[2] The scene is set on the Isle of Cythera, the island of love itself; a statue of Aphrodite stands at the edge of the woods and cupids accompany their new acquaintances, hovering above the cavaliers and their female companions. There is no emotional crescendo despite the assumption implied by the artist's choice of subject.[3] Nevertheless, Rodin was correct in his interpretation of the action taking place in the scene. The theme of the painting lies in the subtle gradations of sentiment, now appearing, now disappearing, in continual motion.

Watteau revealed the poetic value of barely discernible nuances of human emotion by capturing fleeting moments of the most breathtaking and unique eloquence. He transferred to the canvas a new realm of spiritual state, ranging from gentle timidity to secret disillusion, provoked by the difference between dream and reality.

One of Watteau's great merits as the painter who ushered in eighteenth-century French painting, was that he countered the bigoted and narrow-minded "ultimate truths" of Le Brun's imitators with the poetry of subtle impulses and fleeting emotions. Charles Montesquieu might have been thinking of this, when in his Essai sur le goût dans les choses de la nature et de l'art (Essays on Taste in Matters of Nature and Art) he spoke of people being endowed with "... an invisible charm, a natural, indefinable grace which one is obliged to call the je ne sais quoi". [4]

Watteau's artistic discoveries were of special significance with the decline of absolutism which marked the beginning of the eighteenth century. The absolutist era of the Sun-King had imposed uniformity on art, banning all individuality and originality. This does not mean that Watteau was inclined to break with tradition. Neither the subjects of his paintings nor the evidence of his contemporaries furnish grounds for such an assumption. Yet his art revealed the new opportunities for artistic cognition that were the natural result of this historic watershed.

Watteau's vision of the world was undoubtedly enhanced by the artistic training of this, the eighteenth century's first truly great painter, which was unfettered by the rules of the academic school. Although little is known about Watteau's early years, he certainly frequented the studios of the popular genre painters. He is also known to have preferred the Flemish school, with its realistic traditions and was attracted by Venetian Renaissance art, for its emotionalism.

Before discussing Watteau's "discoveries" in painting, which set him apart from the devices used in seventeenth-century painting, something needs to be said about his immediate predecessors. Le Brun's academic dogma placed classical models above nature and demanded that nature be improved upon for the sake of the abstract, ideal perfection of the "grand goût" ("great taste"). Watteau's rich graphic legacy has made it possible for future generations to know what France looked like in his day, reflecting a profound interest in reality and demonstrating convincingly that a turning point had been reached in the French school.

The academic doctrine of the seventeenth century considered the artist's individual view of the world to be subordinate to the creation of a sort of apotheosis of painting. Watteau restored art to its true place in life. His striking individuality manifested itself in every aspect of his art, and some paintings (such as Pierrot-Gilles) were of an autobiographical nature. He created interest in the rhythm of line in his drawings, which is sometimes leisurely as if in contemplation, sometimes troubled and agitated. The range of feelings expressed in his paintings is readily communicated to the viewer, who does not even need to be familiar with their allegories and symbols, but merely need to be able to feel them. It was just such an art which was most appropriate at the

start of an era in which the ability to be express emotion was to become the criterion of human greatness.

Watteau's friends were amazed by the originality of his creativity. Jean de Julienne said of him: "...he had a lively and penetrating spirit and lofty sentiments; he spoke little, but well, and wrote similarly. Most of the time he was deep in thought. A great admirer of Nature and of all the masters who copied it, assiduous labour had made him somewhat melancholy. Cold and embarrassed in manner, which at times made him difficult for his friends and often for himself, he had no other shortcomings except that of indifference and of liking change."[5] The art dealer Gersaint said of him: "...His character was restless and inconstant; he was unrestrained in his desires, a libertine in spirit, yet prudent in behavior, impatient, timid, of a cold and embarrassed manner, discreet and reserved with strangers, a good but difficult friend, a misanthrope, a malicious and even biting critic, ever dissatisfied with himself and with others, and not too willing to forgive." [6]

Comments by the master's contemporaries touch on other, more concrete, aspects of his creativity. An insight into Watteau's artistic method is provided by the advice he gave to his pupil, Nicolas Lancret. Here is what Lancret's biographer Balot de Sovot tells us: "Watteau, who at first took a liking to M. Lancret, told him one day that he would only be wasting his time by remaining any longer with a Master; that he should go further with his work by following that Master of all Masters, nature; that he, Watteau, had done just that and had profited thereby. He advised him to go to the outskirts of Paris and sketch landscapes, following which he should sketch some figures and use them to create out of all this a painting after his own imagination and preferences." [7]

It is unlikely that the biographer added anything of his own. Everything he recounts rings true. Watteau's advice runs totally counter to the traditional principles of art teaching, rooted in the previous century. It was a tradition which was undermined by dogmatism and the system of academic teaching that fettered any originality of pupils, forcing them to make do without nature for long years and to blindly copy their master's works. Watteau's own method consisted in the production of a multitude of studies from nature

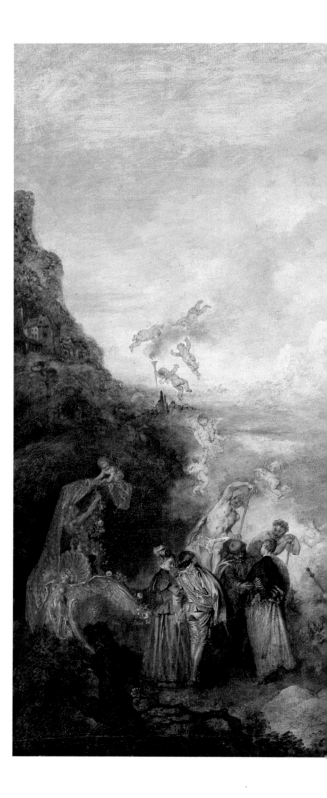

Pilgrimage to the Island of Cythera.
The Louvre, Paris.

10

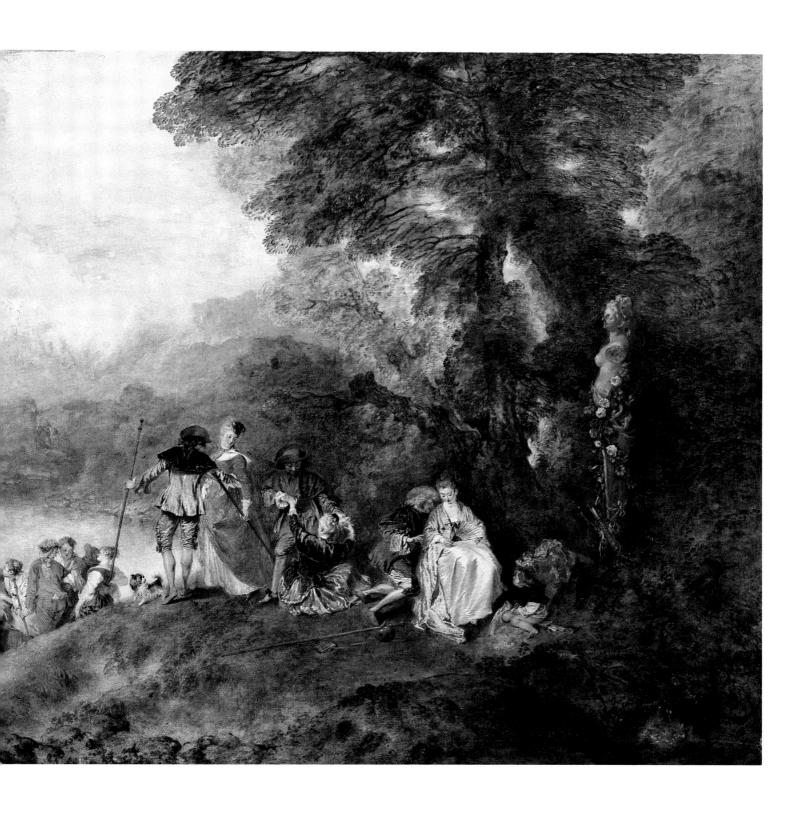

which he then used for his paintings. The drawings he left include surprisingly few sketches for determining the composition, although there are many landscapes, as well as figures in different poses, heads and hands - all of which were later incorporated in his pictures. One of the artist's biographers, Count de Caylus, made the following remark about Watteau at the Académie Royale de Peinture et de Sculpture, in 1748: "Most of the time the figures that he sketched from nature were produced with no definite aim in view... He never made preliminary sketches for, nor gave preliminary thought to, any of his paintings, no matter how light or fleeting. His custom was to draw sketches in a bound book so as to always have a great number of them to hand... When he felt the urge to paint, he could turn to his collection. He chose the figures that suited him best for the occasion. He formed them into groups, usually against a background which he had designed or prepared. It was indeed rare for him to act otherwise."[8]

That Watteau constructed his scenes from the material he had amassed, much in the manner of mosaics, is confirmed by at least two facts. Firstly, the sketches found on one and the same sheet of paper served for paintings produced at different periods. Even if it is assumed that the artist made new sketches in the margins of old pieces of paper, that only serves to support the thesis that in the course of his creative process, Watteau would return constantly to earlier drawings. Secondly, the same figures and groups often recur in different paintings, although they are slightly rearranged each time. Thus, the figures presented in *Le Faux Pas* (Louvre) reappear among other figures in *Plaisirs d'amour (Pleasures of Love)* (Gemäldegalerie, Dresden). There are many similar examples. However, there is also little doubt that Caylus, who measured Watteau by doctrinaire academic standards, had little understanding of the artist's method. Watteau's art cannot be reduced to elegant marquetry. When he combined previously used motifs in a new composition, the poetic integrity of the painting always remained paramount. Figures and landscapes merged into a harmonious unity. It is no accident that when Balot de Sovot quoted Watteau he claimed the mater used the word "imagination" more than any other. This leads to an analysis of Watteau's poetic fantasy,

the singular structure of his perception and, last but not least, his specific choice of subjects.

While still the apprentice of an obscure painter, Watteau found himself among artists and engravers who specialized in little pictures of *"modes et mœurs" (fashion and custom)* as they were called at the time. The influence of these naive genre scenes, produced by Bernard Picart, Claude Simpol and others, is evident in Watteau's early work, although his lyrical gift very soon imbued these subjects with a new and an essentially deeper meaning. Scenes of military life, so well represented in Russian museums (including the *Camp volant (Mobile Camp)*, Pushkin Museum, Moscow), are an expression of the artist's frank interest in the lives of the masses, an interest which manifests itself even more powerfully in the *La Marmotte (The Marmot)*, or *Le Savoyard* (both in the Hermitage Museum, Leningrad).

These re evidence of Watteau's artistic fidelity to life. The artist's preoccupation with scenes of everyday existence took on a special meaning in view of the plethora of mythological subjects cultivated by the members of the Académie. Contemporaries are unanimous when speaking of Watteau's dislike of traditional subject-matter. In 1729, the painter Etienne Jeaurat wrote: "The subjects of his paintings are pure fantasy."[9]

The story of Watteau's *The Embarkation for Cythera* is also noteworthy. The minutes of the Académie Royale de Peinture et de Sculpture of June 30, 1712, stated that the painter would be given a subject by the Académie's director. Then those words were crossed out and replaced with the following statement: "The subject for his acceptance work has been left to his discretion."[10] Watteau's choice of subject-matter was undoubtedly determined by his own ideas and by his opposition not only to the official hierarchy of genres, but also to the practice of the times whereby distinguished patrons imposed their own choice of subjects on painters. There is much evidence of this practice, for example, in the note addressed by the Duke d'Antin to Lancret containing a detailed description of a comical genre scene related, in all probability, to a humorous incident which had actually occurred. The duke wished to have this scene painted for the entertainment of his guests. [11]

While stressing Watteau's interest in contemporary life, one must not ignore the general

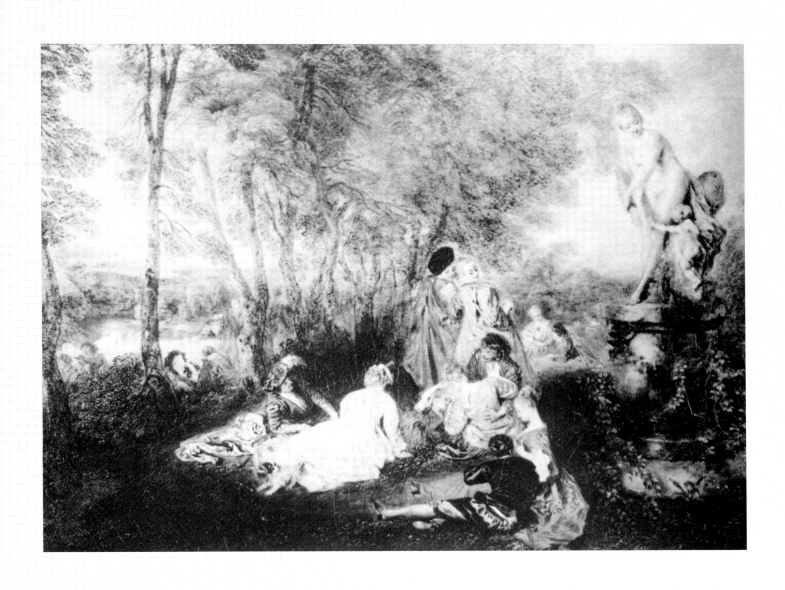

Plaisir d'amour.
Gemäldegalerie, Dresden.

development of his artistic interpretation, from the naivety of his early genre scenes to the complex structure of the imagery in his later paintings. Watteau did not become a mirror of French society's morals and manners, and humdrum daily life obviously held no attraction for him. The confines of genre art were too narrow for him, and in that sense it is a mistake to interpret, for example, his *L'Enseigne de Gersaint (The Gersaint Signboard)* as a return to the commonplace.

The problem of Watteau's subjects becomes much more complex when applied to his theatrical scenes and so-called "fêtes galantes." The narrative element gradually faded in the artist's works. His imitators, Lancret and Pater, sought to entertain their audience with amusing situations. The story as such, the plot, the intrigue were far less important to Watteau than the sentiment expressed, the "inner melody" of his paintings, addressed to his emotionally responsive viewers rather than to those with a taste for amusing or moralizing tales. Both the little Savoyard and Pierrot (Gilles) themselves seem inert, yet inexplicably they stir the viewer's soul. The lyrical nature of Watteau's figures is revealed not in their actions, but in the innermost realm of their feelings in special moments of poetic lucidity.

Many contemporary scholars of Watteau persistently try to trace the sources of his subjects, hoping that this iconographic path will lead them to the secret of his art. In connection with the "fêtes galantes", they recall that Watteau had the opportunity to observe the life of high society in the home and at the country estate of Pierre Crozat, a wealthy patron of the arts. They also recall that the French literature of the period abounds in descriptions of country outings and picnics. One name that comes up, for example, is that of François Savinien d'Alquié, who extolled the charms of the high life in rural settings in these terms: "There is no pleasure equal to that enjoyed by ladies dressing up to take part in ballet scenes or pastorals and arranging to meet in woods and gardens."[11] This was an age when many "family theatres" became fashionable on estates near Paris - Voltaire described them in *La Princesse de Babylone*.[12] Here is a story told by Hippolyte Taine which, though undated, is typical of the period: "Madame de Civrac being obliged to

take a cure, her friends decided to amuse her during the journey; they would keep ahead of her and, wherever she stopped to spend the night, would arrange for her a little country fair, dressing themselves as villagers and merchants, with a bailiff, scrivener and other stock characters singing and reciting verses."[13] This is convincing evidence that the life of high society in those days had a distinctly theatrical flavor; human relationships were expressed in a theatrical form which tended to mask their real nature.

On the other hand, students of Watteau's art seek to discover the prototypes of his subjects in the plays he may have seen on the professional stages of Paris. We know that the artist became a theatre buff in his early years, and was well versed in that art. Gersaint tells us that in his youth Watteau "...would spend his free time in going to the square and sketching the different comical scenes that are usually performed for the public by the charlatans and hawkers who roam the country."[14] In his mature years, Watteau was often inspired by plays, especially by performances of the Commedia dell'arte, in which the actors were often masked. Society outings in the spirit of Savinien d'Alquié, a scene from Dancourt's comedy, *Les Trois Cousines*, the comic ballet *La Vénitienne* by the composer de La Barre and the poet Houdar de La Motte,[15] have all been suggested at different times as sources for *The Embarkation for Cythera*. But Watteau was neither a portrayer of the manners and morals of French Régence society nor a historiographer of early eighteenth-century French theatre. No one can seriously deny the legitimacy of carefully examining the motifs in Watteau's works; the method has discoveries to its credit and others will follow, shedding new light on his paintings. But one point cannot be disputed, namely, that the approach to Watteau's art as a kind of chronicle of theatrical and high society life of the period always encounters insuperable contradictions and resistance on the part of the material itself.

One could begin with an example which, though pertaining to a very specific area, is by no means of minor importance. Costume experts never cease to argue about the dress worn by Watteau's figures. Some insist that it is pure fantasy, thus confirming the artist's penchant for invention.[17] Others, on the contrary, note the reflection (both in drawings and paintings) of "one of the most

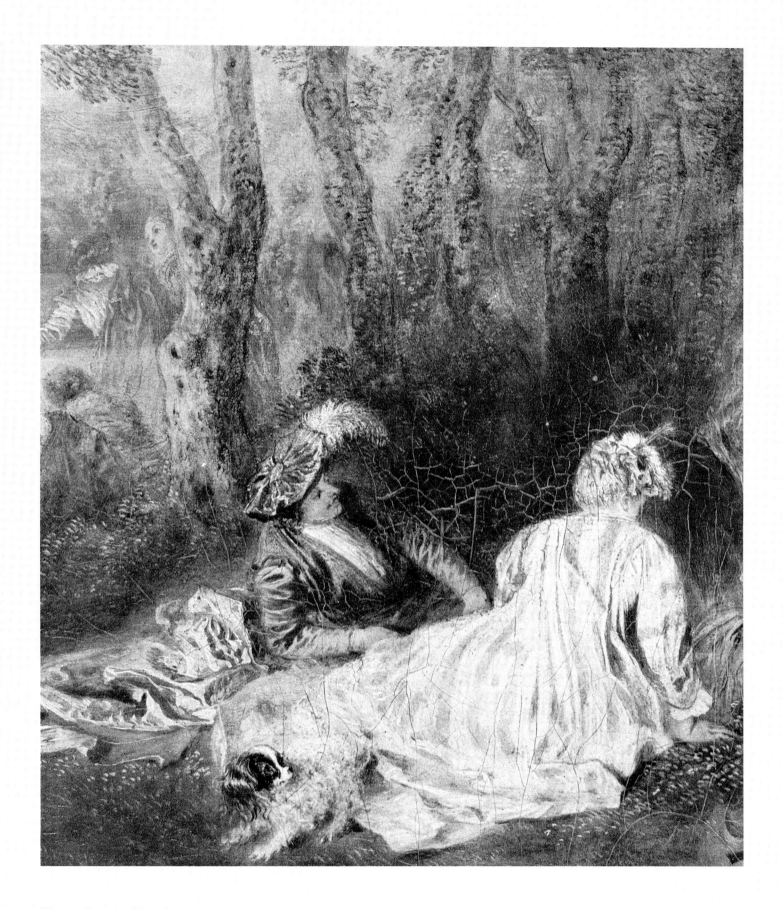

Plaisir d'amour. Detail.

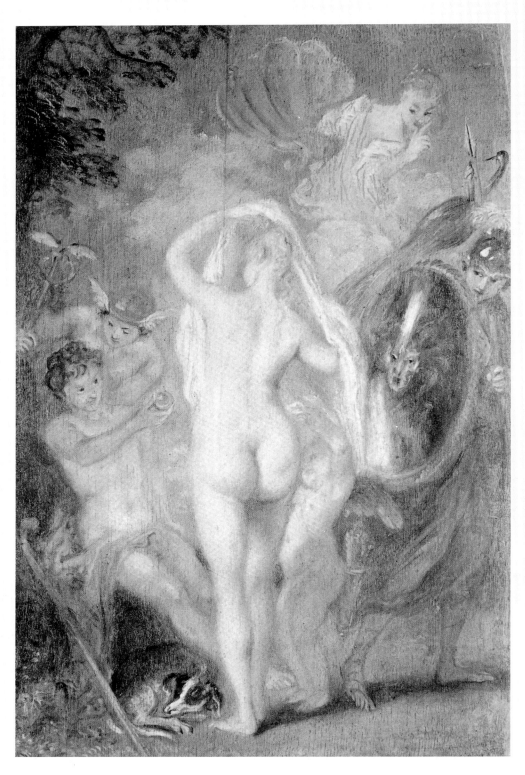

The Jugement of Pâris.
The Louvre, Paris.

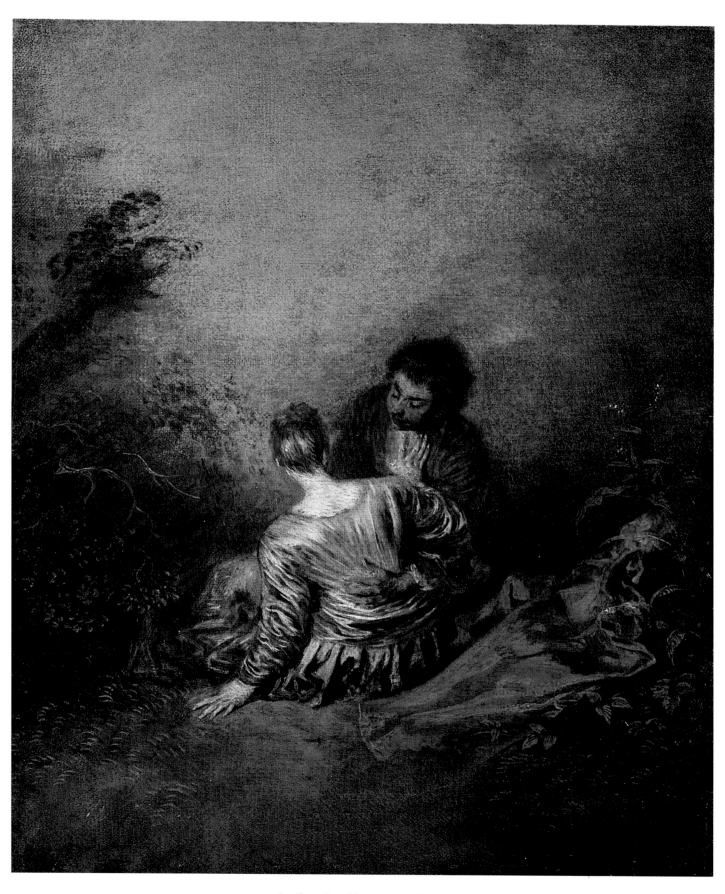

Le Faux Pas. The Louvre, Paris.

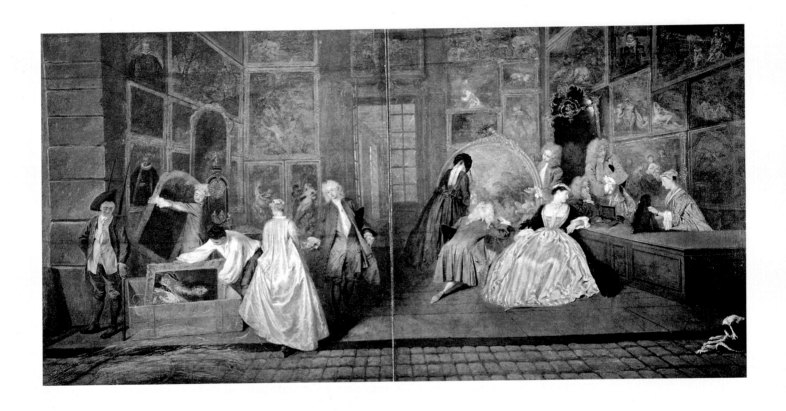

L'Enseigne de Gersaint.
Charlottenbourg Palace, Berlin.

brilliant chapters in the history of French fashion."[18] In 1727, Dubois de Saint-Gelais contended in *Descriptions des tableaux du Palais Royal* that Watteau's pictures could serve as a guide to the history of costume.[19] A 1718 English design for silk from the Victoria and Albert Museum, London, was published in a book about silks of the baroque and rococo periods. Reproduced next to it was Watteau's painting *Iris, or La Danse,* now in the Gemäldegalerie, Berlin-Dahlem. The patterns of the fabrics are almost identical.[20] Nevertheless, experts in the field justly note that at the start of the eighteenth century, as at all times, costumes varied, depending on the occasion on which they were to be worn, and that Watteau's preference is for informal and even theatrical,[21] rather than to formal, dress. Moreover, in one of the latest books on Watteau the suggestion is once again made that, just as he introduced into his paintings backgrounds containing architecture of the early part of the previous century (Salomon de Brosse), he dressed his figures in costumes of the Louis XIII period.[22] Antoine de La Roque, Watteau's closest friend, probably understood this phenomenon best of all when he wrote in the artist's obituary of the "...caprices of French fashion, both ancient and modern." [23]

To return to the problem of subjects, virtually every book and article on Watteau that mentions *Pierrot (Gilles)* contains a fresh attempt to identify the model for the central figure.[24] Since the painting depicts figures wearing Italian Commedia dell'arte costumes, various actors have been named (Biancolelli, Belloni, Bréon and others) who played the part of Gilles or of Pierrot in this very specific tradition of masked theatre masks which was not only quite different to the style of the Comédie-Française, but was in open conflict with it in the early eighteenth century.

In the Hermitage painting, previously known as *Les Comédiens italiens (The Italian Actors),* scholars recognize certain actors and actresses of the Comédie-Française. There are Christine-Antoinette-Charlotte Desmares on the left, and Pierre La Thorillière on the right.[25] In this respect, it is interesting to note the undeniable resemblance between the actor second from left in the Hermitage painting and the one in the Louvre painting who sits at the feet of *Pierrot (Gilles),* third from right. The arched eyebrows, the pointed nose and narrow nostrils, the

disdainful curve of the upper lip are alike in both faces. But if this is so, if one and the same person is depicted among actors of the Comédie-Française in the Hermitage painting and among Commedia dell'arte figures in the Louvre painting, then the very method of interpretation based on linking such pictures to a given theatrical company or play appears doubtful. That Watteau may have reproduced certain scenes from plays is, of course, possible. But his approach to the subject displays a far greater complexity. That is why the conclusion reached by a French theatrical historian that Watteau, guided by imagination, depicted in his compositions a theatrical troupe of his own invention, is not so odd as may seem at first glance. Yet the author then proceeds to list the names of all the actors of the Riccoboni company whom he is able to recognize in the painting *L'Amour au théâtre italien (Love in the Italian Theater)* (Berlin-Dahlem) - which is indeed odd.[26] *Sous un habit de Mezzetin* (known in English as *Mezzetin*), a small composition in the Wallace Collection, London, has a noteworthy history. Watteau's work continues to remain full of enigmas and to this very day his subjects and figures provoke contradictory opinions. In that sense, the London painting is a happy exception. In the notes to his *Abecedario* of painting, Mariette speaks of "the Sieur Sirois, friend of Watteau, represented amidst his family in the guise of Mezzetin playing a guitar." [27] Mariette's interpretation of Watteau's theatrical scenes is not generally as scenes from plays and he cautiously speaks of "persons in disguise", in Commedia dell'arte fancy dress. Mariette may also have been mistaken at times, but the former Bordeaux-Groult collection, Paris, included a portrait drawing, undeniably of the same individual, with the name *Syroie* inscribed in Watteau's hand. Consequently, this is one of the rare cases in which a model for a Watteau painting can be positively identified. A sketch in the British Museum is directly related to the two female figures in the painting *Mezzetin*. It depicts the heads of Sirois's daughters, at exactly the same angle as in the painting. Incidentally, the British Museum sketch seems to belong to those produced for a specific composition. Thus, the family of the artist's friend Sirois is portrayed in the Wallace Collection painting as an improvised company of Commedia dell'arte actors. According to Caylus, Watteau

kept a stock of theatrical costumes in his studio, in which he liked to dress his models.

The story behind *Mezzetin* provides grounds for the supposition that the other theatrical subjects of Watteau's mature period, far from being "portraits of performances", may, like the above painting, be his own "plays", created and staged on canvas by that most skilful director, the artist's imagination. Watteau's *Embarkation for Cythera* was probably another example of his own imaginary "theater."

Clearly, the boundaries between the themes most often used by Watteau are indistinct and hard to define. His "fêtes galantes" and theatrical scenes are linked by a common thread expressed through the artist's poetic fantasy.

Before attempting to define the essence of this interweaving of motifs in Watteau's work, as well as his commitment to the theatre, certain peculiarities of early eighteenth-century French theatre should be mentioned, especially as they are little known. They are essential, however, in order to make it possible to understand not only the artistic environment, but also of the social climate of Watteau's time.

As noted earlier, a bitter battle was being waged between the Comédie-Française and the Commedia dell'arte traveling theaters. T. Karskaya convincingly describes the stages of that struggle. [28] The popularity of the Commedia dell'arte plays produced for the Saint-Germain and Saint-Laurent fairs is due mainly to their being reflections of everyday life itself. It was in them, that the most important ideas of the day found what was probably their most striking expression. It is no accident that the history of the popular theater's struggle for existence, despite being banned by the police, is linked to the name of Le Sage, the most important satirical writer of the period, who began to work for fairground theaters in 1712. Watteau's preferences for a particular troupe or style of acting are less important than the the fact that early eighteenth-century theatrical life, especially when viewed as a unity between actor and audience, was a truer reflection of the life of the masses than of the life of the aristocratic milieu in which, as the the Count de Caylus, a nobleman of ancient lineage puts it, Watteau always seemed "un peu berger" (a bit of a rustic). [29]

Thus, for Watteau, life was bitterly perceived as play-acting and hypocrisy, while the theater, which the artist had loved from his youth, is seen as real life, exciting and undeniably real. Such was the spirit of the times in which Watteau's poetic ideals developed. That is why it would be a mistake to see the artist's passion for the theater as something that led him away from the essence of human nature and from the humanist tradition.

During a period of decline and moral corruption, Watteau's art manages to retain its poetic purity. His works reflect his dreams of a radiant and serene world governed by tenderness and kindness. The hint of bitterness and a feeling of solitude only serve to enhance his thirst for hope.

Paintings such as *Plaisirs d'amour (The Pleasures of Love)* (Gemäldegalerie, Dresden), *Fêtes vénitiennes (Venetian Festivities)* (National Gallery of Scotland, Edinburgh), *Les Charmes de la vie (The Charms of Life)* (Wallace Collection, London) and many other paintings of his prime are an expression of the perfect harmony between emotions, rhythm and color. The contention that Watteau only strove for perfect harmony, but never achieved it, is clearly groundless. *Fêtes vénitiennes*, one of the artist's masterpieces, is imbued with the same serene happiness that is shared by Watteau and Giorgione. Such works refute the modern, somewhat naive, tendency, to set Watteau's imagination at odds with his powers of observation, which leads some authors to speak of two, as it were, different artists continually at odds with each other, much like some split personality of twentieth-century literature.

There may be contradictory trends in Watteau's paintings, but they are not conflicting; the vital principle is the interplay between the various expressions of sentiment. The contrasts between joy and sorrow, melancholy and impishness, are associated with special moments, far removed from humdrum existence. The theatrical scenes and fancy dress of the figures serve the same purpose, magically of transforming ordinary mortals into actors on the stage of life.

These emotional states alternately bring the figures together and alienate them, inducing in them a meditation so deep as to cut them off from their surroundings. This characteristic of Watteau's art finds its strongest expression in *Mezzetin*, with its ecstatic preoccupation with the inner self. There is a similar underlying feeling in Watteau's last work, *L'Enseigne de Gersaint (The Gersaint Signboard)*, where the contemplation of

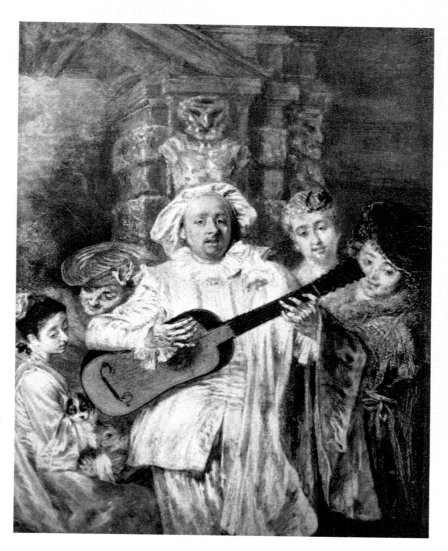

In Mezzetin dress.
Wallace Collection, London.

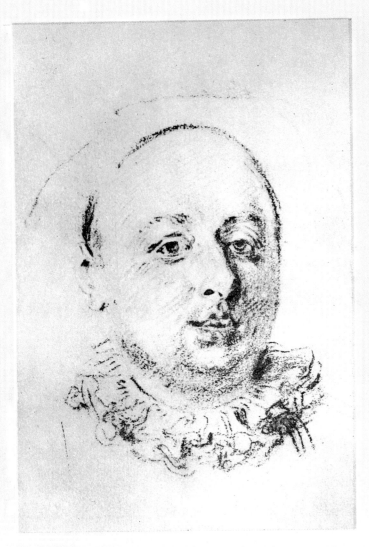

Pierre Sirois.
Formerly in the Bordeaux-Groult Collection, Paris.

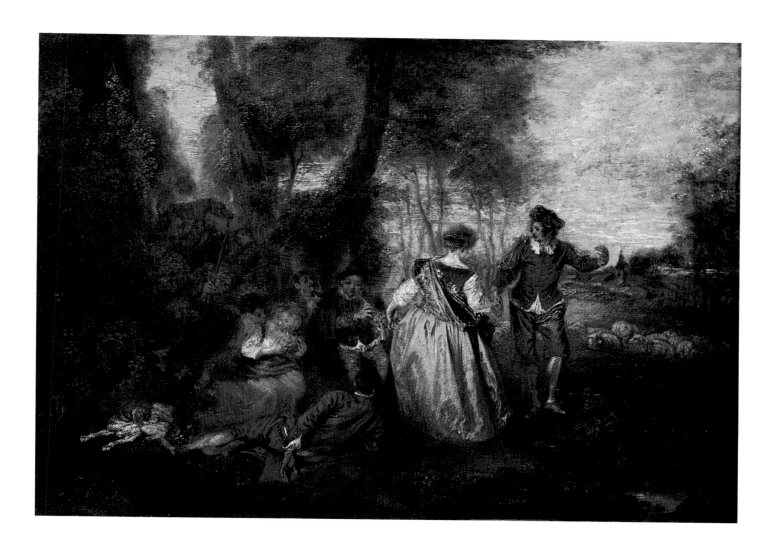

Le Plaisir pastoral (Pastoral Pleasure) Condé Museum, Chantilly.

artistic masterpieces serves as the poetical back-drop. Each group of characters has a specific type of painting assigned to it. The portraits of monarchs or great nobles (one of which is being packed into a box) may be a play on words associated with the name of Gersaint's gallery - "Au Grand Monarque" - at which Watteau lived in 1720 after his return from London. Symbolic interpretations of this motif cannot be ruled out either; the more so since alongside there is a large clock - a reminder of the inexorable march of time. The artist's thoughts move simply, though by no means arbitrarily, and the contrasts are highly significant. The area by the central door, is hung with scenes of seduction. The easiest to make out are Mars and Venus, Venus and Cupid and – higher up – a nymph pursued by a satyr that appears to be Pan and Syrinx. They correspond to two figures inside the shop – the gallant cavalier and the young lady taking a step toward him. He stands ready to take her hand, but her answering move is evasive : she is looking to the side. A note of irony then enters the tale. An elderly couple are being shown a large, oval landscape featuring nymphs in poses of abandon. The doddery connoisseur examines their buxom forms, while his companion fixes her gaze on the upper part of the canvas, which contains nothing but sky. This group, too, is echoed in the paintings hanging on the wall, but this time the motif of repentance is more pronounced. And so to the final group. The owners of the gallery offer a lady a casket and other items for her boudoir. The background for the young Gersaint dealers is provided by large paintings, such as *The Mystic Marriage of St Catherine* and (higher up, over the mirror) *The Adoration of the Shepherds*, as well as some sort of bacchanalia. All this has been little noted to date, yet the meaning of the motifs just mentioned is closely related to what is happening inside the shop.

The subject-matter of *The Gersaint Signboard* was not new. Long before Watteau, the interiors of art galleries and studios had become an established subject in European art. Paintings of this kind were produced by Frans Francken, Willem van Haecht, Hans Jordaens, David Teniers the Younger, and many others. Never before, however, had the subjects of the paintings depicted on the walls served as the key to the character of the figures and scenes depicted in the interior. Not only is Watteau's painting testimony to the artis-tic tastes of the age, it also represents a profoundly new approach to a traditional theme. Works of art are introduced into the painting not merely for their own sake, but as parts of the grand design.

In many of Watteau's paintings, for instance in the *Fêtes vénitiennes*, Watteau succeeded in achieving a harmony that could be communicated to the sensitive viewer; but it is also true that this harmony was precarious, as vulnerable and susceptible as the artist's own soul, judging from his friends' memoirs.

Speaking in terms of watersheds in French culture, Watteau's art appeared not at the turn of a century, but rather at the turn of a period of history. The heroic ideals of Classicism with its faith in human reason and man's noble deeds were left behind, while the optimism of the Age of Enlightenment was yet to come. In the difficult interim period that was Watteau's, the tradition of a poetic world outlook clashed with the acute sense of life's imperfections. The imagery of Watteau's world, formed at this historical juncture, reflects a growing measure of melancholy. Hence the theme of loneliness in the artist's later paintings, which finds its strongest expression in *Pierrot (Gilles)* (The Louvre), in which reserve and alienation merge with an invincible desire to communicate innermost feelings to the world.

There is good reason why whoever the model was, he is the personification of all the lyricism of his creator. *Pierrot (Gilles)* stands, as it were, stage front, deep in meditation, facing the viewer head on. This is a return to Watteau's theater theme, this time in relation to the composition. The theater, which was an integral part of Watteau's world view, provided not only his subject-matter and an appropriate setting for his figures, but also helped to determine the composition of his paintings.

Of course, any artist who recognizes the laws of perspective may place his figures on the canvas in such a way as to give the illusion of a stage set. However, not every artist views the models in his paintings as if he were seeing them from the auditorium of a theater. A seventeenth-century painting is usually an image complete in itself, with which the artist identifies. The viewer thus often experiences the feeling of "being there", as if actually participating in the painting's action. Watteau's works, on the contrary, show an

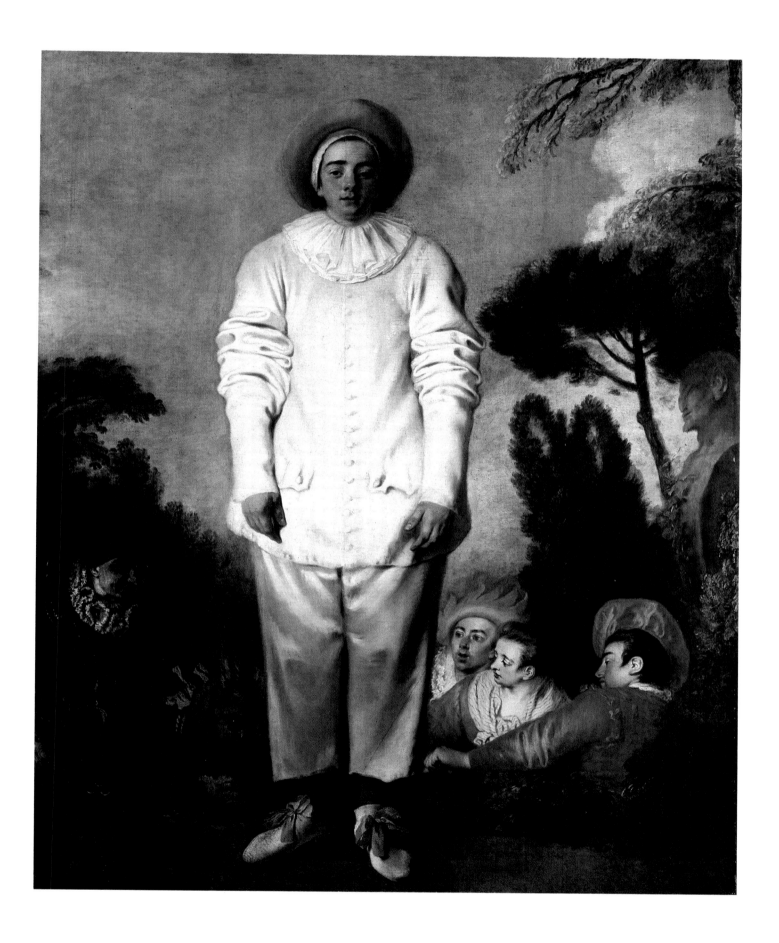

Pierrot (Gilles). The Louvre, Paris.

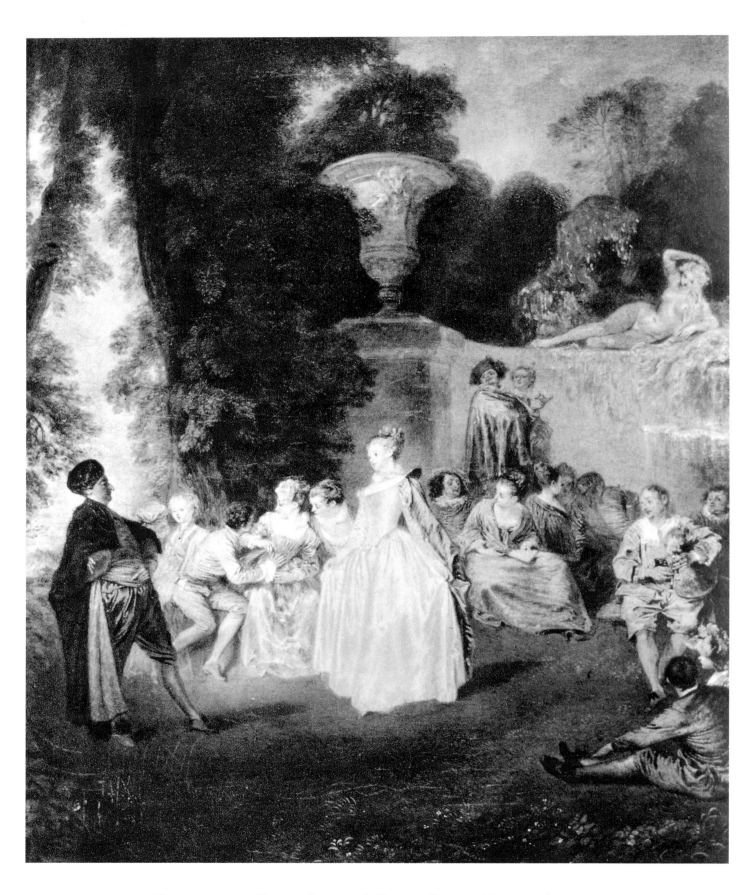

Fêtes vénitiennes (Venetian Festivities). National Gallery of Scotland, Edinburgh.

L'Amour désarmé (Cupid Disarmed) Condé Museum, Chantilly.

increasing estrangement which is reflected in the development of his composition. In Watteau's early paintings we see clearly differentiated planes. An important role is played by the spatial depth (as in *La Perspective*, Museum of Fine Arts, Boston). But this principle is short-lived; the rules of the stage take over, and Watteau's figures, as though mesmerized, stand frozen above the footlights (*L'Indifférent*, The Louvre). In his later works, there is an even stronger theatrical quality. The artist places his figures on a bench-like projection that runs parallel to the lower edge of the canvas. This apron stage is flanked by on either side by stage sets depicting landscapes or architecture, while there is a distant backdrop which is romantic rather than narrative in style. This applies to the painting *Les Charmes de la vie (The Charms of Life)* (Wallace Collection, London), in which the foreground consists of two terraces, as well as to the Dresden *Réunion en plein air (Meeting in the Open Air)* and to other compositions, including *The Gersaint Signboard*. The most striking feature of the emotional and figurative structure of Watteau's works is the rhythmical movement of the figures, whose whimsically changing motivations and impulses always find their plastic and rhythmic expression. This is a valuable quality in Watteau's art. It manifests itself even in his drawings, in which the figures are not connected by any common theme but just happen to have been placed on the same sheet of paper. One such drawing is the Pushkin Museum's *Etude de quatre personnages (Study of Four Figures)*. The figures are presented in different positions, as if embodying successive stages of movement through space, while the gaps between them accentuate this paced development. The principle finds its ultimate expression in Watteau's drawings and finished paintings. The dynamism of the pictorial content of a painting as a whole was characteristic of seventeenth-century Flemish art, and in particular that of Rubens and Van Dyck. The works of these Old Masters were used as ammunition in the battle waged at the turn of the eighteenth century by those French painters who favored Rubens against academic dogmatism, and they are also known to have had a marked influence on Watteau's style. It is significant that Watteau's patron in his early years was Charles de La Fosse, who cherished the legacy of the Venetian and Flemish colorists. Delacroix was to say later that Flanders and Venice had blended in Watteau's art. In Paris, Watteau often sketched the works of the great Flemish masters and his drawings show the influence of the powerful traditions of the Flemish school. Furthermore, the Swedish art collector Carl Tessin confirmed Watteau's interest in Van Dyck's works. [30]

A set of sketches and figures in a private collection in New York, which are preparatory studies for Watteau's *L'Histoire de Marie de Médicis (Life of Marie de Medici)* series, now in the Louvre, shows at a glance that Rubens's full-blooded sensuality was converted by Watteau into delicate and susceptible images, that the mighty polyphony of the Flemish apotheosis was transformed into the delicate strains of chamber music of Watteau's art.

The French master's paintings recreate nuances of emotional states conveyed not only by the narrative itself, but also by the spatial relationships between the groups and figures, by the rhythmical repetitions which express a subtle modulation of the general emotional theme, rather than a development in time. In *Les Deux Cousines (The Two Cousins)* (private collection, Paris), as in many other works, the landscape environment is a part of this complex unity, a theme of echoes, typical of the musical and rhythmic structure of Watteau's compositions. The withdrawn attitude of the standing figure is perceived as contrasting with the poses adopted by the other figures in the composition. Such contradictions did not and could not exist in the paintings of Rubens, permeated as they are by an overall sensual passion and by powerful, spontaneous impulses.

The specific rhythm of Watteau's composition also depends on the painterly correlation of the poses he makes his figures adopt. Taken separately, they seem incomplete, as if concealing an anticipated reciprocal movement, and they take their meaning only through this interaction. They listen to their interlocutor's soft words without looking at him, cast a quick glance over their shoulder while turning away, as if continuing to feel the presence of someone they have left behind. Each pose seems to be a continuation of the next; each seeks for, and finds, a response; glances cross, creating an intricate spatial pattern. For Watteau, composition is not neither order nor a rigid system, but a process unfolding,

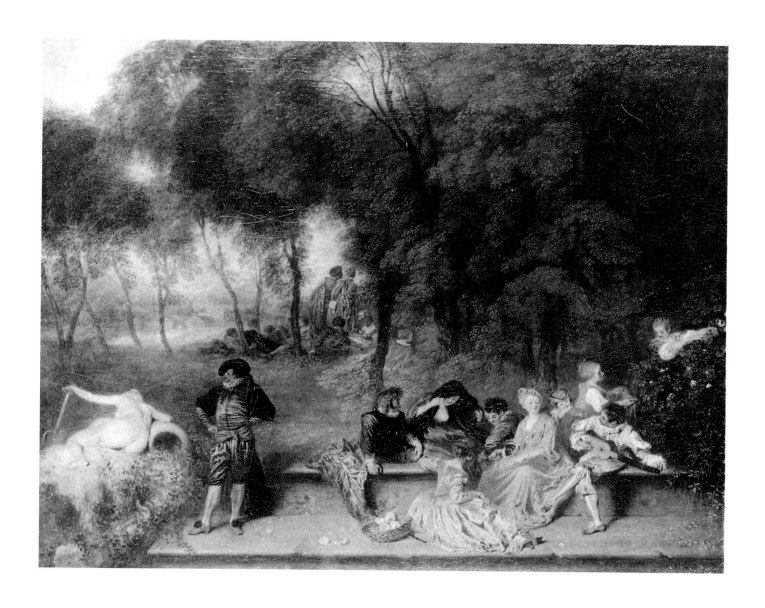

Réunion en plein air (Meeting in the open air).
Gemäldegalerie, Dresden.

as it were, before the viewer's eyes, somewhat like the development of a melody. In *La Proposition embarrassante (The Embarrassing Proposal)* (Hermitage Gallery) the theme's plastic and spatial development begins with the figure of the young man reclining on the grass. He gazes in the direction of the two seated ladies, turned toward each other in a way that makes the spatial orientation of the foreground appear to change direction. The movements of the seated figures, echoed in the drooping branches of the trees on the left and the diagonal line of the pale clouds, draw the viewer into this complex rhythm and draw the eye toward the central group. The arrangement of this group again alters the axis of the spatial orientation.

The development of the theme seems to end here, but on the right, the tree-tops again incline toward the center, and a new movement to the left begins with the figure of the standing woman recoiling in confusion and mistrust. This hint of a movement returns the viewer to the seated group, and so completes the circular, undulating motion of the scene. Were the viewer to begin to examine the picture in the opposite direction, the compositional principle would be no less apparent. The series of movements started but arrested in mid-air, determined by emerging and changing emotional impulses, is clearly important in the feeling of the painting.

Hence the specific quality of attitude and movement in Watteau's figures which seem to unwind in a spiral and to generate flowing, circular spatial rhythms. For Poussin, the plastic possibilities of the human body were a means through which to express strong passions. For Watteau, they embody the changing and sometimes contradictory shades of lyrical emotions. These features of Watteau's method of composition are revealed even more convincingly in his final masterpiece, *The Gersaint Signboard*.[30] Here, the theme develops from the central group, the lady and the gentleman, the latter inviting her to follow him inside. But, as if ignoring his outstretched hand, the lady casts a glance to the left. This typically complex and ambiguous gesture is the starting point for a movement, diverging right and left, and finding its rhythmical development in the other groups, as well as in the poses of the figures in the paintings that hang on the walls of Gersaint's shop. An analysis of the spatial and plastic rhythm of Watteau's paintings once again demonstrates that it is an oversimplification to suppose that Watteau's imagination and his powers of observation are in conflict. There is also a frequently encountered tendency to simplistically divide Watteau's work into two stages, the first when he put his observations on paper, and the second when he arranged the figures sketched from nature into a pattern like a game of solitaire played with images.

A close study of Watteau's drawings shows that his poetic imagination found its first expression in these records of attitude, gesture, or movement of particular individual expressiveness. These sketches were of immense importance to the artist, since a whole world of complex and subtle emotions is contained in each gesture, glance, and inclination of the head, a world as rich in its diversity as that of Watteau's paintings. The drawings that served as compositional sketches clearly illustrate how the traditional academic principles of composition are overridden by the artist's flights of the imagination.

Watteau was not an artist who painstakingly and methodically constructed a painting from counterbalanced and strictly apportioned elements. His compositional sketches are not calculated versions of the arrangement of figures within a certain space, but rather the recording on paper of certain stages in the flight of the artist's imagination; that is the reason why they do not predetermine the final composition. To Gersaint, these irrepressible and impetuous flights of fancy were nothing more than manifestations of impatience and instability: "He was bored by anything that he saw for any length of time; he sought but to leap from subject to subject; often, he would begin a commission and become tired of it before it was half-finished."[31]

The sketches for the picture *Les Comédiens italiens (The Italian Players)* (Laughlin collection, New York; British Museum, London) furnish an example of the great freedom and mobility of Watteau's own creative system of composition. In one case, he introduces architectural scenery at each side, in another, a landscape backdrop; the composition becomes markedly asymmetrical; the central and minor figures change places and are moved forward on to the apron-stage. The light and intricate rhythm of these various versions expresses the spirit of the quest of the artist,

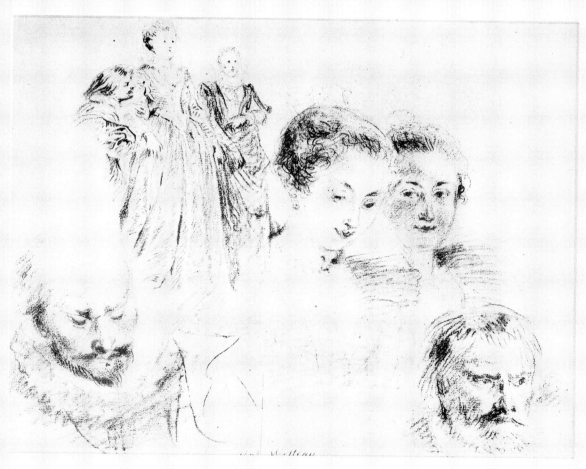

Sketches of figures for the series The Life of Marie de Medici.
Private collection, New York.

animated or disappointed by turns with his improvisations. Watteau's contemporaries (Tessin, La Roque) found an element of the grotesque in his work. In the eighteenth century, this term was used to denote decorative or figurative motifs dominated by the fanciful and the fantastic. The "painting of grotesques" was also distinguished in those times from the lofty historical genre painting, the former being considered as pure entertainment and akin to low comedy – the lowest level, in fact, of the academic hierarchy. Watteau's first biographer, La Roque, had occasion to note the blend of the serious and the grotesque in the artist's work,[33] while d'Argenville found it necessary in his biography of Watteau to qualify "grotesque" with the word "crude." [34]

Watteau's scenes, as a rule, are placed in a landscape setting. The attraction to Nature, so typical of the eighteenth century, manifested itself in the artist's work at a relatively early stage. The lyricism of his world outlook served as the major stimulus for his landscapes which harmonized with his figures' poetical moods. In effect, there are no main or secondary elements in the pictorial fabric of the artist's work; the whole is imbued with one feeling, and each part contributes to the overall theme.

Watteau helped in the development of the feeling for nature in the eighteenth century. His contemporaries commented upon the artist's preoccupation with painting from life. Mariette, for example, mentions "these two views that were made by Watteau from nature during the time he lived at Porcherons."[35] *Paysage de rivière et clocher d'église (Riverside and Church Tower in Landscape* (Teyler Museum, Haarlem) is in the same vein. However, the preferred view is that of the park of a country estate. Sculptures, urns, terraces, pavilions are all among the most popular elements in his compositions. Many of these scenes can probably be identified with real views over parkland (Mariette mentions Crozat's garden in Montmorency and the park at Vincennes). However, the artist's imagination should not be discounted. It must have been stimulated by the paintings of Italian masters, with their crags, large expanses of water, and mountain ranges on the horizon. None of these could be observed in the surroundings in which he lived, yet mountains and bays figure in his

compositions (including *The Embarkation for Cythera*). Watteau is known to have copied landscape drawings by Titian, Annibale Carracci, and Domenico Campagnola. Judging from catalogues and remarks by his contemporaries, his source was the Crozat collection. Mariette remarks of Campagnola's landscape drawings: "While at Monsieur Crozat's, Watteau copied them all and admitted that he had profited much by this."[36] Incidentally, this explains the relatively late appearance of italianate motifs in Watteau's works.

As regards park and rural landscapes taken directly from nature, Watteau's drawings testify to his particular preference for the views of Porcherons, the valley of the river Bièvre at Gentilly and the Crozat gardens at Montmorency. Curiously enough, there are almost no park scenes among his landscape drawings (one notable exception being the remarkable red chalk drawing in the Hermitage depicting a shady avenue with a small pavilion in the distance). Is this not supporting evidence for the theory that the parks in Watteau's works were, to a large degree, the product of his imagination?

It is extremely interesting to note, in this connection, that Watteau himself was the "creator" of the sculptures that decorate the gardens in his paintings. That probably explains their amazing spirituality and textural warmth; they are perceived almost as living beings. The history of the figure in *Les Champs-Elysées (The Elysian Fields)* (Wallace Collection, London) furnishes the most striking example of this creative approach. Watteau transformed the heroine of his large Louvre painting *Nymphe et Satyre,* known under the title of *Jupiter et Antiope,* into this small statue. Sketches of actual sculptures are rarely found among Watteau's drawings and are limited to the rough copies of a relief by François Duquesnoy and of a group by Jacques Sarrazin, which served for several paintings.

The landscapes of Watteau's paintings are an integral part of the imagery and compositional structure. When Watteau uses short, curved brushstrokes to depict the delicate foliage of trees, he applies them in such a way as to form a pattern surrounding the figures. The decorative element becomes a means of poetic expression. Landscapes are not introduced merely as backgrounds; like living beings, they become

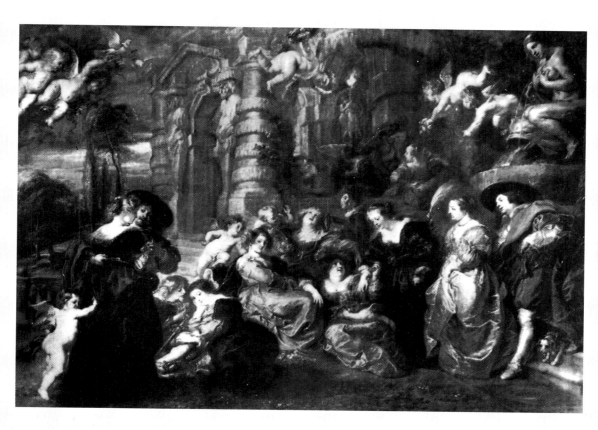

Rubens, *The Garden of Love.*
The Prado, Madrid.

imbued with the pensiveness and lassitude that fill the scene. Thus, in the Dresden *Réunion en plein air*, the branches of trees bend with lithe suppleness over the figures, their curving pattern matching the outlines of the figures.

The flowers are the focus of emotional attraction between the figures, their fragile beauty emphasizing the painting's suppressed lyrical quality. This is especially significant because the "language of flowers" was of particular importance at the time.

In some of Watteau's compositions, amid rows of slender trees, there are glimpses of distant views, suffused with a soft light and captivating in their dreamlike quality. The colors of the landscape background are muted and subdued. Watteau avoided sharp chiaroscuro contrasts; the sky in his pictures is often shrouded in pinkish clouds that keep out the brilliant sunshine.

The essence of a work of art is to capture, as it were, an image of reality, and to perpetuate it on the canvas. One has difficulty applying this concept to Watteau. In his paintings, palpitating and mutating nature is rendered as subtle changes of tone, muted shades, and the interplay of color. When studying a Watteau landscape one can almost hear the soft rustle of leaves which seem to be in constant movement. This impression of movement is enhanced by light flickering in the tree-tops.

In such paintings as *The Embarkation for Cythera*, the landscape is bathed in a soft golden hue reminiscent of Venetian painting. The gradual change of this tone, which becomes increasingly light and translucent in the distance, brilliantly conveys the atmosphere. When placing his figures and groups in a landscape, Watteau was not overly concerned with the accuracy of spatial relationships. Of far greater importance to the artist is the decorative pattern with its unfettered rhythm which evokes an emotional response in the viewer. In *Le Pèlerinage*, as in many of Watteau's other compositions, this rhythm is enhanced by the general undulating movement of the figures. They ascend the steep hill, then descend to the boat, and the cupids flitting above the scene complete this exquisite and intricate motif. The branches of the trees and the dark-colored grass in the foreground combine to form a garland-like frame for the figures. These specific compositional devices attest to Watteau's

Preceding pages:
La Femme en source (The Woman at the Spring.

Above:
Enfants parodiant un bal (Children parodyng a Ball).
Städeliches Kunstinstitut, Frankfurt

Comédiens italiens. (Italian Players)
Laughlin Collection, New York.

Comédiens italiens (Italian Players). British Museum, London.

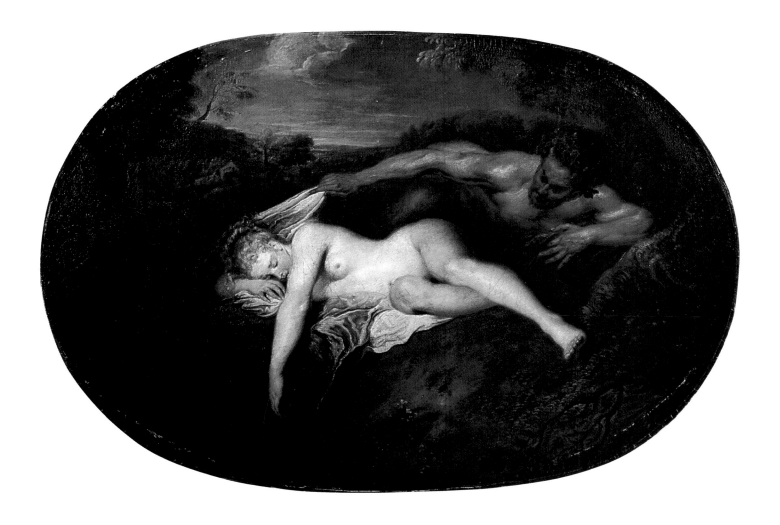

Nymphe et Satyre (Jupiter et Antiope). The Louvre, Paris.

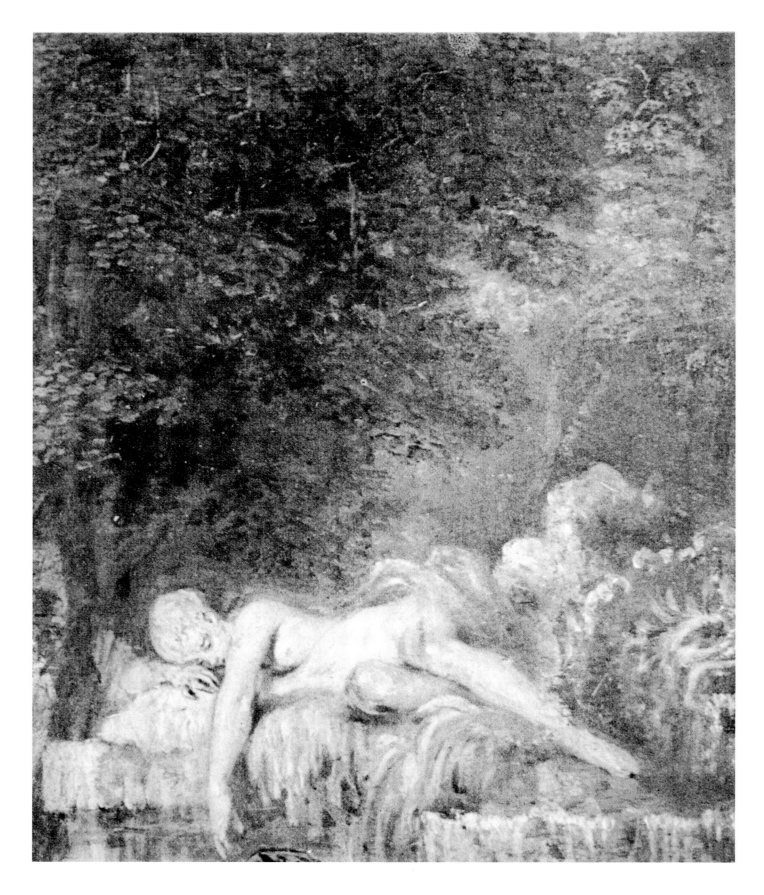

Les Champs-Elysées (The Elysian Fields). Detail. Wallace Collection, London.

great decorative talent. Watteau's contribution to eighteenth-century French art was, in this sphere, significant.

The rocaille interior with its soft and delicate colors, fanciful rhythms, and slightly asymmetrical, refined ornamentation was in many ways anticipated by this painter of small canvases, usually meant for the *cabinets de tableaux* of the new town houses of the aristocracy in Paris. It was during the period of Watteau's apprenticeship to Gillot and Audran, that his early decorative designs came into being. They were few in number and hardly any have survived. Watteau may have assisted Audran in fulfilling a commission for the Château de Meudon. According to Julienne, he also worked with Audran in the Château de La Muette and painted a series of decorative panels called *Les Quatre Saisons (The Four Seasons)* for Crozat's house. But of particular interest are his "arabesques", decorative panels depicting different scenes and figures enclosed in an ornamental frame. They are usually dated to the period of Watteau's work in Audran's studio – circa 1708-9, and are known only from engravings and the artist's preparatory drawings. Engravings by Aveline and Moyreau reproduce Watteau's panels (only a few of which have survived) on mythological and genre subjects which decorated the dining-room of the Maintel mansion.[37] A similar series was produced for the Chauvelin mansion. Incidentally, there is evidence that the architectural designs in these compositions were painted by Lajoue, rather than by Watteau himself. We know that Watteau also decorated screens, fans, and even a harpsichord. An X-ray photograph of the picture *La Leçon d'amour (The Lesson in Love)* (Nationalmuseum, Stockholm) reveals beneath the layer of paint an earlier decoration for a coach door, which included a coat-of-arms with unicorns. The treatment of the ornamental motifs here is reminiscent of a similar work by Claude Audran; Watteau repeated these motifs in the decoration of the boat in *The Embarkation for Cythera*.[38] It is best to judge of this aspect of his work on the basis of his own drawings, many of which have been preserved; some of these can be found in the Hermitage collection.

The sketches for decorative panels demonstrate the wide range of the artist's fantasy. Mythological, pastoral, and genre figures intermingle here to create a fanciful and graceful ornamentation, together with trelliswork and flower vases, pergolas, all kinds of decorative plants, volutes, sea shells, statues, masks, and cartouches. All these forms merge in an effortless and free manner; strokes of lead pencil, red, and black chalk, often akin to ornate flourishes, are sometimes swift, at other times smooth and flowing. The ornamentation on each sheet of paper is asymmetrical, thereby intensifying the sensation of the mobility of forms.

The effect produced by such compositions is remarkable in that it conveys, just as Watteau's paintings do, the mutability of existence, the transient nature of his swiftly changing images and impressions. In several designs intended to be placed over doors to the rooms, the elegance of the ornamental frame is reminiscent of the eighteenth-century decorative compositions intended to adorn interiors in the rocaille style.

It would be difficult to grasp the meaning of Watteau's work without comparing it with the early eighteenth-century development of new stylistic forms in Rococo interior decor, a development in which he himself played no small part. It would be erroneous and one-sided to examine the composition, color scheme and rhythm of his easel paintings without a corresponding analysis of the rules governing this new style. His works are better understood when imagined in a rocaille interior, the lyrical emotionality of which was in keeping with Watteau's poetical style.

Judging by the few dates available to students of Watteau's work, he stopped producing arabesques shortly after 1710. But tendencies continued in his paintings and these influenced the subsequent development of French decorative art.

The painter's style changed with his new view of the world. Count de Caylus, one of Watteau's biographers, was amazed at his extraordinary combinations of colors and insisted that the artist never cleaned his brushes and dipped them in a pot in which all his paints were mixed. De Caylus, who had been brought up on the historical paintings of academicians, was evidently not receptive to Watteau's new color principles.

The subtlety of each shade of color was Watteau's major discovery. Tonal and color variations turn his small paintings into diminutive treasuries of amazing imagery. In the painting *Voulez-vous triompher des belles? (Do you Wish to Triumph from the Beautiful Women)* (Wallace Collection,

London) it is virtually impossible to define the color of one of the dresses. It is nearest to yellow, yet it is woven from lemon, grass-green and light pink hues, airy and transparent tones, which emit a shimmering wealth of shades in the soft, diffused light and the hazy air blurring the outlines. In the figure in the left background, Watteau boldly blends delicate pink and green nuances with the basic blue shade of the dress. These hues can hardly be called reflections of light in the true sense of the term as applied, for instance, to the painting of Chardin. Chardin used reflections of color to convey the relationship between objects; his contemporaries said that in his pictures all the objects are reflected in one another ("tous ses objets se mirent les uns dans les autres"). The essence of Watteau's more conventional imagery lies not in the actual relationships between objects of various colors, but in the very changeability of the delicate nuances of color. Watteau chose backgrounds of relatively dark foliage or drapery in order to highlight certain colors which outshine everything else in their brightness, even the sky; but this alone does not explain the particular luminescence of his colors. The fact of the matter is that, he inherited these from seventeenth-century Flemish painters, along with the warm, golden hues and the transparency of their color washes, although his style, when compared with theirs, seems much looser. Even his contemporaries noted that Watteau used a lot of oil on his brush.[39] His figures radiate a gentle, flickering light that shimmers in the tiny folds of the draperies and in the trembling leaves of the trees. Using a fine, hard brush, the artist applied short strokes that are slightly curved, as if vibrating. The almost imperceptible variations of hue in these brushstrokes produce the most elegant color harmonies. He has a nervous touch, and the sinuous curves of the strokes are often reminiscent of hieroglyphics.

La Finette (Louvre) and many other pictures show clearly that Watteau applies his strokes as if embellishing the canvas's surface. His sense of decorative unity is particularly strong and this impregnates all his work. Watteau used an unusually wide variety of brushstrokes. They can be thick, close to impasto, when the artist chooses to accentuate the chiaroscuro effects; they can also be thin and resilient, when he wants to convey swift movement. At times, they become

Panels for the Hôtel Nointel (Poulpry). Private collection, Paris.

Panels for the Hôtel Nointel (Poulpry).
Private collection, Paris.

transparent and seem to melt in a soft blur. Thus, in *La Boudeuse (The Pouter)*(Hermitage) a thin layer of paint has been rubbed into the canvas and tiny strokes superimposed on it (white over pink, ocher over green), making the entire surface emit a soft glow. Brushwork also plays no small role in the capricious, restless rhythms that fill the artist's paintings.

Watteau's favourite colors merge in exquisite, harmonious combinations of light blue, dark yellow shot with gold, pink, light green, blue, cherry-red, lemon, lilac, white, and brown. At times, the artist seeks greater color variety, but more often chooses the line of complex tonal variations. Thus, in *Assemblée dans un parc (Gathering in a Park)* (The Louvre) the foreground color scheme is based on a combination of different, but equally pale, colors that alternate with deeper blue accents. The blue is repeated without changing in quality, but it is precisely due to this constancy that the eye can appreciate the nuances of the variations and juxtapositions. The landscape is not there to simple fill a space in the composition, it is integrally linked to the foreground. The major color tonality is repeated, in a muted manner, in the leaves of the trees, the golden clouds, and the blue of the sky. This richness of color variations is characteristic not only of the foregrounds, but also of the backgrounds. In *La Proposition embarrassante (The Embarrassing Proposition)* (The Hermitage) the bright highlights of the clothing are echoed by the pale color combinations in the landscape – pinks (the roofs) and light greens. The artist's technique is easily observed in the clump of trees to the right. He first painted the olive-brown tree trunks, then the blue sky visible between them, and superimposed yellow paint, to represent the delicate foliage. This is a striking example of the innovation in his painting techniques. Watteau seems to have addressed his artistic discoveries to the future, anticipating to a certain extent the color principles of nineteenth-century painting. The drawing *Paysage de rivière et clocher d'église* in Haarlem's Teyler Museum (often linked with the Hermitage *La Marmotte*[40]) bears this typical inscription in the master's hand "Demi-teinte grise et généralement les ombres grises." (A gray half-tone and in general the shadows should be gray). Watteau's drawings are just as innovative as in his paintings. The "trois crayons" technique

(charcoal, red, and white chalk) served to superbly convey soft skin texture, the sheen of silky material, and the gentle transitions from light to shade.

A study of Watteau's legacy is extremely difficult, since he did not date his works. The solution to many of the problems pertaining to his work requires a historical approach, an analysis of the development of the artist's style. A clear understanding of the sequence of development of the artist's technique would help to elucidate its dominant tendencies and characteristics.

True, there is no lack of key dates insofar as Watteau's artistic biography is concerned. But by some unfortunate coincidence, nearly all of them contribute little to an analysis of the development of his style and techniques. Watteau was born in 1684 and went to Paris around 1702. It is not known what his early efforts were like (he probably studied under Jacques-Albert Gérin in Valenciennes). In Paris, Watteau earned his keep by copying images of St Nicholas for an obscure tradesman. These copies have been lost. This was followed by an apprenticeship to the decorative artists Gillot and Audran, but the sources have supplied no dates (even the artist's close friend, Jean de Julienne, uses the ambiguous phrase "quelques temps après" (some time after)). As noted earlier, the decorative works of those years are known almost exclusively from engravings done by others.

In 1709, the Académie records show that Watteau competed for the Prix de Rome. His entry, the biblical composition *Retour de David après la défaite de Goliath. Abigaïl apporte des vivres à David (David's return after defeating Goliath. Abigail brings food to David)* has not been preserved. Consequently, this precise date, rare as it is, has no practical significance in reconstructing the artist's development.

It is appropriate to mention here Gersaint's story about the paintings of military subjects which began to appear around 1709 and are related to Watteau's journey to Valenciennes. At last, there appears to be some definite information about the painter. Gersaint refers to the *Départ de troupes (Departure of the Troops)* as the first, and to the *Halte d'armée (Army Halt)* as the second military scene. Clearly, this is the painting now in the Pushkin Museum in Moscow. However, further difficulties arise in reconstructing the painter's biography.

In 1712, seeking the title of "agréé" (approved), Watteau presented *Les Jaloux (The Jealous Ones)* to the Académie (engraved by Gérard Scotin) and perhaps several other works as well.[40] Practically nothing is known of the next five years. The year 1717 is important because on August 28, 1717 Watteau presented his *Embarkation for Cythera* to the Académie, the painting which was to earn him the title of academician.

After that, once again, there is no definite information until 1720. Caylus and Gersaint indicate the years of the artist's stay in London (1719 and 1720). According to Gersaint, the painter was very busy in England, where his works were greatly admired, but exactly which works cannot be said with certainty. Shortly before his death, Watteau produced *The Gersaint Signboard* (Schloss Charlottenburg, Berlin). Gersaint mentions 1721, and twentieth-century students of Watteau's art have narrowed it down to several months of the year, but this is hardly of great importance.

Thus, the information that researchers have at their disposal allows them to date only a few paintings from Watteau's large legacy with any degree of accuracy. His drawings are not dated either, rendering them of little use in determining the chronology of his work. With this knowledge in mind one can fully appreciate the phenomenally painstaking work of the many experts in France and elsewhere who, with the help of analogies and comparisons, have constructed the outlines of Watteau's creative biography. Nevertheless, there are still so many riddles to be solved that Watteau's work offers much scope for further study.

Naturally, audacity in such studies must be matched by solid argumentation. In our opinion, the exact dates given in Hélène Adhémar's catalogue of Watteau's paintings are insufficiently substantiated.[42] Even dates traditionally attached to some of the master's works must now be considered questionable.

To summarize all that has been said concerning Watteau's creative development, our understanding of his paintings rests on three elements. Firstly, there are the early military scenes, which contain a strong narrative element and a dark, restrained palette. Secondly, *The Embarkation for Cythera*, painted in 1717, demonstrates the golden, warm range of tones used by the artist in

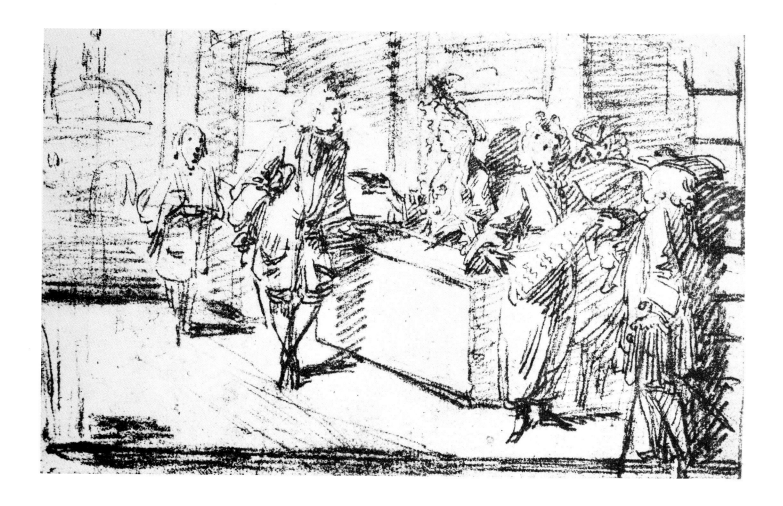

Une boutique de marchands d'étoffes.
(Cloth Merchants' Shop)
The Louvre, Paris.

his prime. Finally, there is last group of paintings, produced c.1720, typified by the replacement of the golden tones by colder silvery ones. The painting is distinguished by a greater subtlety and purity of color, and impasto gives way to light, transparent glazes. Watteau's style becomes more precise and acquires a special finish, a filigree quality and a plastic clarity of form. *Les Comédiens français (French Actors)* (Metropolitan Museum of Art, New York) and *The Gersaint Signboard, Réunion en plein air (Meeting in the open Air)* (Gemäldegalerie, Dresden) fall into the same stylistic period.[43] In this connection, it would also be interesting to examine the style of *Mezzetin* with its cool, refined pinkish tone.

La Boudeuse (The Pouter) (Hermitage) is also closely related to this last cycle. V. Loewinson-Lessing discovered an engraving of this picture among other items in the Walpole Collection (London); this seems to support a date of 1720, when Watteau was in London.[44] The style of the painting also places *La Boudeuse* among Watteau's late works, due to its silvery tones, the subdued color combinations, brushstrokes once free and open but now discreet, and the precision of each element of the composition.

The year 1720 could have marked a fresh start of the artist's creativity, one which was both brilliant and energetic, for it is the year in which Watteau produced his indisputable masterpiece, *The Gersaint Signboard*. The highly finished style of the signboard is combined with a clarity of vision that bespeaks a broad and mature mind. Here, too, the sentimentality is still implicit but it is supplemented by the unambiguously original quality of the subject-matter; each figure embodies a world of its own, offering something uniquely personal and thus significant.

Watteau's untimely death did not permit him to express himself fully. Yet he managed to say a great deal. His work was an important stage in the development of artistic endeavour. Watteau's painting gave rise to a new vision, one which differed radically from that of the seventeenth century's main tendencies in painting, with their wide-ranging subject-matter and powerful sense of tragedy. This is quite apart from the highly individual nature of Watteau's style and its intimate quality, naturally linked with the artist's heightened sensitivity to the poetical side of life. His art conveys the subtlest range of transient spiritual states; he was the first to demonstrate how much may be concealed in that infinitesimal, but artistically indispensable value – the nuance of feeling.

Watteau's works were the expression of his dream of a wonderful world of poetic response. Yet it should be remembered that, historically speaking, his art coincided with a time of social crisis, disbelief, cynicism and apathy. Watteau's dream could not but clash with the reality of human nature perverted in a class-ridden society. This contradiction bears some resemblance to the tragic discord between dream and reality experienced by nineteenth-century painters; this is probably why Watteau is sometimes called an early-day romantic. But the romanticism here is of the most general nature; far more important is the fundamental difference between the two ages. In the work of an artist during the Régence, this awareness of the divergence between dream and reality was suppressed and incomplete. Unlike the disputes between the nineteenth century Romantic painters, it led only to the emergence - within the context of the general lyrical theme, the mournful and melancholy tonality with which Watteau's mature works are imbued. This poetic tonality, the embodiment of a certain attitude toward the world, was one of the most noteworthy features of a new stage of artistic development.

Watteau was neither a lyrical genre painter in the Dutch and Flemish tradition nor the creator of epic paintings filled with the drama of conflicting passions, like Poussin. The specific nature of his imagery, in which poetic fantasy prevailed, called for metaphorical subjects laden with indirect meaning. It is not for nothing that the traditional description "*fêtes galantes*", coined by the Académie, has been repeatedly disputed by modern researchers who, even if they accept it, regard it only as a very general description of a complex and profound artistic phenomenon. Emotional involvement was a major feature of Watteau's poetic style. Significant, in that sense, is the question of his landscape backgrounds. Some see them as stage settings, others as representations of nature, but the crux of the matter is that in Watteau's art the landscape background has basically a poetic function, creating the emotional and rhythmical harmony which constitutes an essential element of the painter's idiom.

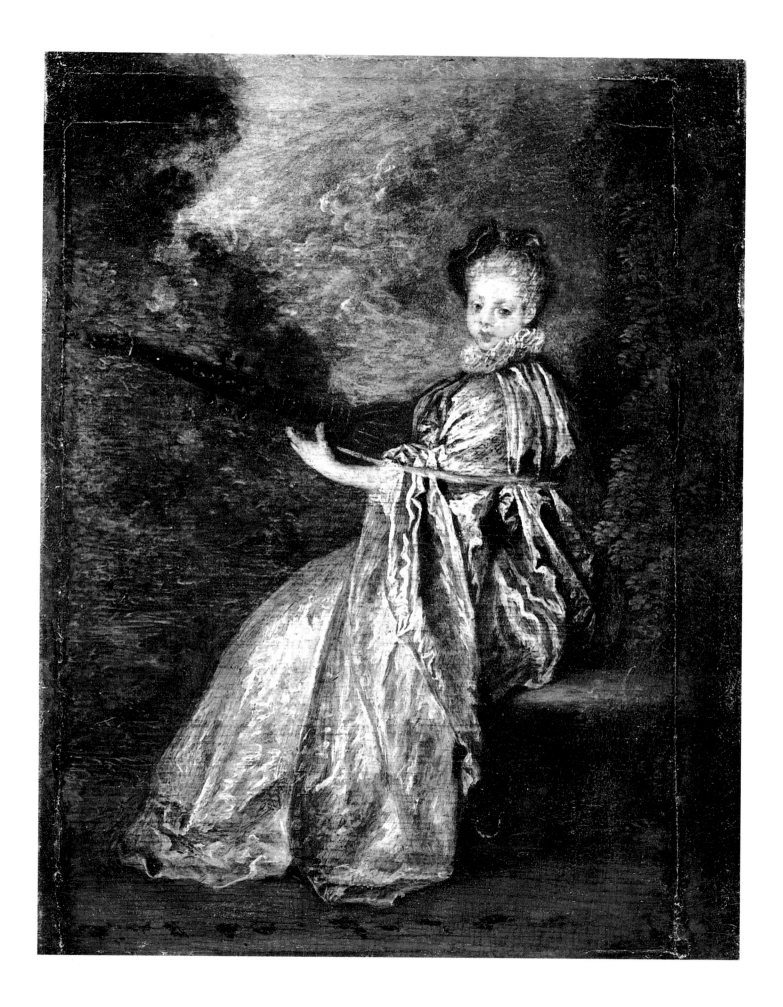

Preceding page:
La Finette
The Louvre, Paris.

Above:
Comédiens parodiant un défilé militaire
Actors Parodying a Military Parade.
Hessian Landesmuseum, Darmstadt

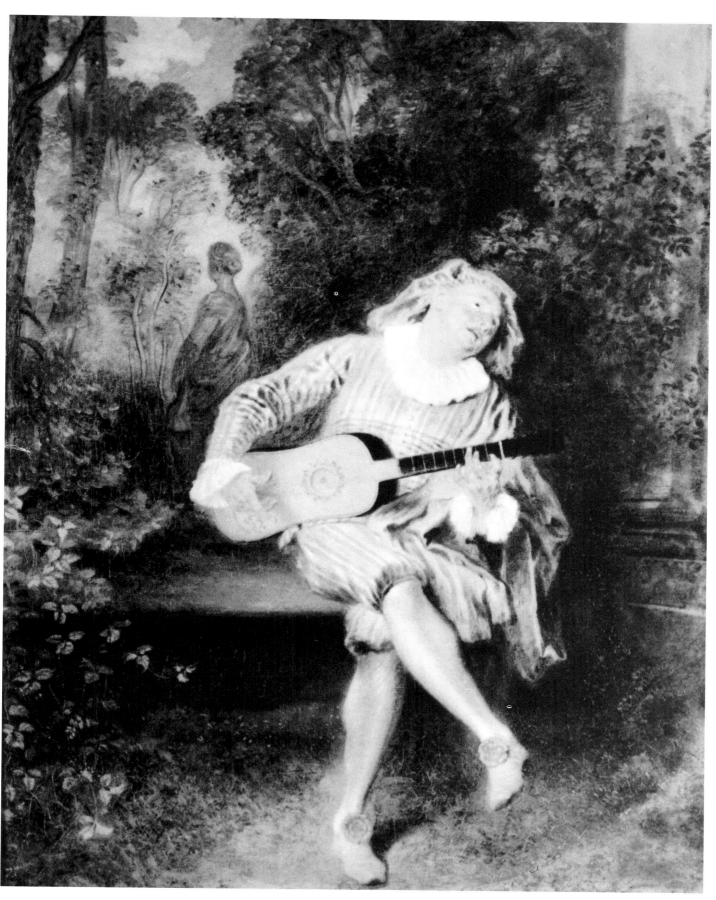

Le Mezzetin. Metropolitan Museum of Art, New York.

This type of artistic approach naturally manifests itself in a corresponding type of painting, one which is normally intimate and small in size. This was partly a response to the demands of connoisseurs, who were then building up their private collections, since grandiose historical scenes were still being produced during the period. It was, however, mainly a question of the artist's strict esthetic principles. To be fully appreciated, the artist's concept called for intimate contact with the viewer, requiring his emotional involvement. Watteau's art needed neither crowds nor grand reception halls; in that sense, it is very much part of the typical early eighteenth-century interior. It should also be noted that such platitudes as "cultural refinement", when applied to Watteau, only serve to distract from an appreciation of the true value of his artistic discoveries.

No less original is Watteau's attitude toward the figures in his paintings. Their appearance, poses and gestures are expressive and amazingly life-like. At the same time, they are as related to each other as the musical phrases which the artist used to compose his "Couperin melodies." The fact is that Watteau paintings always bear the imprint of the artist's individuality; his inimitable style has been stamped on each of them, determining the scene's emotional content. As for the models, their personalities are of little significance. The emotional link between them varies through their relationships, their bonds, and the gaps between them which serve as rhythmical pauses.

Finally, the primary importance of color shading in Watteau's art should be mentioned again as being of prime importance. This, in turn, is linked to the concept of form, perceived as ever-changing by the artist. The rhythmical structure of his works is based on the barely perceptible, but keenly observed and precisely delineated correlations of movements and gestures. The interaction of all these elements creates a novel and highly significant stylistic phenomenon. Without doubt, it was the source of eighteenth-century French artistic culture and a natural stage in the general development of art.

Since this introductory essay precedes a *catalogue raisonné* of the Watteau paintings in Russian museums, it would seem appropriate to provide a general description of the Russian collections and comment on some of the works they contain. It should be noted that research by Tatyana Kamenskaya and Inna Nemilova has contributed in no small measure to the study of the collection in the Hermitage Museum in St. Petersburg. This makes it possible to confine this overview largely to the Watteau paintings in the Pushkin Museum of Fine Arts in Moscow.

First, a few words about the history of the collection. In July 1768, Prince Andrei Mikhailovich Beloselsky, the Russian envoy to the court of Saxony, acting on behalf of Catherine II bought the private collection of Count Brühl, a statesman in the service of Augustus III and a patron of the arts. The price paid was 180,000 florins. The following month, the collection was shipped from Lübeck and Catherine was soon able to invite Falconet, who was then working in St Petersburg, to admire the new treasures at the Hermitage.[44] They included three compositions by Watteau, *La Proposition embarrassante. Satire contre les médecins* and *Le Repos pendant la fuite en Egypte*. The paintings *Les Fatigues de la guerre, Les Délassements de la guerre* and *Acteurs ("Les Coquettes")* were acquired for the Hermitage in 1772, on the instructions of Catherine II, from the collection of Louis-Antoine Crozat, one of the heirs of the Pierre Crozat, of whom Watteau had been a protégé. The Russian scholar, Dmitry Golitsyn, then a diplomat in Paris, and Denis Diderot, participated in the negotiations. These were the two largest acquisitions. Information pertaining to the provenance of the other pictures and drawings is supplied in the *catalogue raisonné*.

The paintings now in the Hermitage Museum and the Pushkin Museum represent different stages in Watteau's art. Probably the most fully represented is the relatively early series of military subjects. In his biography of Watteau, Gersaint says the artist painted his *Départ des troupes* while still studying under Audran. After selling it to the merchant Sirois, the artist left for his home in Valenciennes near which military operations were taking place. From there, according to Gersaint, Watteau sent Sirois a second painting as a pair to the first. Gersaint calls it *La Halte d'armée (The Halt of the Army)*. These works brought the painter wide recognition. Subsequently, the issue became confused due to the groundless assumption that Watteau's first military painting was *Recrue allant joindre le régiment (Recruit going to join the Regi-*

ment) (Rothschild collection, Paris).[46] H. Adhémar repeats the suggestion.[47] However, both *Gersaint* and Mariette assert that Watteau's first two military scenes were engraved by Charles Nicolas Cochin père. Conversely, *La Recrue* was engraved by Watteau and Thomassin, not by Cochin; moreover, this last work demonstrates a greater maturity of style and a more refined color scheme. The title mentioned by Gersaint might fit the subject of the lost painting *Défilé (Parade)*, of which an engraving by Jean Moyreau is in the City Art Gallery, York. It was a pair to *La Halte d'armée* (Thyssen-Bornemisza collection, Lugano). But the name of the engraver is wrong again. In all probability, our choice should be the pair consisting of the *Camp volant (Flying Camp)* (Pushkin Museum, Moscow) and *Retour de campagne (Return from the Campaign)* (E. W. Edwards Collection, Cincinnati).[48] Both were engraved by Cochin père. A stylistic analysis of both paintings reveals characteristics pointing to Watteau's early period, such as the panoramic landscape, the alternation of planes, the abundance of figures and the strong narrative element.

Thus we can take it that the Moscow *Camp volant* is the picture referred to in Gersaint's memoirs as the second military subject which Watteau sent to Sirois from Valenciennes. This is corroborated by the authenticity of the representation, clearly based on actual observations. It has long been noted that when painting military scenes Watteau was more concerned with harsh reality than with the official, ostentatious side of army life.

It is more difficult to determine the date of two Hermitage drawings, *L'Automne* and *La Naissance de Vénus*. As examples of decorative art, they remind us that Watteau studied under Claude Gillot and Claude Audran. However, that alone is not sufficient reason to give them an early date.

In *L'Automne* the mask of a faun is shown below an oval medallion. The mask resembles that of Momus (the god of ridicule and censure in ancient Greek mythology) from a reverse proof of the red chalk drawing *Groupe de comédiens autour du buste de Momus* (Nationalmuseum, Stockholm). The Stockholm drawing comes from the former collection of Carl Tessin, who visited Paris in 1715. The same type of mask is used in another decorative sketch in similar vein (Boymans-Van Beuningen Museum, Rotterdam). In all these drawings, the light, sinuous strokes form an intricate and imaginative pattern, tending to indicate a relatively more mature period in Watteau's art, c. 1710-15. Furthermore, the ornamental motifs of the painter's early works do not have the elegance and freedom of *La Naissance de Vénus (The Birth of Venus)* and *L'Automne (Fall)*.

There is no doubt, however, that the red chalk drawing *Trois Personnages masculins debout (Three Standing Male Figures)* in the Hermitage pertains to Watteau's early period. It contains many of the features characteristic of his apprenticeship period, the style sometimes referred to as "gillotesque". These include the straight stroke, lacking in confidence and flexibility, and the elongated proportions of the figures. It is hard to say whether the study is related to the little drawings referred to as "gravures des modes" (fashion plates) or whether the figures are actors in

L'Automne (Fall). detail.

Groupe de comédiens autour du buste de Momus.
(Group of Actors around the Bust of Momus)
Nationalmuseum, Stockholm.

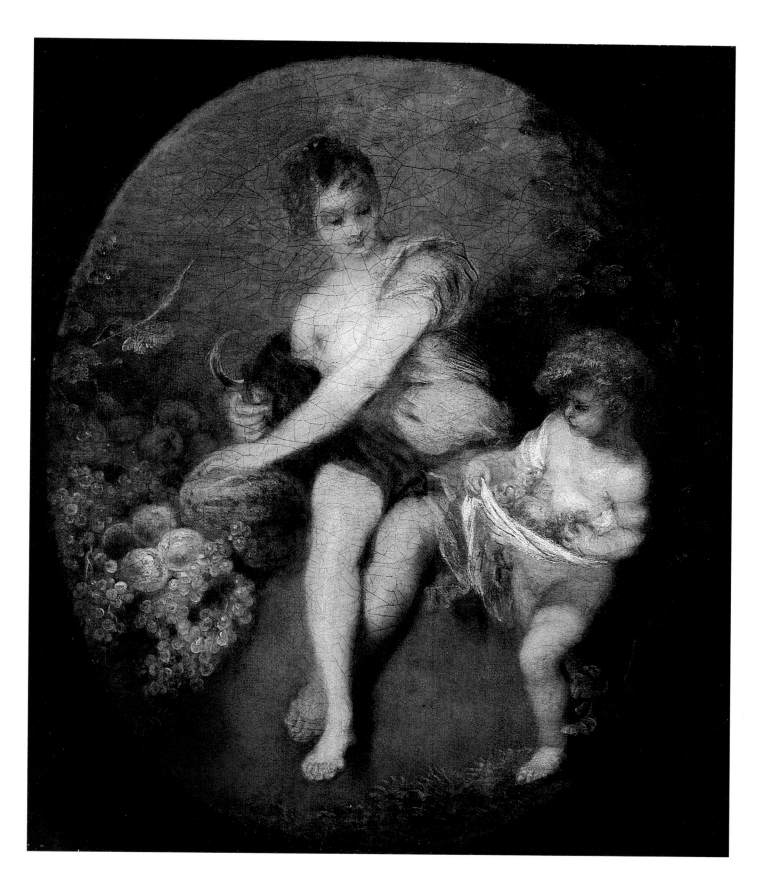

L'Automne (Fall). The Louvre, Paris.

costume for some Comédie Française play. Similar sketches to the Hermitage drawing exist for Watteau's early paintings. For example, *Treize Croquis de figures populaires* (Pierpoint Morgan Library, New York) depicts figures which were later used for his *Retour de guinguette (Return from the Dance-Hall)*, and a man holding a clyster (a scene shown in the *Satire contre les médecins*). The red chalk drawing *Trois musiciens et deux joueurs de cartes* (Phillips Memorial Gallery, Washington) is of a similar type. The greatest similarity to the Hermitage study, however, can be found in two red chalk genre drawings from the Louvre, *Une boutique de barbier* (*A Barber's Shop*) and *Une boutique de marchand d'étoffes* (*A Cloth Merchant's Shop*), forerunners of the concept found in the *Gersaint Signboard*. The shoppers in these drawings furnish a most convincing analogy to the figures in the Hermitage study.

In so far as the problem of the Flemish tradition in Watteau's works is concerned, the Hermitage study *Tête de femme* (identified by M. Dobroklonsky and T. Kamenskaya) has a most direct bearing on it. The same problem arises in studies related to the Hermitage painting *Le Repos pendant la fuite en Egypte*. Nemilova based her argumentation on Watteau's letters.[49] However, experts now doubt the authenticity of these letters[50] and thus there is no support for the dating of the painting. Adhémar dates the painting to 1716,[51] while Nemilova suggests the somewhat later date of 1719, but at the same time calls attention to the imperfections of the composition ("the whole is not integrated"; "the figures are depicted on different scales"; "the perspective lacks consistency.")[52] These doubts are further enhanced by a comparison with the painting on a similar subject that hangs on the right-hand wall of Gersaint's shop in *The Gersaint Signboard* (1720) in which figures are arranged in a free and skilful manner.

All this leads to the belief that the Hermitage *Le Repos pendant la fuite en Egypte* was the work of a still inexperienced artist and should therefore be dated to an earlier period. Watteau's drawings for the Hermitage painting furnish circumstantial evidence of its having been produced at an earlier date. The group on the left in the drawing *Le Mariage mystique de Sainte Catherine et la Sainte Famille (The Mystical Marriage between St. Catherine and the Holy Family)*(Courtauld Institute, London) is reminiscent of a Veronese painting on the same subject (The Betrothal of St Catherine), which was in the Crozat collection at the time. This could mean that *Le Repos pendant la fuite en Egypte* and related subjects aroused Watteau's interest during the period when he copied the classical masters' works with particular diligence. To be sure, this does not provide the date, but it is a reminder that Watteau was familiar with the Crozat collection at the beginning or middle of the first decade of the century.

One more drawing on the subject of the Holy Family, the reverse proof of a red chalk drawing from the Nationalmuseum, Stockholm, comes from the collection of Carl Tessin, a Swede who met Watteau in Paris in 1715 and apparently acquired his drawings that same year. Everything points to the fact that both drawings were produced at one and the same period.

Tessin visited Watteau at his home on the Quai de Conti near the Pont-Neuf, on June 13, 1715. It was also then that he bought, from a Paris collector, a Van Dyck drawing of a Madonna and Child. Tessin wrote the following inscription on the drawing: "I acquired this beautiful head in 1715 in Paris, from the collection of a dealer named Lober. It totally enchanted Watteau, who borrowed it from me to copy it on several occasions; hence we see that several of his paintings clearly demonstrate the strong impression it made on him."[53] Parker and Mathey point out that at a relatively early period, Watteau was making red chalk sketches from an engraving of Van Dyck's composition *The Rest on the Flight into Egypt* (Pitti Palace, Florence). This is confirmed by a drawing in a private London collection.[54]

It has been repeatedly noted that the style of the Hermitage *Le Repos pendant la fuite en Egypte* is reminiscent of a Van Dyck. Adhémar refers in her catalogue to a similar Watteau composition, which in the early nineteenth century was believed to have been created after Van Dyck[55] Van Dyck's subtle lyricism must have held a powerful attraction for Watteau. Such works by the Flemish painter as the drawing *The Betrothal of St Catherine* or paintings on similar subjects – *The Madonna and Child* (Galleria, Parma), *The Holy Family with Mary Magdalene* (Rijksmuseum, Amsterdam) and particularly another *Rest on the Flight into Egypt* (Alte Pinakothek,

Munich) – demonstrate the elements in the Flemish master's work which Watteau found attractive, although Watteau could not possibly have seen all of them. Of course it would be wrong to exaggerate the role of Flemish influence in Watteau's works; the issue has been studied primarily in order to establish a date for the Hermitage canvas which, judging by the technique, could not have been produced in 1719.

Interestingly enough, there is another reason for favoring the year 1715. This is the date of a composition by Louis de Boullogne le Jeune, *Le Repos pendant la fuite en Egypte* (Musée d'Arras). Watteau's Hermitage painting contains motifs similar to those of Boullogne (including the column base and the angels' heads). At the time when Watteau entered the competitions organized by the Académie, Louis de Boullogne was already a leading painter; he became Dean of the Academy in 1717. It is known that Watteau borrowed a nymph from Boullogne's 1707 painting *Repos de Diane (Diana at Rest)* (Musée des Beaux-Arts, Tours). This makes it possible to compare the Hermitage *Le Repos pendant la fuite en Egypte* with Louis de Boullogne's painting of the same name.

The Moscow painting *Satire contre les médecins (Satire against the Physicians)* is apparently related to Watteau's early theatrical impressions (the painting is also called *Qu'ai-je fait, assassins maudits? (What have I done, accursed assassins?)*. At the sale of the Tronchin collection in 1785, a reproduction or copy of the painting is listed under the name *Une scène comique du "Malade imaginaire" de Molière*, while the name of another play, *"Monsieur de Pourceaugnac"* is mentioned elsewhere.[56] Be that as it may, Watteau's penchant for inventing his own "performances" on canvas must not be forgotten. Perhaps this is why his contemporaries spoke of the auto-biographical implications of *Satire contre les médecins* (both Gersaint and Mariette, as well as Dezallier d'Argenville, wrote that Watteau had depicted himself fleeing from ludicrous and cruel physicians). Yet one cannot ignore the fact that certain theatrical motifs influenced the treatment of the scene.

The drawings which served as sketches for the Moscow painting belong stylistically to Watteau's early period, e.g. *Le Docteur et les apothicaires* (Bordeaux-Groult collection, Paris), *Trois études*

d'homme (British Museum, London) and others. This subject is often found in Watteau's early work to mark the grand entrances of theatrical companies. *Le Cortège de l'amour* (Hohl Collection, Basle; the landscape in the background is extremely similar to that in the Moscow painting). Watteau's tendency to choose amusing episodes dates back to his apprenticeship under Claude Gillot who loved the theater for its dynamic quality and dramatic encounters. It was only later that the theatrical theme acquired a different, more profound meaning in Watteau's works.

The scene in *Satire contre les médecins* which attracted Watteau's attention is also often seen in engravings of that time. All this points to the early 1710s. This assumption is confirmed by specific features of the composition. The painting's color scheme still has many sombre tones, although some brighter tones emerge.

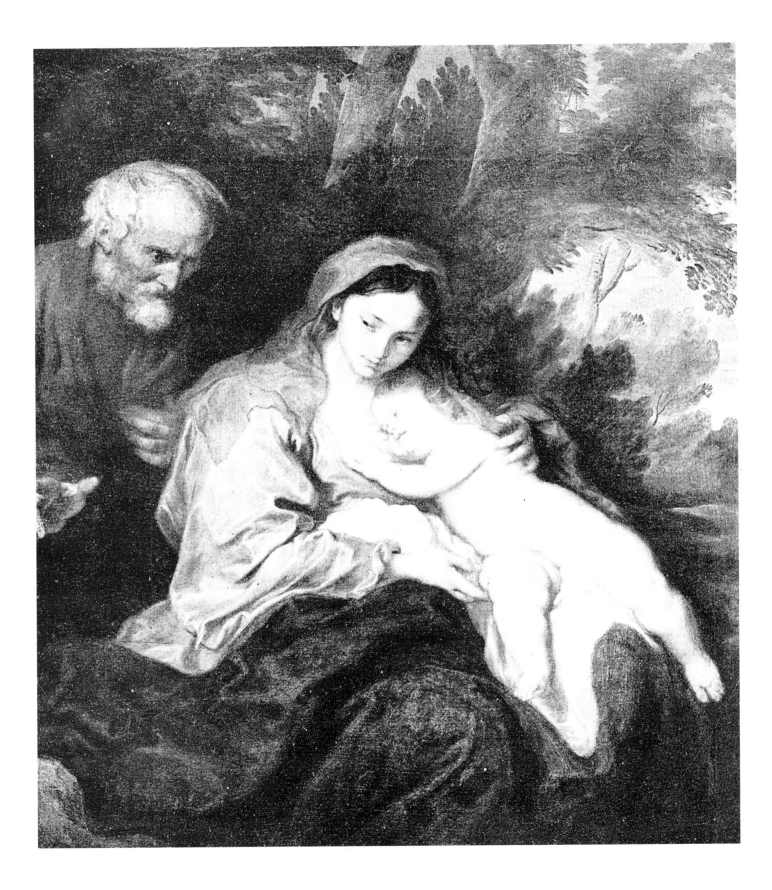

Van Dyck. *Rest on the Flight into Egypt*. Alte Pinakothek, Munich.

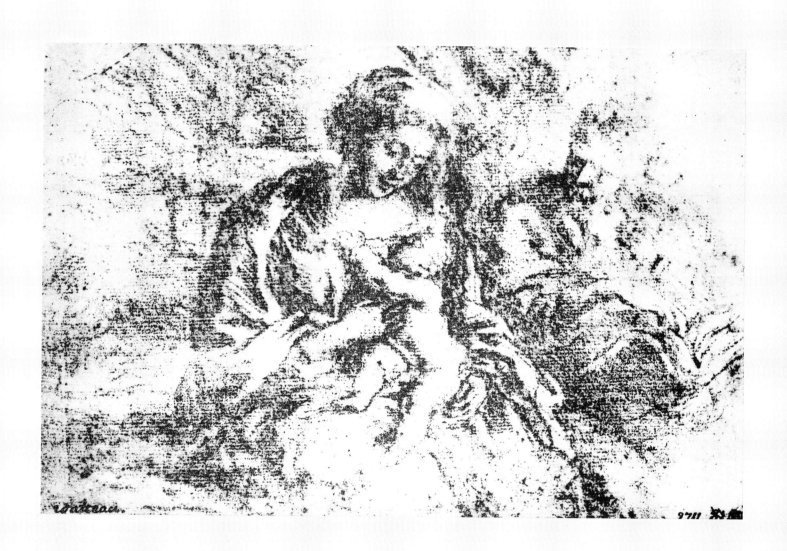

La Sainte Famille (The Holy Family). Nationalmuseum, Stockholm.

NOTES

1. Denis Diderot, *Pensées détachées*, in : *Œuvres complètes*, vol. 12, Paris, 1876, p. 75).

2. A. Rodin, *L'art. Entretiens réunis* par P. Gsell, Paris, 1911, pp. 94-97. Having given his interpretation of the Louvre painting, Rodin concludes his analysis with the following words : "The lovers now go down to the shore and of one accord they laughingly make for the barque ; the men no longer need to use entreaties : it is the ladies who cling to them ... And they are carried along by the breeze of Cupids who hover above them, guiding the travelers toward the azure island which appears on the horizon."

3. In the records of the Académie the painting was not originally called *L'Embarquement*, but *Le Pèlerinage à l'isle de Cithère* (sic !). M. Levey's article "*The Real Theme of Watteau's Embarkation for Cythera*" (The Burlington Magazine, 1961, May, pp. 180-185) is an attempt to interpret the painting's subject. However, while stating his argument, the author forgets one important fact in his favor : long before, in his biography of Watteau, Caylus referred to the painting as *Embarquement de Cythère*. Levey's interpretation was the subject of a witty critique by H. Bauer in his article "*Where Lies Cythera ?*" (H. Bauer, "*Wo liegt Kythera ? Ein Deutungsversuch an Watteaus Embarquement*", in : *Probleme der Kunstwissenschaft*, vol. 2, Berlin, 1966, pp. 251-278).

4. "... an invisible charm, a natural grace, which cannot be defined, and which one has been forced to call a 'je ne sais quoi'" (Montesquieu, *Œuvres complètes*, vol. 4, Paris, 1835, p. 592).

5. "... He had a lively and penetrating sprit, and exalted emotions : he spoke little but well, and wrote the same way. He contemplated almost all the time. As a great admirer of nature and of all the masters who had copied it, hard work had rendered him rather melancholy. On first acquaintance he was distant and embarrassed, which sometimes rendered him an inconvenience to his friends, and often to himself, but he had no other fault except indifference, and a love of change." (H. Adhémar, *Watteau. sa vie – son œuvre*, Paris, 1950, p. 168.)

6. "His character was restless and changeable ; he was complete in his desires, libertine of spirit but wise in his morals, impatient, shy, at first distant and embarrassed, discreet and reserved with strangers, a good, but difficult friend, a misanthrope, even a malicious and biting critic, always discontented with himself and others, and slow to forgive." (H. Adhémar, op. cit., p. 172.)

7. "Watteau, who began by liking M. Lancret, told him one day that he could not waste his time by staying any longer with a Master ; that he needed to experiment further, after the Master of Masters, Nature ; that he had started to do so and found it good. He advised him to go and sketch a few landscapes in the Paris region ; and then to draw a few figures, and put them into a painting of his imagination and his choosing." (Balot de Sovot, *L'Eloge de Monsieur Lancret. Peintre du Roi*. Paris, 1743, p. 5.) M. Florisoone quotes a different text, though he gives no reference, containing an additional sentence about observations made in the streets, in homes and at markets, absent in the Sovot original. This seems to be a misunderstanding (see M. Florisoone, *Le Dix-huitième siècle*, Paris, 1948, p. 33).

8. "Most of the time, the figure he drew from life had no predetermined destination... Since he never produced a sketch or a thought for any of his paintings, however light and incomplete they might be. He was in the habit of producing studies in a bound sketchbook,in such a way that he always had a large number to hand... Whenever he fancied producing a painting he had recourse to his collection. He used it to choose the figures which suited him best at the time. He used them to form his groups, generally against a landscape background which he had designed or prepared. It was even rare for him to do otherwise." (H. Adhémar, op. cit., p. 181.)

9. "The subjects of his paintings are pure fantasy." (*Vies anciennes de Watteau*. Compiled and introduced by P. Rosenberg, Paris, 1984, p. 23.)

10. "The subject of his entrance work was left to him" (L. Gillet, *Watteau*, Paris, 1921, p. 229).

11. See E. Pilon, *Watteau et son école*, Brussels, Paris, 1912, pp. 204-205.

12. "There is no pleasure equal to that experienced by ladies from ballet costumes, representing pastoral scenes, and making assignations in woods and gardens" (H. Adhémar, op. cit., p. 106).

Preceding page :
Diane au bain.
The Louvre, Paris.

Above :
Louis de Boullogne le Jeune.
Le Repos pendant la fuite en Egypte.
Museum, Arras.

13. Voltaire, *La Princesse de Babylone*, London, 1768, p. 81.

14. "Mme de Civrac was obliged to take the waters, and her friends undertook to offer her distractions during the journey; there were several stops at post-houses, and wherever they stopped for the night, they offered a little *fête champêtre*, disguising themselves as villagers and bourgeois, with a bailiff, scrivener and other figures singing and reciting poetry" (H. Taine, *Les Origines de la France contemporaine*, vol. 1, Paris, 1899, p. 218).

15. "... profited at the time from his leisure time to go and draw various comic scenes normally performed in public by hawkers and charlatans who traveled all over the country" (H. Adhémar, op. cit., p. 169).

16. See *L'Opera completa di Watteau*, Milan, 1968, p. 7.

18. "... one of the most brilliant chapters in the history of French fashion." (M. Gauthier, *Antoine Watteau*, Paris, 1959, p. 9).

19. See W. Bredt, *Die drei galanten Meister von Valenciennes*, Munich, 1921, pp. 103-104.

20. P. Thornton, *Baroque and Rococo Silks*, New York, 1965, ill. 12; A. Renan, *Le Costume en France*, Paris, 1890, p. 203.

21. See A. Jullien, *Histoire du costume au théâtre*, Paris, 1880, pp. 72-73.

22. R. Huyghe, *L'Univers de Watteau*, Paris, 1968, p. 10.

23. "... the caprices of French fashion, ancient and modern" (H. Adhémar, op. cit., p. 166).

24. See, for example, Y. Boerlin-Brodbeck, *Antoine Watteau und das Theater*, Basel, 1977.26. Dacier et Vuaflart, p. 66.

25. See I. Nemilova, *Watteau and His Works in the Hermitage*, Leningrad, 1964, pp. 81-91 (in Russian). Special caution must be exercised in relation to the names indicated in the engravings. Many experts have time and again noted that the same model is called La Thorillière in one case, and the Abbot Harenger, in the other; the same person in one case is referred to as the actor Poisson, while in another he is identified as Le Boucq-Santussan. See K.T. Parker, J. Mathey, *Antoine Watteau. Catalogue complet de son œuvre dessiné*, Paris, 1957-58, pp. 377, 378, cat. 910, 914.

26. Xavier de Courville, *Riccoboni dit Lélio. Un apôtre de l'art du théâtre au XVIIIe siècle*, Paris, 1943, p. 192. De Mirimonde is almost as inflexible when he insists on Watteau's predilection for comic opera (A.-P. de Mirimonde. "*Les Sujets musicaux chez Antoine Watteau*", Gazette des Beaux-Arts, 1961, November).

27. "... the gentleman Sirois, friend of Watteau, represented in the midst of his family as the figure of Mezzetin playing the guitar." (E. Dacier, A. Vuaflart, *Jean de Julienne et les graveurs de Watteau au XVIIIe siècle*, Paris, 1924, p. 66).

28. T. Karskaya, *French Kermis Theatre*, Leningrad, Moscow, 1948 (in Russian).

29. See M. Alpatov, *Essays in the History of Western European Art*. Moscow, 1963, p. 315 (in Russian).

30. See C. Nordenfalk, "*Kärlekslektionen av Watteau*", in: *Antoine Watteau och andra franska sjuttonhundratalsmästare i Nationalmuseum*, Ehlins-Stockholm, 1953, p. 147.

31. A recent discovery shows that the painting originally had a different shape, adapted to the arched entrance to Gersaint's shop, but was later squared off and divided in two (H. Adhémar, "*L'Enseigne de Gersaint par Antoine Watteau. Aperçus nouveaux*", Bulletin du Laboratoire du Musée du Louvre, Paris, 1964).

32. "Anything he looked at for a long time would begin to bore him; he merely liked to skip from subject to subject; he would often begin a commission and abandon it halfway through before it was complete." (H. Adhémar, *Watteau, sa vie - son œuvre*, Paris, 1950, p. 172).

33. Ibid., p. 166.

34. A.-J. Dezallier d'Argenville, *Abrégé de la vie des plus fameux peintres*, vol. IV, Paris, 1862, pp. 406-408.

35. "... these two views, which were painted by Watteau from nature, while he was living at Porcherons" (E. Dacier, A. Vuaflart, op. cit., p. 69).

36. "Watteau copied all of them, living at Monsieur Crozat's, and he avowed he had greatly benefited thereby." (P.-J. Mariette, Abecedario, vol. 1, Paris, 1851-53, p. 294).

37. J. Cailleux, "*Decorations by Antoine Watteau for the Hôtel de Nointel*", The Burlington Magazine, 1961, March.

38. C. Nordenfalk, op. cit., pp. 61-158.

39. P.-J. Mariette, *Abecedario*, vol. VI, Paris, 1859-60, p. 135.

40. I. Nemilova, "*The Dating of the Hermitage Savoyard and the Problem of Different Phases in Watteau's Genre Painting*", Papers of the Hermitage, 8, Leningrad, 1965, p. 84-98 (in Russian).

41. J. Cailleux, "*A Rediscovered Painting by Watteau: La Partie quarrée*", The Burlington Magazine, 1962, April, pp. I-V.

42. H. Adhémar, op. cit.

43. In this case, the red chalk drawing from the Jacquemart-André Museum, Paris, supports the stylistic analysis. A naiad for the Dresden painting and the actors for the Washington picture were drawn on the same sheet of paper.

44. See I. Nemilova, *Watteau and His Works in the Hermitage*. Leningrad, 1964, p. 29 (in Russian).

45. See Papers of the Russian Historical Society, XVII, St Petersburg, 1876 (in Russian).

46. E. Dacier, A. Vuaflart, op. cit., p. 72.

47. "*Gersaint l'appelle un Départ des troupes. C'est sans doute La Recrue*" (H. Adhémar, op. cit., p. 75). The chronology of Watteau's military scenes was the subject of an article by J. Cailleux, "*Four Studies of Soldiers by Watteau. An Essay on the Chronology of Military Subjects*", The Burlington Magazine, 1959, September-October. In connection with that article we should note that the available information is insufficient for a solid argument in favor of the precise datings suggested (for instance, the dating of The Flying Camp to early 1710).

48. The Cincinnati painting raised doubts as to its authenticity, but the original is documented by an eighteenth-century engraving.

49. I. Nemilova, op. cit., p. 71.

50. Watteau. 1684-1721. Catalogue, Paris, 1984, p. 31.

51. H. Adhémar, op. cit.

52. I. Nemilova, op. cit., p. 188.

53. "I bought this beautiful head in 1715 in Paris from the inventory of a collector called Lober. Watteau was delighted with it and he loaned it to me to copy it on various occasions, and it can also be seen in many of his paintings where one can see that it made a considerable impression on him." (See C. Nordenfalk, op. cit., p. 147.)

54. K.T. Parker, J. Mathey, op. cit., p. 42, cat. 272.

55. H. Adhémar, op. cit., p. 225.

56. E. Dacier, A. Vuaflart, op. cit., p. 74.

More than twenty years have passed since the publication of the first edition of this book (Aurora Publishers, 1973). When preparing the second edition, in 1985, I restricted myself to making corrections. But new pieces of research appeared in time for the international colloquium held to mark the 300th anniversary of Watteau's birth, and, most importantly, in 1987 the material presented at that colloquium was published (Antoine Watteau (1684-1721). *Le peintre, son temps et sa légende. Paris-Geneva, 1987*). Scholars became aware of previously unknown information which needs to be reflected here.

The colloquium took place in Paris, in the Grand Palais on the Champs-Elysées, at the end of October 1984. The same year saw the opening of a Watteau exhibition which toured three cities in succession: Washington (National Gallery of Art, 17 June - 23 September 1984), Paris (Galeries Nationales du Grand Palais, 23 October 1984 - 28 January 1985) and Berlin (Schloss Charlottenburg, 22 February - 26 May 1985). The organizing committee of the colloquium comprised Henry A. Millon of the Center for Advanced Study in the Visual Arts, Washington, Pierre Rosenberg, currently director of the Louvre, and François Moureau of the University of Dijon.

The exhibition and colloquium were an outstanding event for art historians and provided a new powerful impulse for their researches. Many of the results were already reflected in the catalogue of the Watteau exhibition which also appeared in 1984. (The authors were Pierre Rosenberg - paintings, Margaret Morgan Grasselli - drawings, and Nicole Parmentier - prints and biographical outlines.) Work on catalogues of this kind usually involves a careful reappraisal of existing data. In the present instance, it is important to note that the authenticity of five letters which have long figured in literature on Watteau was called into question. These documents were the supposed letter from the art-dealer Sirois dated 23 November, 1711 and four items of correspondence signed A. Watteau and addressed one to Gersaint and three to J. de Julienne. The exhibits included several works from Russian museums: the paintings, *Camp volant. Le Repos pendant la fuite en Egypte. La Marmotte. La Proposition embarrassante*

and La Boudeuse and also *the drawings. Une allée d'arbres. L'Automne and La Naissance de Vénus*. The catalogue also included entries on paintings by Watteau which were not sent to the exhibition. It is gratifying to observe that many conclusions reached by Russian art historians were taken into account by Rosenberg and the other authors of the catalogue.[1] For that reason, it makes sense to focus on certain distinctive views and differences of opinion.

Margaret Morgan Grasselli, in my view, justly disputed the dating of the Hermitage drawings *La Naissance de Vénus and L'Automne* to Watteau's time in the studio of Claude III Audran (ca 1708-9) as being too early and suggested attributing them to the artist's mature period - closer to the year 1715. It is appropriate to mention that, as far back as the first edition of *Antoine Watteau*, I dated those particular drawings to the early 1710s.[2]

The small Hermitage painting, which Inna Nemilova interpreted as a group portrait of actors from the Comédie-Française, recovered its traditional (of course, conventional) title of *Les Coquettes* in the 1984 exhibition catalogue. This is what Rosenberg writes about its subject: "Mariette sees here 'people dressed up for a ball, among whom one has disguised himself as an old man'. Lépicié, in his obituary of Thomassin (Mercure de France, March 1741, p. 569), speaks of a Retour de bal. As for Lacurne de Sainte-Palaye, the compiler of the 1755 Crozat catalogue, and Dezallier d'Argenville (1757), they incline towards Les Personnages en masque se préparant pour le bal."

"Modern critics," Rosenberg goes on to say, "are also divided... Fourcaud (1904), undoubtedly the closest to the truth, sees it as 'a family group, got up for a mascarade galante: all the figures represented evidently come from sketchbooks'." This has not prevented more recent writers, notably I. Nemilova, from wishing to identify the scene and the characters brought together by the artist (from right to left, Dr Baloardo, Columbine, Mezzetin...) and the names of the models. This Russian scholar ignores the reference to a ball made by all the eighteenth-century writers and sees the work representing actors of the Comédie-Française, in, say, Dancourt's Trois Cousines, rather than Italian comedians (a traditional hypothesis) and recognizes, on the left,

Mme Desmares (see D. Posner, *Antoine Watteau*, London, 1984, p. 26) and, on the right, Paul Poisson, rather than La Thorillière.

"We for our part," Rosenberg concludes, "prefer to adhere to Fourcaud's persuasive analysis and to regard the painting as a group of Watteau's friends, dressed imaginatively by the artist and arranged without any particular link between them."[3]

The year 1984 also saw the appearance of Marianne Roland Michel's seminal work.[4] She also rejected the new Hermitage title for the work in question and retained the traditional interpretation of the subject: *Le Retour de bal (Les Coquettes)*. I note also, in passing, the pleasing coincidence of opinion on the possible date of the Moscow painting *Satire contre les médecins (or Qu'ai-je fait, assassins maudits?)*: "early 1710s" from Yury Zolotov,[5] "about 1710-12" from Roland Michel.[6]

The view Roland Michel expressed in that same 1984 book concerning the date of the Hermitage's *Repos pendant la fuite en Egypte* deserves special attention. Referring to the unreliability of the supposed letter from Watteau on which certain chronological versions are based, she proposed allocating the painting to a period "around 1716".[7] We again note with satisfaction that in the introduction to the first Russian edition of Antoine Watteau (1973) Zolotov cited analogies and gave a series of arguments which tended to place the painting in the middle of that decade, that is about 1715.[8]

Let us examine what Rosenberg had to say on this matter in the catalogue to the 1984 Paris exhibition. He wrote that the dating of this work "had proved a sticky question for all critics, with some refusing to express their opinions. Adhémar went for 1716, Sterling for 1717, while Nemilova and Roland Michel preferred 1719 [Roland Michel's actual opinion has just been cited - Yu.Z.]. For our part, we ask ourselves - together with Zolotov (written comment) - whether this canvas was not perhaps contemporary with the purchase of the Van Dyck drawing and with Tessin's first stay in Paris in 1715, before the discovery of Venice in the Crozat collection."[9]

Those analogies which I gave in the introduction to the first edition of Antoine Watteau (Aurora Publishers, 1973) and which I stood by in the second (1985) edition, can be supplemented by

one more: Claude Charpignon's engraving of Laurent de la Hyre's composition Le Repos pendant la fuite en Egypte. The print is mentioned in Charles le Blanc's reference book (vol. 1, p. 630). In this engraving the Holy Family is presented among fragments of classical architecture overgrown with shrubs, while an obelisk seen in the depth of the work serves to indicate the Egyptian setting. Similar ruins are included in Watteau's composition, as is a characteristic bush on the top of the wall. One gets the impression that in the search for a design for the Gospel scene - a sphere of art in which he was not greatly experienced - Watteau examined old engravings, especially those made from works by seventeenth-century French painters, although he then, of course, modified everything in his own manner.

The gathering together of so many works of painting and graphic art at the 1984 Watteau exhibition made it possible for the first time to compare them with each other and to make well-founded deductions regarding the artist's imagery, his style, the dating of his works and his links with other artists. Yet at the same time the exhibition made one aware how many problems raised by this artist's oeuvre still required further study. The colloquium answered this deep-felt need.

It lasted three days and comprised eight sessions. A number of papers linked to some common problem were followed by discussion. The emphasis given to the various major themes was indicative of the current state of Watteau studies which can be judged from the book: Antoine Watteau (1684-1721): Le peintre, son temps et sa légende (Paris-Geneva, 1987).

In that publication, however, the papers have been re-arranged, while for me, as a participant and eye-witness, it is more interesting to recall them in their original order, in other words to recount what actually occurred on 29, 30 and 31 October 1984 in auditorium 404 of the Grand Palais. That room, designed to hold 300 people (if not more), was packed on each of the three days.

All the sessions were plenary; there was no provision for smaller working groups. The first session, on the morning of 29 October, was chaired by Donald Posner (USA) and titled "Watteau and History".[10] That day, two more groups of papers were presented: "Watteau and His Cultural

*Paysage avec un torrent
(Landscape with Waterfall)*, detail.

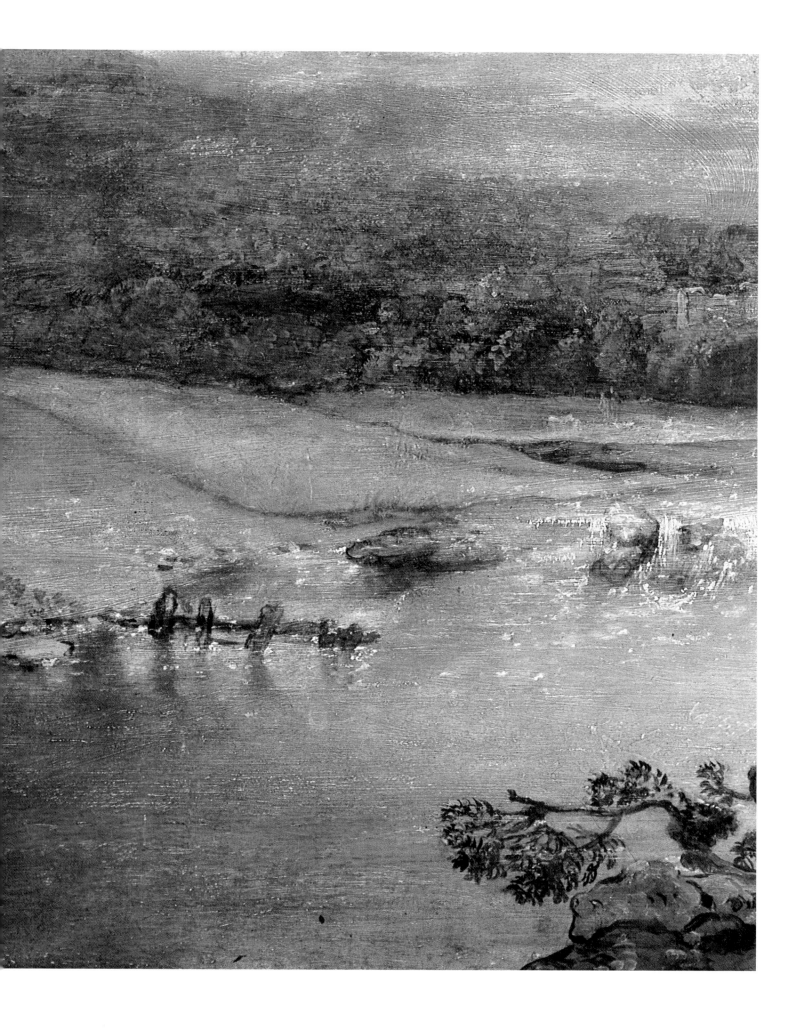

Environment"[11] presided over by Jean Deprun (France) and "Watteau: Drawings and Engravings" with Carl Nordenfalk (Sweden) in the chair. The second day, 30 October, began with a group of lectures united by the title "Watteau: Themes and Variations" under the chairmanship of D. Ponnau (France). The afternoon brought two sessions: "Individual Works by Watteau", chaired by Yury Zolotov (Russia), and "Watteau's Studio", chaired by René Démoris (France). In the evening participants set off for Nogent-sur-Marne.

The third day consisted of two sessions and a final one in the evening. The morning session under the chairmanship of François Moureau, was entitled "Watteau and the Arts of His Epoch", with theatrical parallels predominating. The afternoon session, directed by Pierre Rosenberg (France), was devoted to the way the artist's legacy lived on in the art of following centuries ("The Myth of Watteau"). In the evening Régine Astier (USA) dressed in early-eighteenth-century costume to perform dances of Watteau's period, which was a sort of illustration of her paper on the subject. This spectacle provided a stirring culmination to the jubilee event. On 1 November, incidentally, the participants extended their impressions with a trip to the artist's birthplace, the town of Valenciennes. In a brief review it is, of course, impossible to report on all the observations, discoveries, finds and ideas - often well-founded, but occasionally fantastical - which were presented to the audience at that highly-qualified forum in 1984. We shall concentrate primarily on those questions which are of relevance in the context of the present publication. The review will follow the programme of the colloquium as outlined above.

François Moureau, a professor at the University of Dijon, invested his paper with a particular edge right from the title: "Watteau, a Free-Thinker?". His arguments were based on the testimony of the artist's friends. Gersaint spoke of "Watteau's restless, changeable nature", making a telling qualification "a free-thinker in his mind, but wise in his morals". Caylus too remarked on the free-thinking of his mind. The assessments of contemporaries are contradictory, but, in Moureau's opinion, compatible with the spirit of the age and the distinctive features of the intellectual milieu with which the artist was in close touch. The professor concluded that the free-thinking tone of the early century presaged the great outburst of the Enlightenment.[12] It is a remarkable fact that the young Marivaux, in 1717 (this same period), in the preface to Letters on the Inhabitants of Paris, refers to that work as "the product of a free-thinking mind".[13] The distinctive nature of Watteau's intellectual milieu was confirmed by a recent find made by Jeannine Baticle: a list of the books in the library of the artist's friend, the Abbot Haranger. Valuable information was also provided in the paper presented by Hal Opperman (USA): "The Theme of Peace in Watteau", which in part overlapped with Moureau's theses.

The audience were particularly interested by the paper given by Jeannine Baticle, who works in the Louvre, on the painting familiar to us under the title Gilles. The speaker called the results of her researches unexpected: "What we have here is not Gilles, the rather simple countryman character of fairground shows, but rather the Italian Pedrolino who, dressed in white satin, became in late-seventeenth-century France, under the name of Pierrot, the worldly variant of the peasant Gilles."[14] Her argument in favour of the new name was extremely cogent: from Hélène Adhémar's reference to evidence that in 1718 the actor Belloni retired from the theatre and opened a shop "with a sign taking the form of his own portrait in the costume of Pierrot",[15] to analogies with the image of Pierrot found in early-seventeenth-century engravings and drawings by Claude Gillot, Bernard Picart and Surugue. The name Pierrot featured in the verse captions to the engravings. The costume too fits, while Gilles was at that time presented in a different outfit.[16] And, possibly even more telling, there is a mention in a 1736 document of a large painting by Watteau "depicting Pierrot".

The report by Margaret Morgan Grasselli (USA), "New Observations on Some Watteau Drawings", was a step on the way to the established chronology of the artist's oeuvre, which we still lack. The object of study in this particular case was five drawings dated to the late 1710s. A subtle stylistic analysis led to some convincing conclusions. In his paper Pierre Rosenberg (Louvre) examined the problem of replicas, providing some important foundations for a characterization of the artist's creative method. His conclusions

were as follows: Watteau feels less constricted in a first version, than in a replica, something explained by his passionate artistic temperament.[17] The replicas seem colder; they are short on emotional impulsiveness.[18] The paper ends with the words: "The inventor of a new genre, the genre of 'fêtes galantes', and recognized as such by his contemporaries, was Watteau endowed with the 'imagination' to allow him to renew himself? His earliest biographers doubted it, but L'Enseigne de Gersaint provides proof of this confirmed striving, this constant desire to master new subjects in an original manner."[19]

We note the brief, but interesting paper presented by Christian Michel, which in the 1987 anthology is placed straight after Rosenberg's. It is entitled "Fêtes Galantes: Genre Painting or Historical Painting?" Michel commented on a forgotten statement by Watteau, which has come down to us as reported by Ch.-N. Cochin le Jeune: "The celebrated Watteau said, that it is impossible to beat a drum skilfully without knowing how to play the flute."[20] Cochin interprets the artist's aphorism in this way: in order to be a success in a given genre, you have to know more than is needed for just that genre. Michel's discovery is a reminder of how useful it is to re-read old texts. Such finds not only cast light on the spirit of an artistic era, but also help us to understand the meaning of the works of art themselves. Gleanings of this kind also featured in Yury Zolotov's paper, "Watteau: the Iconosphere and Individuality of the Artist".

Questions of genre attracted the attention of Donald Posner (USA). He characterized Watteau as a "park-landscapist". In this sense the master of the "fêtes galantes" emerges as the founder of a new variety of landscape art, taking a step towards Impressionism.

The subject of Marianne Roland Michel's paper was Watteau and the Representation of Different Characters. A thorough-going study of the noted publication Les Figures de differents caractères examined the composition of the volumes, the choice of drawings for engraving, the individuality of the engravers and the changes which they introduced.

The results of laboratory study of Watteau's technique were presented in reports by Lola Faillant-Dumas and Ségolène Bergeon accompanied by some remarkable illustrations.

The 1987 anthology grouped together under the general heading of "Interpretations" a number of papers which were devoted not so much to interpretation as to an objective analysis of the essence of Watteau's work, the distinct character of his view of the world and his style.

Among them was a paper by René Démoris (Lille University): "Watteau, the Landscape and Its Figures". Beginning with some analogies from the works of Roger de Piles, Fontenelle and other authors, he soon passed on to Watteau's oeuvre. "The modern bacchanalia," Démoris observed, "is a bacchanalia of sight. In this galant universe dominated by an awareness of other people and of oneself as another person, a collective 'passion' not registered in Le Brun's catalogue comes to join the others and takes first place: the 'passion' for seeing and being seen."[21] Unconstraint as a characteristic feature of the artist's imagery expresses itself through eloquent detail. One such element is the amusing way the caryatid turns as if unwilling to lose sight of a single detail of the spectacle unfolding around it in Les Plaisirs du bal (Dulwich College Picture Gallery, London). Here, as in the Dresden painting Réunion en plein air, a peculiarity of the artist's perception of the world emerges (one which Mikhail Alpatov called "the little grain of irony"). Not without cause, Démoris recalled the opinion with which Anthony Blunt concluded his book Art and Architecture in France: "For it must never be forgotten that Watteau was essentially a product of Parisian society, which in him, as fully as in Voltaire, asserted once again its independence of the court of Versailles and its determination to follow its own way."[22]

The important issue of the relationship between Watteau's art and pre-Romanticism lay at the centre of a paper given by Y. Boerlin-Brodbeck (Basel): "The Figure Seated in a Landscape". The author supported her argument with an extensive range of analogies from adjacent artistic periods. Comparisons led her to the idea that the motif described in the title of her paper became a key element in pre-Romantic art: the lone dreamer in poetic communion with nature. In Boerlin-Brodbeck's opinion this motif was anticipated by Watteau.

A subtle fine analysis of one of the determinant aspects of the French master's art marked the paper presented by Mary Vidal (USA):

Étude de quatre personnages, detail.

Étude de quatre personnages (Study of four figures), detail.

"Conversation as Literary and Painted Form: Madeleine de Scudéry, Roger de Piles and Watteau". While it cannot be said that the Frenchman specialized in "conversation pieces", the refined culture of talking characteristic of the age also expressed itself, in Vidal's view, in Watteau's art - in his ability to touch the heart of the viewer, in the improvised character of the "dialogues" between characters. In defining the principle difference between literary and artistic forms of conversation, in her analysis the author successfully used literary parallels and such terms as marivaudage. The dramatic gestures inherent to strong action in a seventeenth-century painting were replaced in Watteau's works by refined emotional impulses. "For Watteau, the main pleasure of the ball is talk and not dance."[23] It was in precisely this context that she interpreted L'Enseigne de Gersaint as "a comparison of past and present, a painting on painting and, on several levels, an art of conversation."[24]

The work of a French artist in the early eighteenth century was closely bound up with other forms of art: theatre, dance and music. It is no surprise that the session on the theme of "Watteau and the Arts of His Epoch" turned out one of the most interesting of the 1984 colloquium. There are still many mysteries in this area, and therefore extensive scope for the activities of researchers. Giovanni Macchia (Rome University) again raised the question of exactly which theatre inspired the artist. His paper, entitled "The Theatrical Myth of Watteau", seized on a broad circle of key issues. Macchia observed that "Watteau seems to thwart the naive desire of posterity and of specialists to 'put a name' to the faces that the painter presented. However dated they are, and however much charged with the slightly sad enchantment of their age, these personages elude precise identification."[25] Nonetheless, with regard to the theatre, the speaker believed it possible to give preference to two sources: the commedia dell'arte and the opera-ballet. Thus, for the Louvre's Le Pèlerinage à l'île de Cythère Macchia suggests as a prototype La Vénitienne by the poet Houdar de La Motte and the composer La Barre.[26] That work was staged in 1705. In 1711 the third act of it was included in a production entitled Fragments, preceded by the third act of another

ballet: Le Carnaval et la Folie.[27] Finally, at the Saint-Germain fair of 1714 one could have seen the comic opera Les Pèlerins de Cythère featuring Pierrot, Mezzetin, Harlequin, Columbine and other stock figures of the commedia dell'arte. This last analogy is closest of all in time to the Louvre painting (1717). The paper ends with a remarkable deduction: "And one might interpret the scene in which the portrait of the Sun-King is there, ready to be boxed up by the employee of Gersaint's shop, as a declaration of love for the great Italian comedy that had finally returned to Paris: a breath of liberty."[28]

In his paper, "Watteau and the French Theatre", André Blanc expounded a theory about the theatrical prototypes of three of the artist's works. Among other things, he alluded to Robert Tomlinson's observation regarding the link between the painting L'Amour au Théâtre-Français (Staatliche Museen, Berlin-Dahlem) and Dancourt's comedy-ballet L'Impromptu de Suresnes, which was first staged in 1713. In that piece, Bacchus, Folly and Cupid appear together with real-life characters: an inn-keeper, his two daughters and their suitors. In the painting, the action takes place against the background of a pillar topped with the sculptural bust of Momus, the god of mockery and malignant gossip, which is entwined with grape-vines. Bacchus reclines on a bench with Cupid the huntsman (his attribute is the quiver of arrows) in front of him. The pair about to touch goblets. They are united by the figure of Folly in the guise of a woman, whose dress is decorated with little bells. In the foreground are attributes which she (or Momus) has cast off: a fool's rattle and tambourine. The speaker considered it impossible to identify the performers with certainty. The similarity between the Berlin painting and Dancourt's stage-work strengthens the conviction that in a number of instances Watteau was inspired by quite specific productions. (We remind the reader of what was said in the preceding section of the present article regarding the real-life prototype of the scene in the Moscow painting Satire contre les médecins.) This did not, of course, prevent the artist from creating his own spectacles on canvas, about which much has already been said in this article.

As Robert Tomlinson (USA) demonstrated in his paper "Fête galante and/or Fête foraine? Watteau

and the Theater" the time has passed when the source of Watteau's subjects was narrowed down to any single variety of theatre. Today we speak of a broad range of theatrical impressions that inspired the artist. Nevertheless, in Tomlinson's opinion, an especially significant role was played by the Franco-Italian fairground comedians. The speaker had reckoned which stock characters occur most often in Watteau's paintings: Pierrot, Harlequin, Mezzetin, the Doctor and Scaramouche. This survey points to precisely those characters which the Parisian fairground theatres inherited from the Italian commedia dell'arte. It is interesting that in the juxtaposition of the two most common characters - Pierrot, the inactive dreamer, and the practical, strong-willed, inventive Harlequin - the speaker saw, as it were, two images of the artist himself, at times joyful, at times melancholy.[29] According to Tomlinson, in a branch of theatre that is termed minor, Watteau found models, themes and, above all, a point of view, half-sceptical, half-naive, belonging to the wings, placed somewhere between the reality of the stage and the illusion perceived by the audience.[30]

While acknowledging that the fairground theatre must be the chief source of analogies for Watteau, Philippe Hourcade still drew other comparisons as indicated by the title "Watteau and the Opera of His Time: the Problems of a Parallel". Comparison with the peasant costume in a 1699 engraving depicting a dancer in Du Moulin's opera provided the key to one further figure in *L'Amour au Théâtre-Français* (Staatliche Museen, Berlin-Dahlem) - the one standing in the right foreground with his back to the viewer. This speaker also presented an engraving featuring the costume of Folly. It must be said that the Berlin painting was dealt with especially successfully at the 1984 colloquium. The subject matter was resolved almost completely and in a fairly convincing manner. Indeed, on the whole, questions of the theatre in Watteau's work were examined very thoroughly.

The final section, "The Legend", also produced a rich variety of material. But the space allotted to this introduction obliges us to restrict this review. Later in the book the reader will find texts about the Watteau paintings and drawings now in Russian museums. In this connection, it makes sense to repeat the brief statement with which the present author closed the session of the Paris colloquium on 30 October 1984 that was devoted to individual works by the artist.

"I am pleased to note the thoroughness and depth of the papers presented in this section. In conclusion, I would like to state that pieces of research which concentrate on a single work of art can generate extremely valuable results. We come closer to a vision of an artist not only through the evidence of contemporaries or other sources, but above all through direct contact with his work. It is the individual idiom of a master and the distinctive plastic expressivity of his works which are the foundations and indispensable medium of research in art history. The artist's thought embodied in visual form is not in any way an illustration of some abstract idea. The analysis of the visual image opens the way to an understanding of the artist's creative world and of his own sense of self."

Notes

1. 1984 Catalogue .

2. Zolotov, Nemilova 1973, p. 27.

3. 1984 Catalogue , p. 312.

4. Roland Michel, 1984.

5. Zolotov, Nemilova, 1973, pp. 30f.

6. Roland Michel, 1984, p. 31.

7. *Ibid.*, p. 153.

8. Zolotov, Nemilova, 1973, pp. 29f.

9. 1984 Catalogue , p. 316.

10. Colloque Watteau 1987 : *"Le temps de Watteau"*.

11. *Ibid.: "Sources et parallèles"*.

12. *Ibid.*, p. 19.

13. *Ibid.*, p. 19.

14. *Ibid.*, p. 38.

15. H. Adhémar, "Watteau, les romans et l'imagerie de son temps", *Gazette des Beaux-Arts*, 1977, p. 172.

16. Colloque Watteau 1987, p. 38.

17. *Ibid.*, p. 109.

18. *Ibid.*, p. 110.

19. *Ibid.*

20. *Ibid.*, p. 111.

21. *Ibid.*, p. 160.

22. A. Blunt, *Art and Architecture in France*, Harmondsworth, 1973, p. 404.

23. 1987 Colloque, p. 174.

24. *Ibid.*, p. 178.

25. *Ibid.*, p. 189.

26. *Ibid.*, p. 193.

27. *Ibid.*, p. 195.

28. *Ibid.*

29. *Ibid.*, p. 206.

30. *Ibid.*, p. 209.

Facing page :
Diana in the Bath. detail.

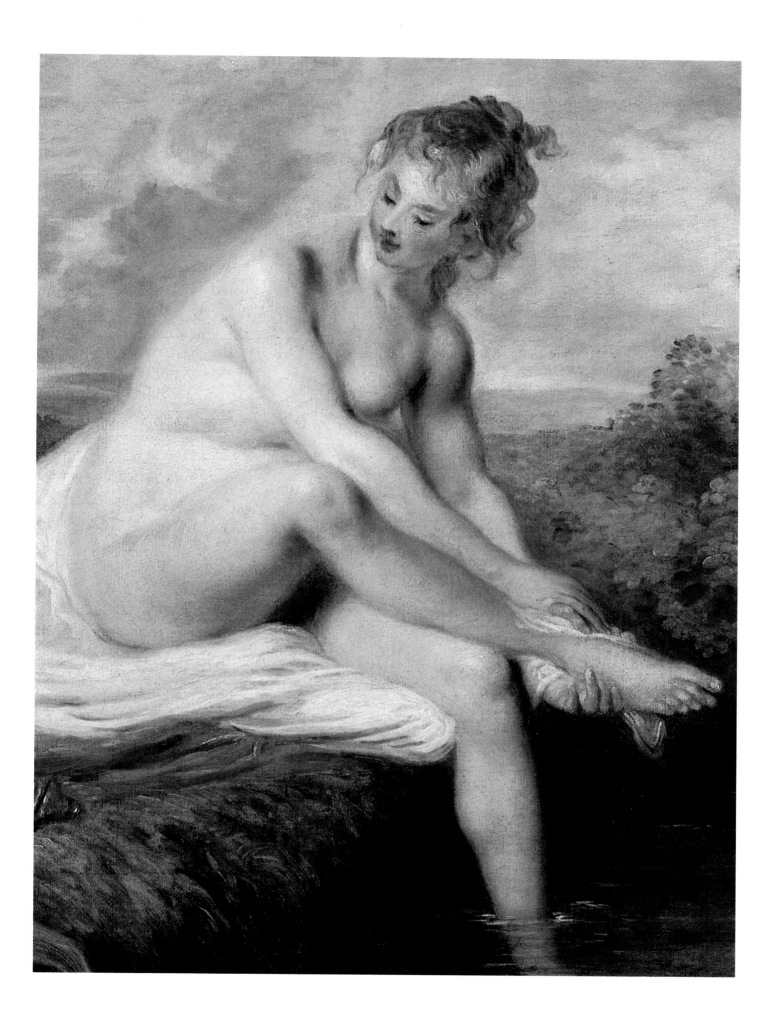

COLLECTIONS
in the Russian
Museums

1. SATIRE CONTRE LES MÉDECINS (SATIRE ON PHYSICIANS)
(Qu'ai-je fait, assassins maudits?)
(What have I done, accursed murderers?)

Oil on wood, 26 x 37 cm
The Pushkin Museum of Fine Arts, Moscow.
Inv. No. 763

A 7-cm strip has been added to the upper part of the panel. On the reverse, the two parts are glued along a shaved-off ledge, 2.5 cm wide. There is minor flaking of the paint layer, mainly in the picture's central area. A web of tiny cracks covers the entire surface. X-ray examination shows no changes in the outlines of the figures or in the composition. Acquired as part of the Count Brühl collection in 1769, the painting was removed from the Hermitage in the second half of the nineteenth century to be hung in the residential quarters of the Winter Palace, after which all trace of it was lost . It was rediscovered in 1918 in an antechamber of the quarters for ladies-in-waiting at the Catherine Palace in Tsarskoye Selo. The subject of the painting has been interpreted in various ways. Watteau's early biographers, such as E.-F. Gersaint and P.-J. Mariette, were of the opinion that the artist, who was often ill and suffered much at the hands of doctors, had depicted himself as the fleeing patient, and his doctor as the man wearing a red cape. That view was shared, with certain reservations, by Goncourt and other scholars in the nineteenth and first half of the twentieth century. The title of the painting usually repeated the first line of the verse that accompanied the Caylus engraving: *Qu'ai-je fait, assassins maudits?* (What have I done, accursed murderers?). Yet at the same time, even at very early auctions as, for instance, that of the Tronchin collection in 1785, versions of this composition figured under the title of either *Une scène comique du "Malade imaginaire"* by Molière, or *Une scène comique de "Monsieur de Pourceaugnac"*. Such interpretations are quite legitimate, considering the extremely high degree of similarity between this scene and Molière's plays. The two comedies in question continued to enjoy great popularity in Watteau's day; *Le Malade imaginaire* was staged for Louis XIV personally in 1710. In the manuscript catalogue of the Hermitage, compiled by Münich (1773-85), the painting is called *Le Médecin (The Physician)*, while in the 1853 inventory it is listed as *Le Carnaval (The Carnival)*. G. Lukomsky published it under the title *Une scène du "Malade imaginaire."* V. Miller reverts to the traditional interpretation of the subject, as supplied by Gersaint and Mariette, stressing its satirical and autobiographical nature. The subject, in his opinion, has nothing to do with Molière's play, as it does not reproduce any of the scenes exactly. The catalogues of

the Pushkin Museum of Fine Arts, Moscow, have always referred to the painting as *Satire on Physicians*. The question of the painting's subject acquires, in this case, a special significance, being directly related to its date. Basing their approach on the content, nineteenth-century scholars dated the painting to the last year of Watteau's life; they were of the opinion that he produced it after returning from England, where he was treated with no success in 1719-20. However, the painterly manner is, on the contrary, typical of the master's early period, as V. Miller also admits. The compositional scheme, with its figures arranged in one line; the poor landscape; the somewhat constrained movements and elongated proportions; finally, the sombre, subdued colours - these are all features of Watteau's early works. But in that case one can hardly insist on the autobiographical element. At the same time, the painting, with its background reminiscent of a stage backdrop, and its actor-like personages, has a marked theatrical flavour.

Etchings by C. Audran after Watteau's drawings
(From *Figures de différents caractères*).

On the whole, there seem to be grounds for dating this work to 1708-9, perhaps even to the period of Watteau's apprenticeship with Claude Gillot, the graphic and theatrical artist. Yu. Zolotov, however, who is inclined to believe that this painting represents a scene from *Monsieur de Pourceaugnac*, suggests the early 1710s as its probable date. Some sketches of figures done for this painting and used in the final composition can be seen on a sheet from the Crozat collection, now in the British Museum (P.-M., I, No. 43). Another sheet with preliminary sketches is in the Bordeaux-Groult collection (P.-M., I, No. 37). Here, too, all the figures except two found their places in the painting. There are similar figures in a drawing from the Teyler Museum, Haarlem (P.-M., I, No. 39), but they were not used by the artist.

We know that one of Watteau's pupils, Jean-Baptiste Pater, made a copy of the painting (see Adhémar, p. 26, No. 256). Several more versions and copies existed and appeared at various sales. One of these versions belonged to Delacroix, who passed it on to his friend Schwiter; it figured in the posthumous sale of the latter's collection in 1886, under the title *Satire on Physicians* (lot 47).

A reverse etching of the painting was done by A.C.F. Caylus and finished with a burin by P. Joullain. Included in the *Recueil d'estampes* gravées d'après les tableaux de la *Galerie et du Cabinet de S.E.M. le Comte de Brühl* à Dresde, 1754 (No. 35).

PROVENANCE

Until 1769: Count Brühl collection, Dresden
1769: The Hermitage (under two titles, *Le Médecin* and *Le Carnaval*)
Second half of 19th century: Catherine Palace, Tsarskoye Selo
1923: The Hermitage
1928: The Pushkin Museum of Fine Arts, Moscow

EXHIBITIONS

1922-25. French Painting of the 17th and 18th Centuries in the Hermitage. Petrograd
1955. French Art: 15th to 20th Century. Moscow (Cat., p. 25)
1956. French Art: 12th to 20th Century. Leningrad (Cat., p. 12)

REFERENCES

Mercure de France, November 1727, p. 2491; Catalogue des tableaux qui se trouvent dans les galeries et dans les cabinets du Palais Impérial de Saint-Pétersbourg, 1774, No. 401; P.-J. Mariette, *Abecedario*, vol. VI, Paris, 1859-60, p. 110; Goncourt, p. 34, No. 25; E. Staley, *Watteau and His School*, London, 1902, pp. 43, 71, 141; Josz, p. 222; L. de Fourcand, "*Antoine Watteau. Scènes et figures théâtrales*", Revue de l'art ancien et moderne, XVI, 1904, pp. 203-204 (reproduction); E. Pilon, *Watteau et son école*, Brussels, Paris, 1912, p. 26; G. Lukomsky, Brief Catalogue of the Catherine Palace Picture Gallery (in Russian), Petrograd, 1918, pp. 29, 47 (under the title *Une scène du 'Malade imaginaire'*); Dacier, Vuaflart, p. 74, No. 150; E. Hildebrandt, *Antoine Watteau*, Berlin, 1922, p. 17 (reproduction of Caylus's etching); V. Miller, "French Seventeenth- and Eighteenth-century Paintings in New Rooms at the Hermitage", The Town (in Russian), 1, 1923, p. 79 (reproduction); S.L. Ernst, "*Exposition de la peinture française des XVIIe et XVIIIe siècles au musée de l'Ermitage à Petrograd*. 1922-1925", Gazette des Beaux-Arts, XVII, 1928, p. 173 (reproduction); Réau 1928, p. 46, No. 181; Réau 1929, p. 95, No. 694; Catalogue 1948, p. 15; Adhémar, pp. 70, 72, 146, 155, 156, 190, 202, 253, No. 9 (pl. 5); Yu. Zolotov, "*Contemporary Subjects in the Art of Antoine Watteau*", in: Moscow University. Collection of Articles on the History and Theory of Art (in Russian), Moscow, 1956, p. 100 (reproduction); Catalogue 1957, p. 23; Ch. Sterling, Musée de l'Ermitage. *La peinture française de Poussin à nos jours*, Paris, 1957, pp. 37, 217; Parker, Mathey, pp. 5, 8, 9; Catalogue 1961, p. 33; Le Musée de Moscou, Paris, 1963, p. 138; Nemilova 1964, pp. 75, 77, 172 (reproduction); Macchia, No. 13; Rosenberg, Camesasca, No. 13; Zolotov, Nemilova 1973, pp. 30, 31, No. 5; Roland Michel 1984, pp. 31, 212, 249, II; Rosenberg 1984; Zolotov 1985, pp. 30, 31, Nos 1-6; Colloque Watteau 1987, pp. 271, 272.

Le Docteur et les apothicaires.
Bordeaux-Groult collection, Paris.

Étude de trois figures.
British Museum, London.

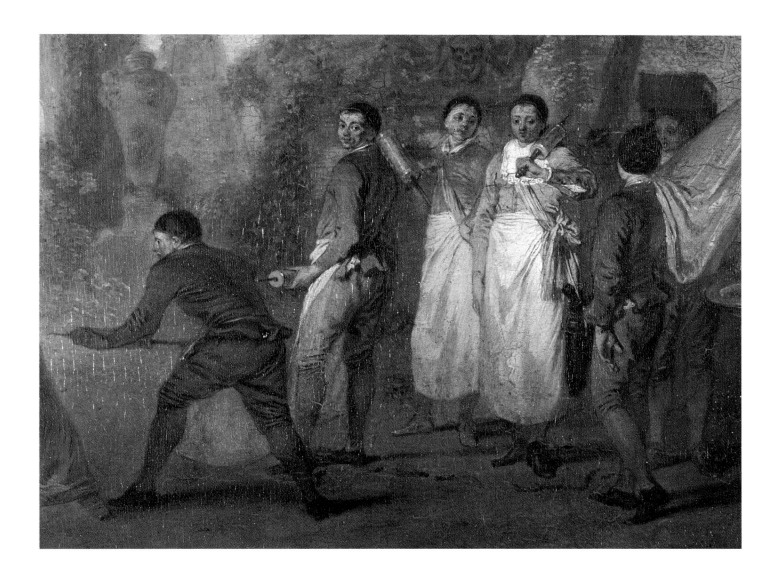

Satire on Phycisians, detail.

Satire on Physicians.
The Pushkin Museum
of Fine Arts, Moscow.

Overleaf:
Details

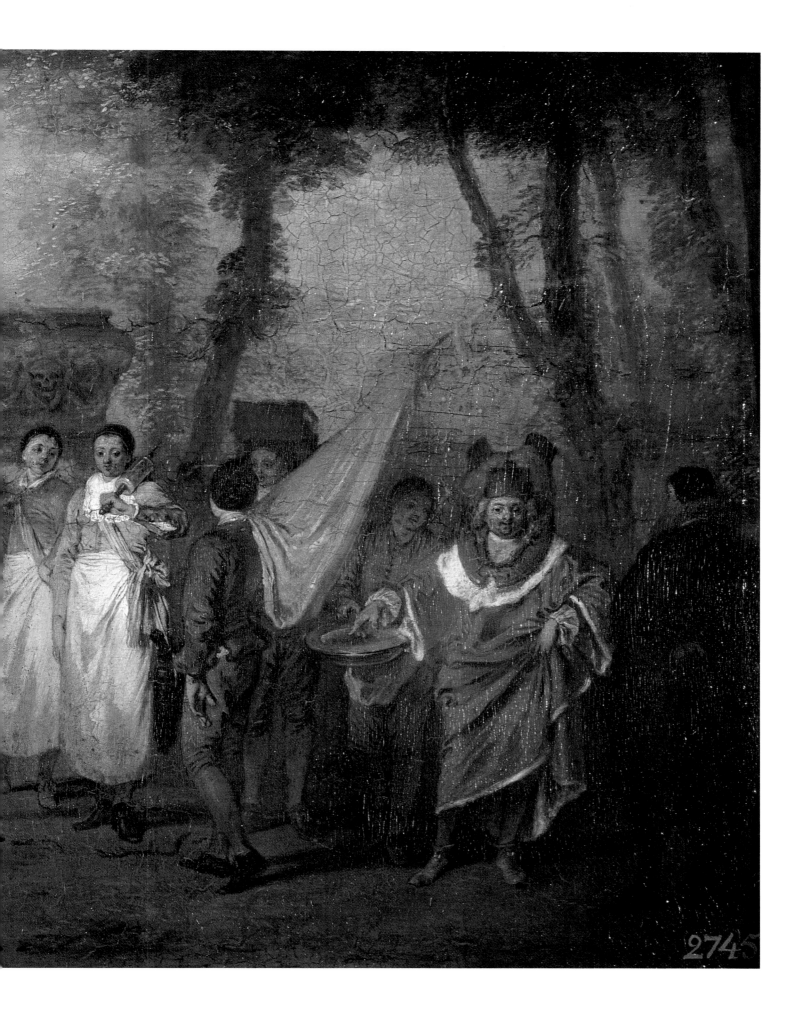

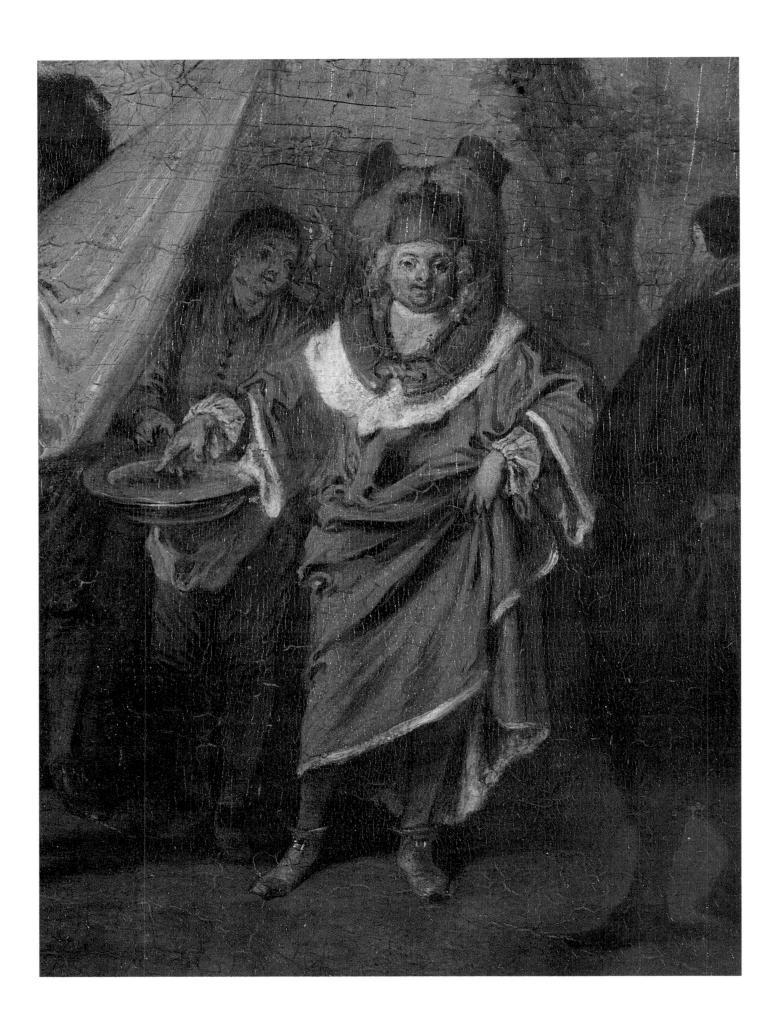

2. AN ALLEY IN THE PARK LEADING TO A PAVILION

Red chalk, 22 x 17 cm
The Hermitage, St Petersburg.
Inv. No. 11855

The drawing was engraved by F. Boucher in *Figures de différents caractères* (No. 40).

This drawing is one of the rare landscapes the artist did from nature, and one that can be linked to a concrete place owing to some convincing data. First, we have a Watteau painting engraved by Crepy as *La Perspective*. In his manuscript notes Mariette describes the painting as "a view in the Crozat Garden at Montmorency" ("une veue du jardin de M. Crosat à Montmorency", see Abecedario, vol. VI, Paris, 1859-60, p. 110). An etching of the central part of this composition was done by Caylus after Watteau's drawing; scratched on the lower part of the etching was the caption "*A Montmorency*". An engraving in the Bibliothèque Nationale in Paris bears the following inscription in Caylus's handwriting: "*Maison de M. Le Brun P.-P. [Premier Peintre] du Roi Louis XIV*". On Le Brun's death, his estate and property passed to Crozat. According to the latest research, the Crepy engraving of Watteau's painting depicts the Le Brun mansion, but instead of the porticos that we see at the end of the alley in the Caylus etching, the Hermitage drawing and Boucher's engraving of it show only a modest park pavilion.

The Hermitage drawing, if it was actually done in the gardens of Montmorency, can be dated to the period when Watteau stayed at Crozat's home.

Une Allée d'arbres. Private collection, Paris.

PROVENANCE

Until 1862: Grassi collection, Paris
1862: The Hermitage

EXHIBITIONS

1955. French Art: 15th to 20th Century. Moscow (Cat., p. 72)
1956. French Art: 12th to 20th Century. Leningrad (Cat., p. 84)
1959. Western European Landscape. Leningrad (Cat. No. 24)
1972. Watteau and His Time. Leningrad (Cat. No. 59)

REFERENCES

Ermitage Impérial. *Collection des dessins*, St Petersburg, 1867, No. 482; Goncourt, Nos 391-400; E. Mantz, *Cent dessins de Watteau gravés par Boucher*, Paris, 1892, No. 18; Dobroklonsky, No. 243, pl. XII; E. Dacier, "*Caylus, graveur de Watteau*", Amateur d'estampes, 1926-27, pl. 48; K.T. Parker, *The Drawings of Antoine Watteau*, London, 1931, p. 18, pl. 25; P. Lavallée, *Le Dessin français*, Paris, 1948, p. 67; Parker, Mathey, No. 457; J. Rosenberg, *Great Draughtsmen from Pisanello to Picasso*, Cambridge, Mass., 1959, p. 94, No. 179; M. Dobroklonsky, The Hermitage. Graphic Art (in Russian), Leningrad, 1961, pl. 110; *Mästerteckningar från Ermitaget, Leningrad. Nationalmuseum, Stockholm*, 1963, No. 40; Nemilova 1964, pp. 68, 191, pl. 25; Zolotov, Nemilova 1973, p. 19, No. 19; Catalogue 1984, p. 148, No. 76; Zolotov 1985, p. 17, No. 48.

Facing:
Allée d'arbres avec une fabrique au fond (Avenue of trees with a factory in the background)
The Hermitage, St Petersburg.

3. ACTEURS, OU LES COQUETTES

Oil on panel, 20.2 x 25 cm
The Hermitage, St Petersburg.
Inv. No. 1131

A crack on the old actor's cloak, to the right, has been restored. There are cracks in the shaded areas, especially along the lower edge and around the head of the woman in a striped gown. A loss has been painted in above the young woman's left shoulder. X-ray examination reveals significant changes in the figure of the woman to the left: in the first version her hand did not hold a mask but lay on the banister. Instead of a Polish costume, she wore a free-flowing dress with horizontal

as depicting "personages in masks making ready for a ball". Lepicié describes the subject as "returning from the ball"; Dezallier d'Argenville believes it to be "preparation for the ball". Owing to these differences, the painting never had a permanent title. For some time it was known as *Les Coquettes*, after the lines inscribed by Thomassin le Jeune under an engraving of the picture and beginning with that word. The painting bears this title in most foreign works on Watteau. However, there are some exceptions. V. Josz calls the painting *Les Comédiens italiens*, a name repeated by other scholars.

The same kind of confusion reigns in Russian works on Watteau and in catalogues of art galleries, beginning with the eighteenth century. In his catalogue, published in

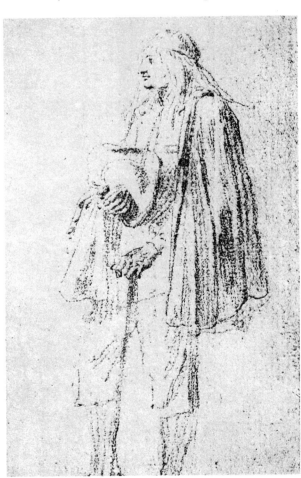

Un Vieillard tenant une canne
(Old man holding a cane). Whereabouts unknown

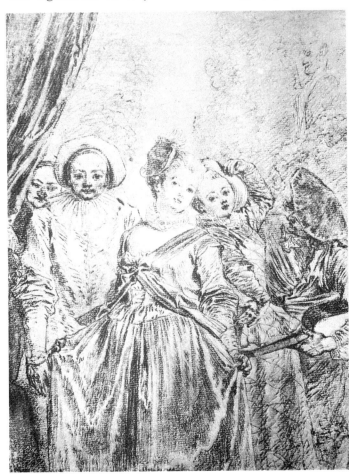

La Troupe italienne (The Italian Troupe)
. Rosebery collection, Leighton Buzzard.

stripes. Her hair was not covered by a bonnet, but brushed high behind her ears and done up at the back of her head. Her facial features were not altered; neither were any other parts of the painting.

The painting's subject has several interpretations. The issue was already confused in the eighteenth century and was further complicated by nineteenth-century studies. In Crozat's catalogue the painting is referred to

1783, Münich refers to the painting as *Personages in Masks*. The catalogue of 1797 lists it as Masquerade. In the 1859 Hermitage inventory we read: "*Two women talking with two men, with a Negro nearby*". A. Benois refers to the painting alternately as *Les Coquettes* and *Italian Comedy*. V. Miller called it *Italian Comedians*. In catalogues and inventories of the Hermitage collection a name is attached to each of the personages. Thus, the old

man is Pantalone, the women are referred to as Rosaura or Isabella, the young man as Scapin. In the 1958 Hermitage catalogue the painting is listed as *Les Comédiens italiens*. We are inclined to believe that the painting has no definite subject, being rather reminiscent of a group portrait. This is corroborated by the identification of the persons depicted. H. Adhémar presumes that the woman on the left is none other than Christine-Antoinette-Charlotte Desmares, one of the leading French actresses of the time. It is usually thought that Madame Desmares was depicted by Watteau only once - as a pilgrim in *Le Pèlerinage à l'île de Cythère*. We can, however, add to that list *La Polonaise* (National Museum, Warsaw), probably a copy of a Watteau painting; *La Rêveuse* (Wildenstein collection, New York); *La Polonaise assise* which we know thanks to Aubert's engraving and to several drawings (for example, *Femme coiffée d'un turban et tenant un loup*, probably a preliminary drawing for the painting listed under No. 89 in Goncourt's catalogue; the reversed proof of this drawing may have served as a preliminary sketch for the Hermitage painting). We do not list here several other drawings associated with Madame Desmares.

It also proved possible to establish the name of the old man on the right. There exists an almost full-length drawing of him (P.-M., I, No. 64, no indication of the subject's name given). That figure (cut off at the knee) was used in our painting. Parker and Mathey point out that Watteau did several other drawings of this model (P.-M., I, Nos 54, 84; II, No. 914), and an engraving of the last was done for Chéreau's collection *Figures de différents caractères* (No. 157); it bears the caption La Thorillière. This makes it possible to identify the man depicted in the Hermitage painting as the actor Pierre le Noir La Thorillière (1656-1731). We were able to discover a certain resemblance to the young man wearing a beret in a drawing of the Bordeaux-Groult collection (P.-M., II, No. 746), which apparently was a preliminary sketch for our painting. The same face looks at us from a drawing (P.-M., II,

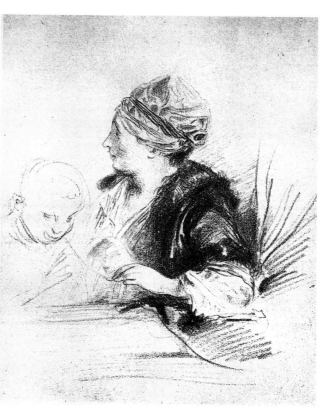

Femme coiffée d'un turban et tenant un loup.
Whereabouts unknown.

No. 741) that also depicts the fourth personage - the girl wearing a striped dress. Full-length drawings of the man we are interested in also exist (P.-M., II, Nos 815, 817, 830, 839). The problem of identification can be finally solved if we compare two more sheets (P.-M., I, No. 172 and P.-M., II, No. 665), both depicting one and the same person whose features resemble those of the young man in a beret. Sheet No. 172 is engraved in the collection *Figures françaises et comiques* with the explanation that it portrays Philippe Poisson, an actor of the Comédie-Française. Sheet No. 665, on the other hand, is a sketch for the painting *La Famille*, and the people portrayed in that picture are listed in a 1777 inventory of the possessions of the late widow of Jean Le Boucq-Santussan. They were Santussan himself, his wife and their son, who later became a jeweller and married Gersaint's daughter. Thus we have two names for one and the same person. In the introduction to their catalogue, K.T. Parker and J. Mathey also attempted to identify this man, but with no definite result. A study of the Hermitage painting may prove helpful in solving this problem. As we have shown it to portray an actress and an actor of the Comédie-Française, it is logical to assume that a third actor of the same company is depicted with his two colleagues. It is thus Philippe Poisson, and not Le Boucq-Santussan. Logic would have us believe that, rather than depicting someone who had no relation whatsoever to the theatre, Watteau portrayed the actor who played the role of Blaise opposite Madame Desmares in *Les Trois Cousines*. The young lady in the striped gown remains unidentified. The Ethiopian boy is usually thought to be one of Crozat's servants. He can be recognized in *La Conversation*, which probably depicts that patron of the arts with his friends against a park background. Nevertheless it seems likely that what we have here is not one of Watteau's usual theatrical scenes but a group portrait of Comédie-Française actors, most probably of those who took part in Dancourt's play *Les Trois Cousines*.

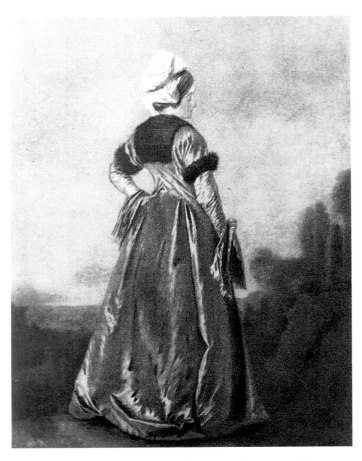

La Polonaise (The Polish Woman). Nationalmuseum, Warsaw.

Preliminary studies include the following: drawings for Madame Desmares's portrait - *Femme coiffée d'un turban et tenant un loup de la main gauche* (red chalk, charcoal; present whereabouts unknown); a portrait of a young woman holding a mask in her hands (oil on wood; E. de Goncourt collection); *Etude de mains* (red chalk; Kupferstichkabinett, Berlin); a drawing for La Thorillière's portrait - *Un vieillard tenant une canne* (red chalk, engraved by C. Audran; present whereabouts unknown); drawings for the portrait of Poisson depicting a young girl - a sheet with nine sketches (done in three colours on grey-brown paper; Louvre, Paris); *Deux têtes et des mains* (drawn in three colours; Bordeaux-Groult collection, Paris). An engraving of the painting was done by Thomassin le Jeune under the title *Les Coquettes*. N. Wrangel, who doubted Watteau's authorship, erroneously considered it to be a copy of a Watteau work by P. Mercier. E. Zimmermann, who never saw the painting, seconded that view. But the extremely high quality of the painting and its typical Watteauesque manner, as well as many drawings related to it and undeniably belonging to Watteau (see above), prove Wrangel's conclusions to be completely groundless. H. Adhémar believes that the painting was done between the spring and autumn of 1716; Ch. Sterling suggests 1716-17; Mathey opts for 1714. In our opinion, it should be referred to 1711, or perhaps 1712. Stylistical analysis shows the work's compositional similarity to such a definitely early painting as *Du bel âge*, known thanks to Moyreau's engraving and dated by H. Adhémar to 1712. The second chronological landmark is the portrait of the Ethiopian boy in *La Conversation*, dated by J. Mathey to 1712 and by H. Adhémar to 1716. H. Adhémar discovered the girl in the striped gown in a work she calls Arlequinades and dates to 1710. But the most conclusive evidence, establishing our painting's date, is furnished by *La Polonaise* and *La Polonaise assise*, both of which are unanimously dated between 1710 (by Mathey) and 1712 (by Adhémar). In both of these pictures Madame Desmares is dressed in the same costume as in the Hermitage painting. Madame Desmares's Polish costume confirms these dates - it was very much in fashion between 1709 and 1712, immediately after the Battle of Poltava. *L'Opera completa di Watteau* (1968), *Tout l'œuvre peint de Watteau* (1970) and the Catalogue Bordeaux 1980 all mistakenly cite I. Nemilova's dating of the painting as 1717. Nemilova had already suggested the date 1711 in works published in 1969.

PROVENANCE

Until 1731 : N. Bolz collection, Paris
Until 1772 : P. Crozat, Baron de Thiers collection, Paris
Mid-19th century : The Gatchina Palace near St Petersburg
1920 : The Hermitage

EXHIBITIONS

1908. The Old Years Exhibition. St Petersburg (Cat. No. 286)
1955. French Art : 15th to 20th Century. Moscow (Cat., p. 24)
1956. French Art : 12th to 20th Century. Leningrad (Cat., p. 12)
1965. La Peinture française dans les musées de l'Ermitage et de Moscou. Bordeaux (Cat. No. 41)
1965-66. Chefs-d'œuvre de la peinture française dans les musées de Léningrad et de Moscou. Paris (Cat. No. 41)
1972. Watteau and His Time. Leningrad (Cat. No. 5)
1980. Les Arts du théâtre de Watteau-Fragonard. Bordeaux

REFERENCES

M. Lepicié, "*Notice nécrologique sur S.-H. Thomassin (Lettre à M[onsieur] D[e] L[a] R[oque] écrite de Paris le 11 février 1741)*", Mercure de France, March 1741, p. 567 ; Catalogue des tableaux du Cabinet de M. Crozat. Baron de Thiers...., 1755, p. 65 ; Goncourt, No. 78 ; Josz, pp. 328-329 ; Zimmermann, No. 122, p. 191 ; V. Miller, "French Seventeenth- and Eighteenth-century Paintings in New Rooms at the Hermitage", The Town (in Russian), 1, 1923, p. 59 ; Dacier, Vuaflart, No. 36 ; Réau 1929, No. 417 ; Adhémar, No. 154, pl. 84, p. 119 ; Parker, Mathey, Nos 53, 64, 84, 541, 729, 823, 828, 914 ; Catalogue 1958, p. 270 ; A. Chegodayev, Antoine Watteau (in Russian), Moscow, 1963, p. 17, pl. 13 ; Nemilova 1964, pp. 81-100, 181 ; I. Nemilova, "Watteau's Actors of the Comédie-Française and the Problem of Portraits in His Art", Collection of Articles on Western European Art in the Hermitage (in Russian), Leningrad, 1970, pp. 145-158 ; Macchia, No. 162 ; Stuffmann, p. 135, No. 336 ; Rosenberg, Camesasca, No. 162 ; Nemilova 1973, pp. 133-135 ; Zolotov, Nemilova 1973, pp. 12, 13, 138-140, No. 6 ; Nemilova 1975, p. 436 ; Catalogue 1976, p. 189 ; Nemilova 1981, No. 45 ; Catalogue 1984, pp. 311-313, No. 29 ; Roland Michel 1984, pp. 217, 305, No. 215 ; Rosenberg 1984 ; Zolotov 1985, pp. 8, 11, Nos 8-11 ; Colloque Watteau 1987, No. 50.

Opposite :
Acteurs. ou Coquettes, detail.

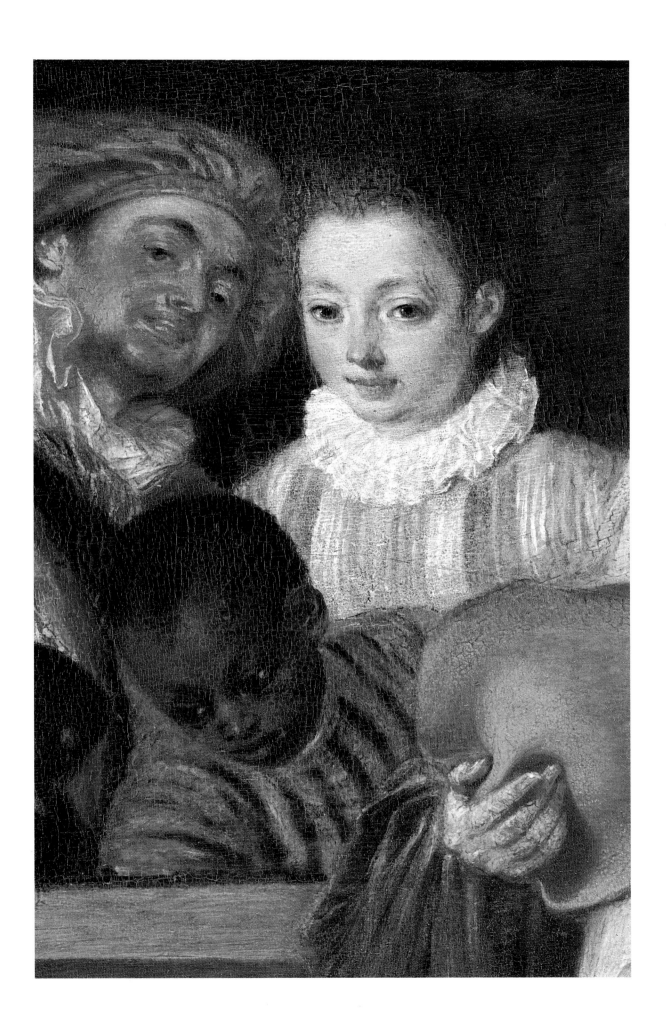

Acteurs, ou Coquettes,
The Hermitage, St Petersburg.

Pages 94 and 95: Details

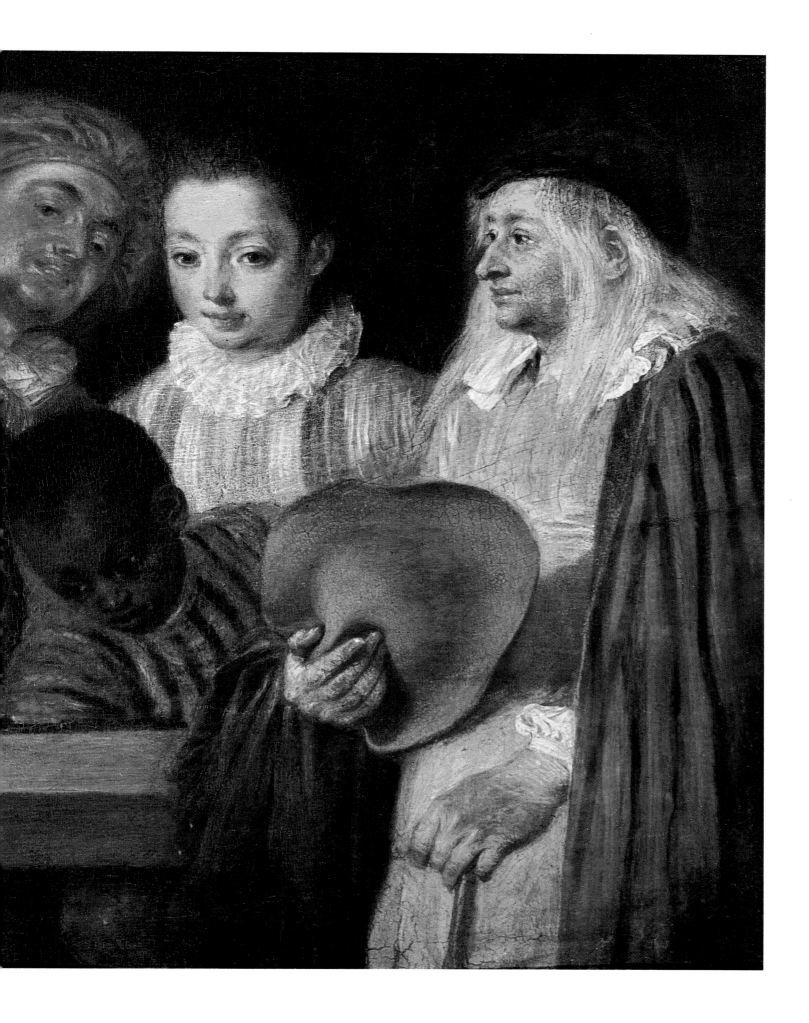

Deux têtes et des mains (Two Heads and Hands)
Bordeaux-Groult collection , Paris.

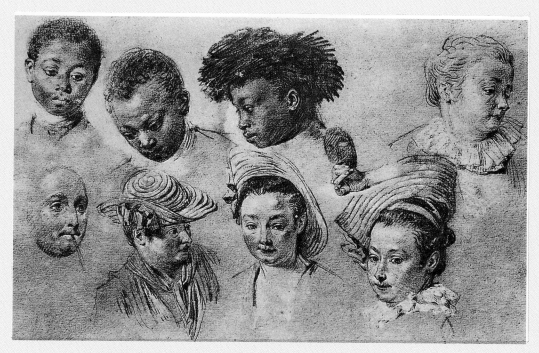

Huit études de têtes (Eight studies of heads). The Louvre, Paris.

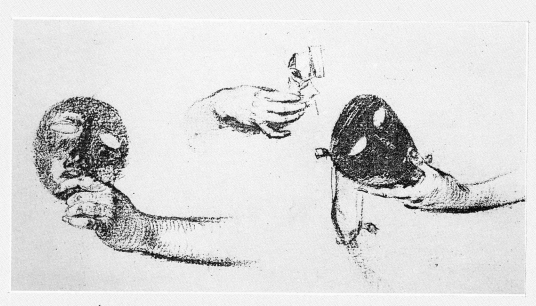

Étude de mains (Study of hands). Kupferstichkabinett, Berlin.

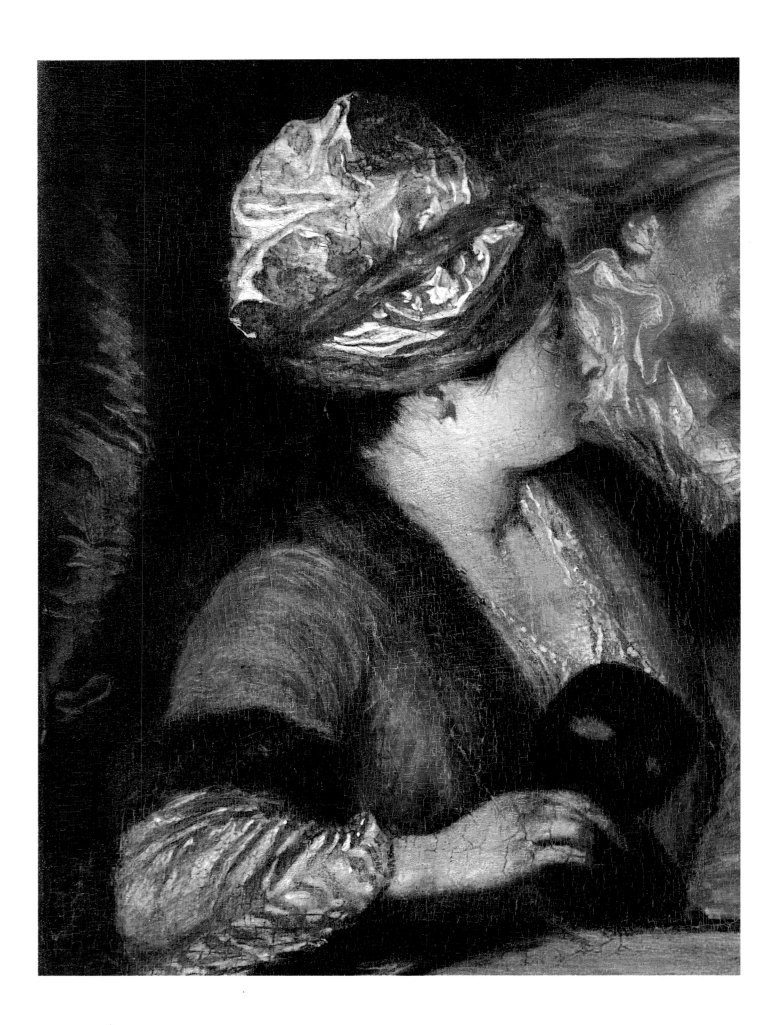

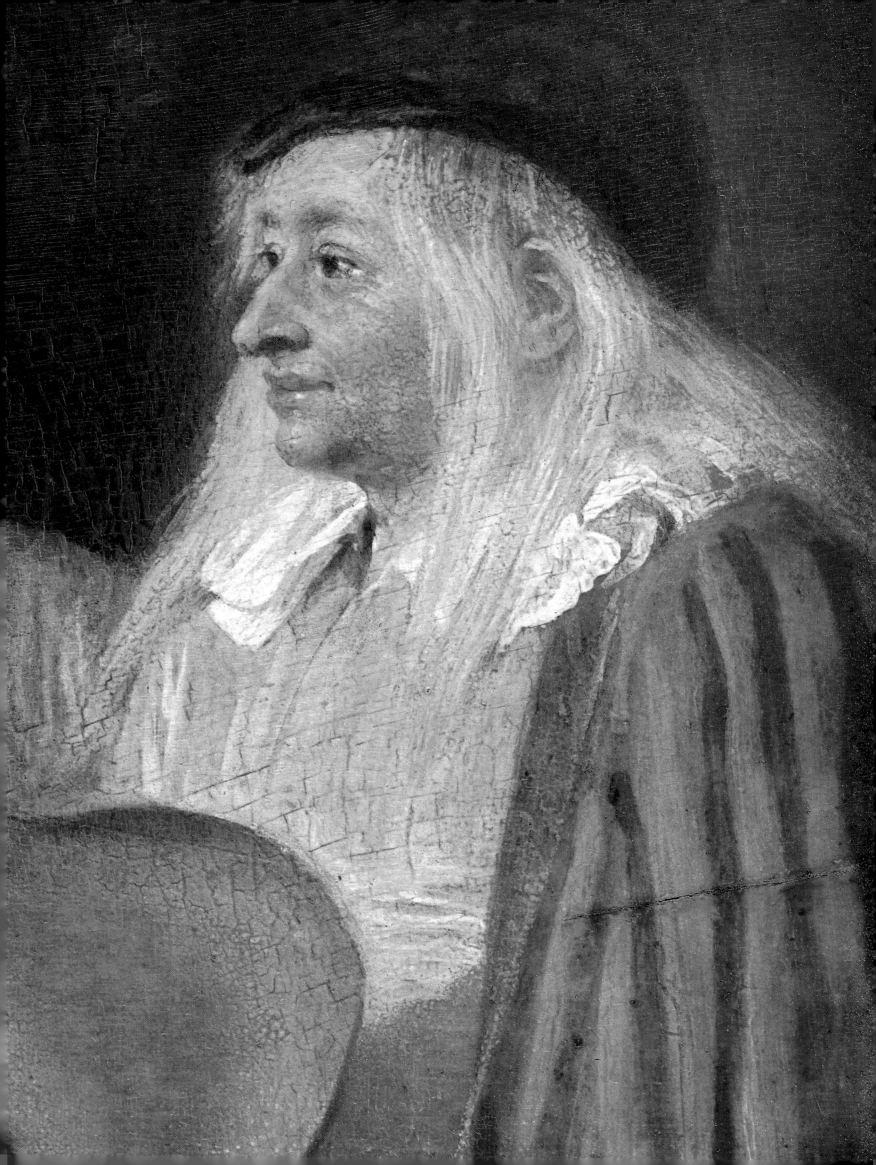

4. ACTOR OF THE ITALIAN COMEDY (Crispin)

Red chalk on cream laid paper, 21.5 x 17.2 cm
The Pushkin Museum of Fine Arts, Moscow.
Inv. No. 4404

The drawing was engraved in reverse by Boucher for *Figures de différents caractères* (No. 57). It is one of the sketches for the figure of Crispin in the painting Arlequin, Pierrot et Scapin, engraved by L. Surugue in 1719; it was also used by the artist for his composition Le Repos gracieux (*Figures de différents caractères*, No. 22). The drawing resembles the sketch in the Rijksmuseum, Amsterdam (P.-M., II, No. 684), where Crispin's pose and the position of his hand on the sword's hilt are the same as in the Pushkin Museum drawing.

PROVENANCE

Until 1918 : Countess E. Shuvalova collection, St Petersburg/Petrograd
1918 : The Shuvalova House-Museum, Petrograd
1924 : The Pushkin Museum of Fine Arts, Moscow

EXHIBITIONS

1927. French Drawings : 16th to 19th Century. Moscow (Cat. No. 28)
1955. French Art : 15th to 20th Century. Moscow (Cat., p. 72)
1956. French Art : 12th to 20th Century. Leningrad (Cat., p. 85)
1959. Exhibition of Drawings and Watercolours. Moscow (Cat., p. 23)

REFERENCES

M. Konopliova, The Shuvalova House-Museum. Guide (in Russian), Petrograd, 1923, p. 46, No. 141; Goncourt, p. 72, No. 410; Parker, Mathey, No. 952; Zolotov, Nemilova 1973, pp. 12-13, 151, No. 20; Zolotov 1985, p. 11, No. 12.

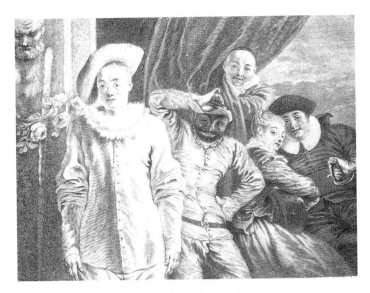

Engraving by L. Surugue after Watteau's painting
Arlequin, Pierrot et Scapin.

Below :
Crispin's hand and Mezzetin's head.
Rijksmuseum, Amsterdam.

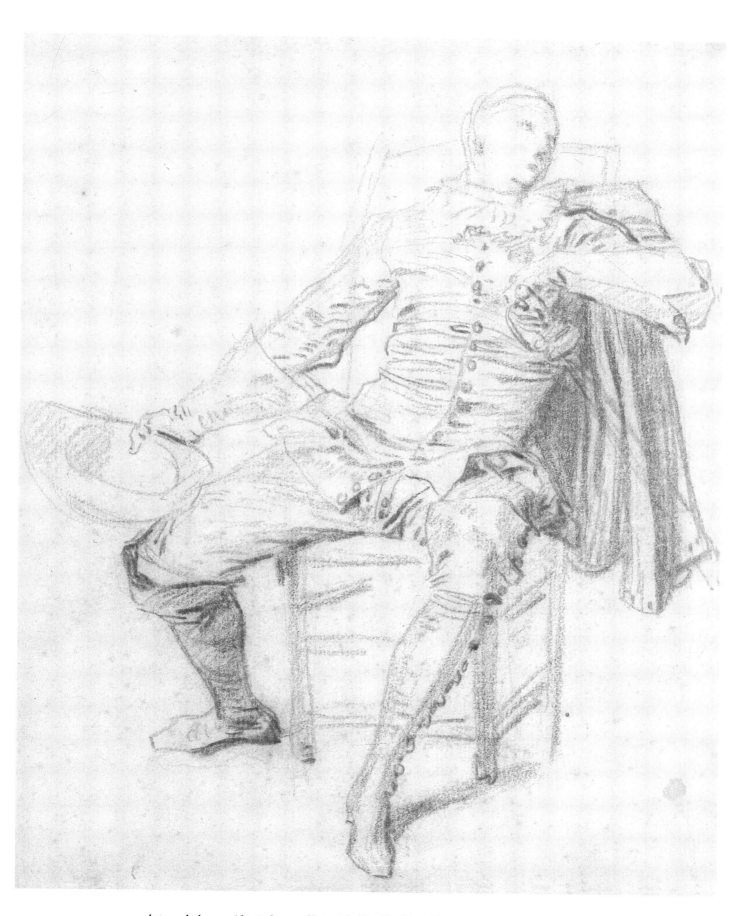

Acteur de la comédie italienne (Crispin), The Pushkin Museum of Fine Arts, Moscow.

5. LANDSCAPE WITH A WATERFALL

Oil on canvas, 72 x 106 cm
The Hermitage, St Petersburg.
Inv. No. 7766

The painting was transferred from wood to canvas by N. Sidorov in 1883. Traces of insufficiently smoothed-out blisters are apparent on the left and in the lower half. Restoration traces along a crack in the centre. The paint layer is wrinkled; there are numerous inpaintings over the entire surface. The left-hand part with the strolling couple, taken from Watteau's picture *Assemblée dans un parc* (Louvre, Paris), was painted in at a later date, probably after the painting was transferred from wood to canvas, to cover up damage; because of that, the painting's length was increased by 10 to 12 cm.

The paintwork has suffered considerably. During the removal of the brownish coating of varnish, it was found necessary to leave patches of varnish on those parts of the painting that were badly damaged during former restorations; hence the yellowish spots on the surface. A drawing in red chalk, copied from Campagnola (Ashmolean Museum, Oxford), may be considered as

the preliminary sketch; its composition, with slight changes, is repeated in the painting.

The Paysage avec *un torrent* was first reproduced in the Kaluga Museum guide as a work by Watteau, although his authorship was not confirmed in the text of the guide. The Hermitage listed it as the work of an eighteenth-century French artist. Our attribution is based on a comparison of the painting with the above-mentioned drawing. Certain elements of the drawing underwent significant change in the painting: for instance, the drawing depicts a typical Arcadian shepherd in an appropriate classical pose; in the painting a typical eighteenth-century personage has taken his place. The trees behind the shepherd have become far more luxuriant and majestic, although they basically preserve their original outline. The main change introduced by the artist concerns his treatment of space. The grandiose classical landscape of the drawing has disappeared completely in the painting.

The attribution of the painting to Watteau is also confirmed by the virtual replica of the shepherd in the left mid-background that we find in another Watteau painting, *L'Amour paisible* (Schloß Charlottenburg, Berlin). The same model served for both figures, although there is a

slight change in pose. A no less marked similarity of detail links the Hermitage painting to Watteau's *Gardeuse de chèvres* (Louvre, Paris): both feature analogous architectural motifs, small waterfalls and masses of dense greenery on the foothills. Both also demonstrate the same kind of brushwork: we find an identical manner in the painting of the waterfalls, done by means of heavy, impasto daubs of white between the dark, contrasting blots of the rocks.

There is yet another technical detail common to both works: in each we see characteristic grooves - the result of the broad and energetic brushstrokes by which the artist reinforced his outlines, using liquid and transparent paint. These grooves cover the entire surface, at times running parallel to each other, at others modelling, in a most genèralized manner, the silhouettes of figures. The direction of these grooves is apparently determined by the shape of the painting: they are horizontal in the horizontal Hermitage Paysage and vertical in the portrait-format Louvre work. Similar and extremely typical grooves appear in *Les Fatigues de la guerre* (Hermitage). A micro-analysis of the paint layer and studies of the brushwork technique definitely confirm Watteau's authorship.

Paysage avec un torrent may be dated approximately to 1714-15, when Watteau studied with special zeal the works of Italian Renaissance masters, particularly those of the Venetian school, in the Crozat collection.

PROVENANCE

A. Sheveliov collection, St Petersburg
N. Bulychov collection, Kaluga
Until 1931: Regional Museum, Kaluga
1931: The Hermitage

EXHIBITIONS

1965. La Peinture française dans les musées de l'Ermitage et de Moscou. Bordeaux (Cat. No. 44)
1965-66. Chefs-d'œuvre de la peinture française dans les musées de Léningrad et de Moscou. Paris (Cat. No. 42)
1972. Watteau and His Time. Leningrad (Cat. No. 10)

REFERENCES

S. Bessonov, Guide to the Art Department of the Kaluga Regional Museum (in Russian), Kaluga, 1929, p. 34; Catalogue 1958, p. 270; Nemilova 1964, pp. 60-68, 182; J. Cailleux, "*Newly Identified Drawings by Watteau*", The Burlington Magazine, 1967, February, p. 59; Macchia, No. 98; Rosenberg, Camesasca, No. 98; Nemilova 1973, pp. 45-46; Zolotov, Nemilova 1973, pp. 19-20, 147, No. 13; Catalogue 1976, p. 190; Nemilova 1981, No. 46; Catalogue 1984, pp. 322, 323, No. 33; Roland Michel 1984, pp. 159, 210, 301, No. 147; Rosenberg 1984; Zolotov 1985, p. 17, Nos 13-15.

Opposite:
Château fort dans un site montagneux avec torrent.
Ashmolean Museum, Oxford.

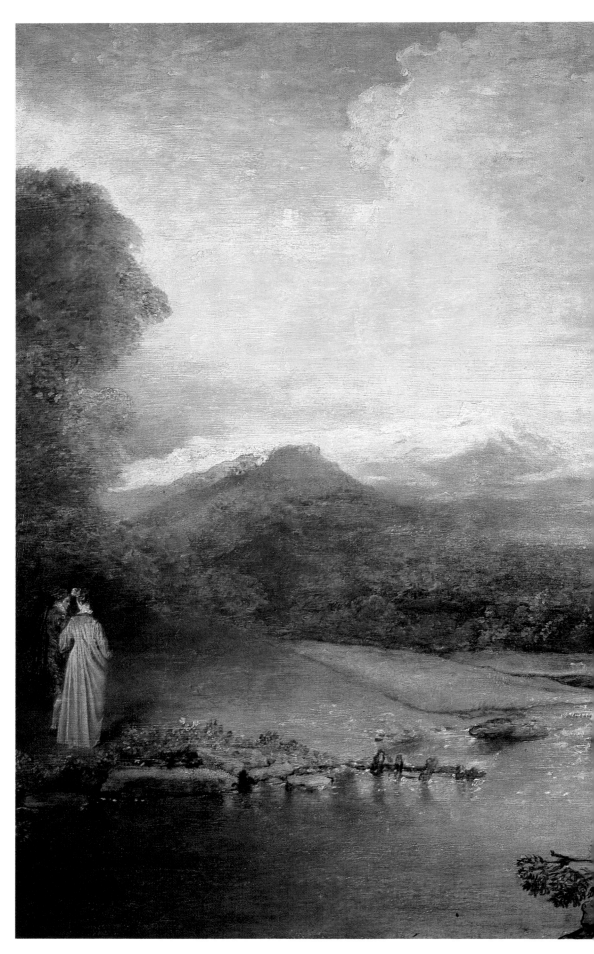

Landscape with Waterfall,
The Hermitage,
St Petersburg..

Overleaf: Details

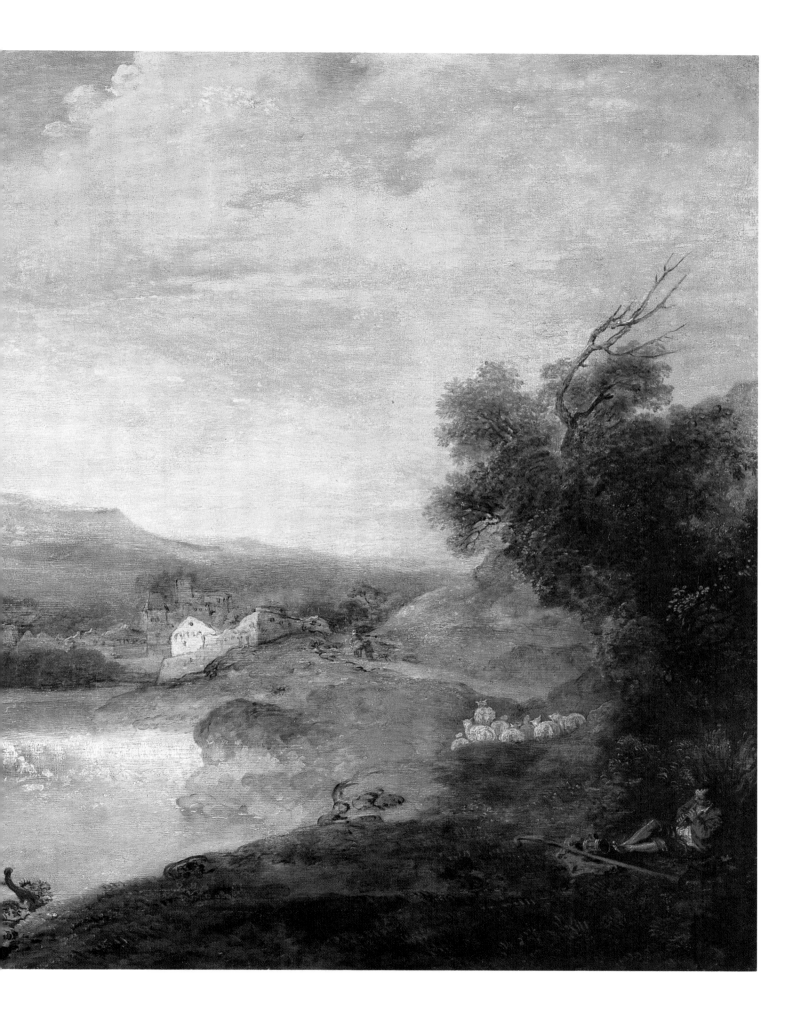

6. THREE STANDING MALE FIGURES

Red chalk, 16.5 x 21.2 cm
The Hermitage, St Petersburg.
Inv. No. 14320

The young man to the right, leaning on a cane, is similar to the figure of Le Promeneur engraved by Cochin for the series of etchings entitled *Figures françaises et comiques*, as well as to the analogous figure to the left in Watteau's drawing from the collection of the Ecole Nationale des Beaux-Arts (P.-M., I, No. 60).
Judging by the graphic technique with its prevalence of vertical lines, absence of shadows and the use of red chalk only, the drawing may be considered one of the artist's early works.

PROVENANCE

Until 1924: A. Vorobyov collection, St Petersburg/Petrograd
1924: The Hermitage

EXHIBITIONS

1926. Old Master Drawings. Leningrad
1972. Watteau and His Time. Leningrad (Cat. No. 56)

REFERENCES

Dobroklonsky, No. 216; Parker, Mathey, Nos 60, 938; Nemilova 1964, p. 192; *Old Master Drawings* (in Russian), Leningrad, Moscow, 1965 (reproduction); Zolotov, Nemilova 1973, pp. 28, 145-146, No. 11; Zolotov 1985, p. 29, No. 16.

Facing:
Three male figures standing,
The Hermitage, St Petersburg.

Below: *Études d'un jeune homme et têtes de femmes.*
Studies of a young man and heads of women
École Nationale des Beaux-Arts, Paris.

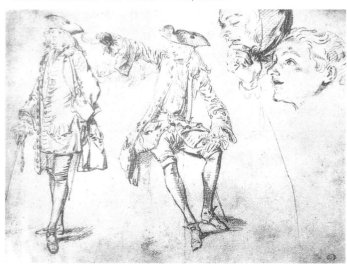

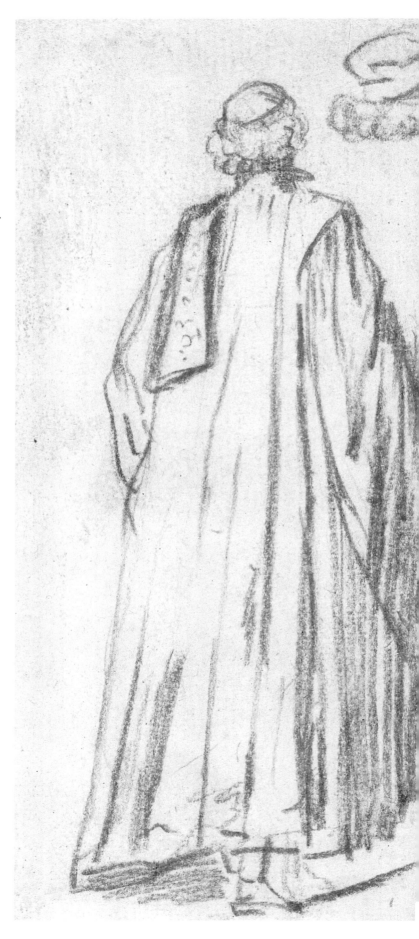

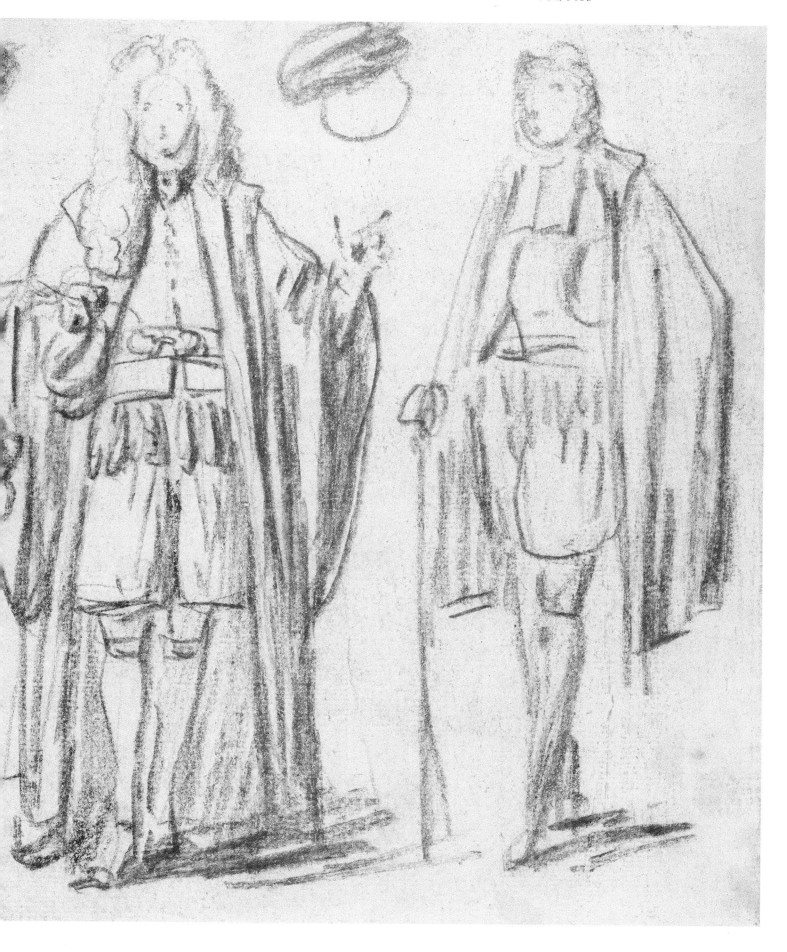

7. THE BIVOUAC

Oil on canvas, 32 x 45 cm
The Pushkin Museum of Fine Arts, Moscow.
Inv. No. 1226

At top left of the painting there is an old dent. In the lower left-hand corner the paint layer has crumbled underneath the varnish. Certain areas show minor inpaintings. X-rays of the underlying drawings show no changes in composition.

According to Mariette, Watteau was commissioned to do this painting by his friend, Sirois, antiques dealer, from whom it passed to the collection of his son-in-law, Gersaint.

There is no information as to the painting's further history; the exact time of its appearance in the Hermitage is unknown. V. Loewinson-Lessing postulates that the painting, along with *Les Délassements de la guerre* and *Les Fatigues de la guerre* (Hermitage, Inv. Nos 1162, 1159), was part of the Crozat collection, in which it came to Russia. However, let us note that Watteau's *Camp volant* is not listed in the catalogue of the Crozat collection, published in 1755.

Camp volant belongs to Watteau's series on the theme of army life and is based on sketches done during a trip to Valenciennes in 1709. The variety of figures and the well-developed composition allow one to postulate that the painting was not the master's first on this theme, but it apparently preceded the two Hermitage pictures, *Les Délassements de la guerre* and *Les Fatigues de la guerre*, which are dated to 1712-15 and show a more mature mastery. H. Adhémar dates Camp volant at 1710. Mariette thought it to be a pair to Retour de campagne (E.W. Edwards collection, Cincinnati). This view is shared by most scholars, from the Goncourt

Deux soldats. Bordeaux-Groult collection, Paris.

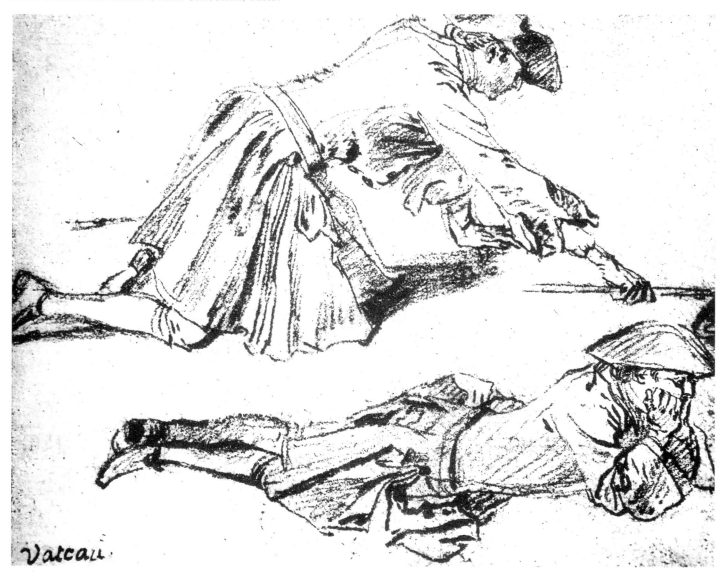

brothers to Réau. H. Adhémar sees no connection between these works and considers *Camp volant* to be a later and technically more perfect painting.

Yu. Zolotov believes this picture to be the one referred to in Gersaint's memoirs as the second military subject sent by Watteau from Valenciennes.

Three sheets of preliminary drawings are known, two in the Dewar collection, London (P.-M., I, Nos 255, 266), and one in the Bordeaux-Groult collection, Paris (P.-M., I, No. 257). Versions of the painting appeared at the following auctions: anonymous sale, Paris, 1847, lot 56; Danilo sale, Paris, 1867, lot 35; G.W. collection, Paris, 1877, lot 26 (the same picture as that in the Danilo sale); David Cox sale, London, 1893, lot 13.

Reversed etching by Charles Nicolas Cochin for Jean de Julienne's collection of engravings.

PROVENANCE

1710: P. Sirois collection, Paris
1726: Gersaint collection, Paris
Mid-18th century: P. Crozat, Baron de Thiers collection, Paris (not confirmed)
End of 19th century: The Hermitage
1928: The Pushkin Museum of Fine Arts, Moscow

EXHIBITIONS

1937. Chefs-d'œuvre de l'art français. Paris (Cat. No. 227)
1955. French Art: 15th to 20th Century. Moscow (Cat., p. 24)
1956. French Art: 12th to 20th Century. Leningrad (Cat., p. 13)
1965. La Peinture française dans les musées de l'Ermitage et de Moscou. Bordeaux (Cat. No. 42)
1965-66. Chefs-d'œuvre de la peinture française dans les musées de Léningrad et de Moscou. Paris (Cat. No. 40)

REFERENCES

Mercure de France, December 1727, p. 2677; *L'Œuvre d'Antoine Watteau... par les soins de M. de Julienne à Paris*, vol. II, 1730-40, p. 58; P.-J. Mariette, *Abecedario*, vol. VI, Paris, 1859-60, p. 109; Goncourt, p. 55, No. 52; A. Somov, The Imperial Hermitage. Catalogue of the Picture Gallery (in Russian), part III, St Petersburg, 1900, p. 27, No. 1874; Josz, pp. 56, 222 (reproduced under the title *Les Délassements de la guerre*); C. Philips, *Antoine Watteau*, London, 1907, p. 19; Zimmermann, p. 185, No. 4 (reproduction); A. Benois, Guide to the Picture Gallery of the Imperial Hermitage (in Russian), St Petersburg, s.a., p. 174 (*under the title Soldiers' Kitchen*), reproduced p. 155 (under the title Soldiers at Rest); E. Hildebrandt, *Antoine Watteau*, Berlin, 1922, p. 92; Dacier, Vuaflart, p. 73, No. 148; Réau 1928, p. 32, No. 40; Réau 1929, p. 95, No. 693; Volskaya, pp. 32, 34, 35 (reproduction); L. Hourticq, *Peinture française au XVIIIe siècle*, Paris, 1934 (reproduction); Les Chefs-d'œuvre de l'art français. Catalogue, Paris, 1937, p. 113, No. 227; Catalogue 1948, p. 16 (reproduction); Adhémar, pp. 33, 35, 179, 250, No. 37; Yu. Zolotov, "Contemporary Subjects in the Art of Antoine Watteau", in: Moscow University. Collection of Articles on the History and Theory of Art (in Russian), Moscow, 1956, p. 85, plate XVI; Catalogue 1957, p. 23 (reproduction); Parker, Mathey, Nos 255, 256, 257; Ch. Sterling, *Musée de l'Ermitage. La peinture française de Poussin à nos jours*, Paris, 1957, p. 37; Catalogue 1961, p. 33 (reproduction); A. Chegodayev, Antoine Watteau (in Russian), Moscow, 1963, pp. 15, 16, plate 5; Nemilova 1964, pp. 44, 170 (reproduction); Macchia, No. 44; Rosenberg, Camesasca, No. 44; Zolotov, Nemilova 1973, pp. 27, 28, 131, 132, No. 1; Catalogue 1984, pp. 254-256, No. 6; Roland Michel 1984, pp. 37, 69, 168, 211, 214, VII; Rosenberg 1984; Zolotov 1985, pp. 25, 27, Nos 17-21; Colloque Watteau 1987, pp. 27, 28, No. 2.

Cuisinier. Dewar collection, London.

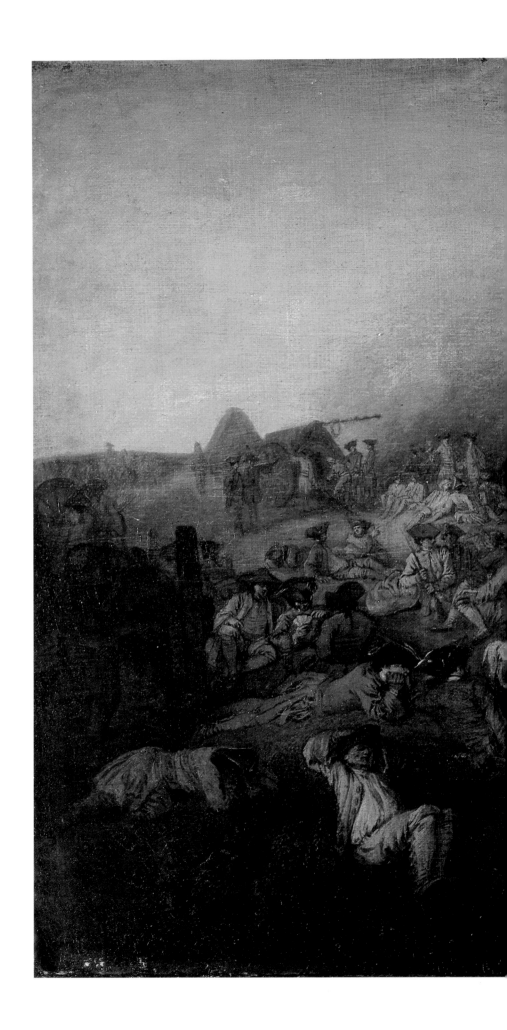

Le Camp volant (The Flying Camp),
The Pushkin Museum of Fine Arts,
Moscow.

Overleaf: Details

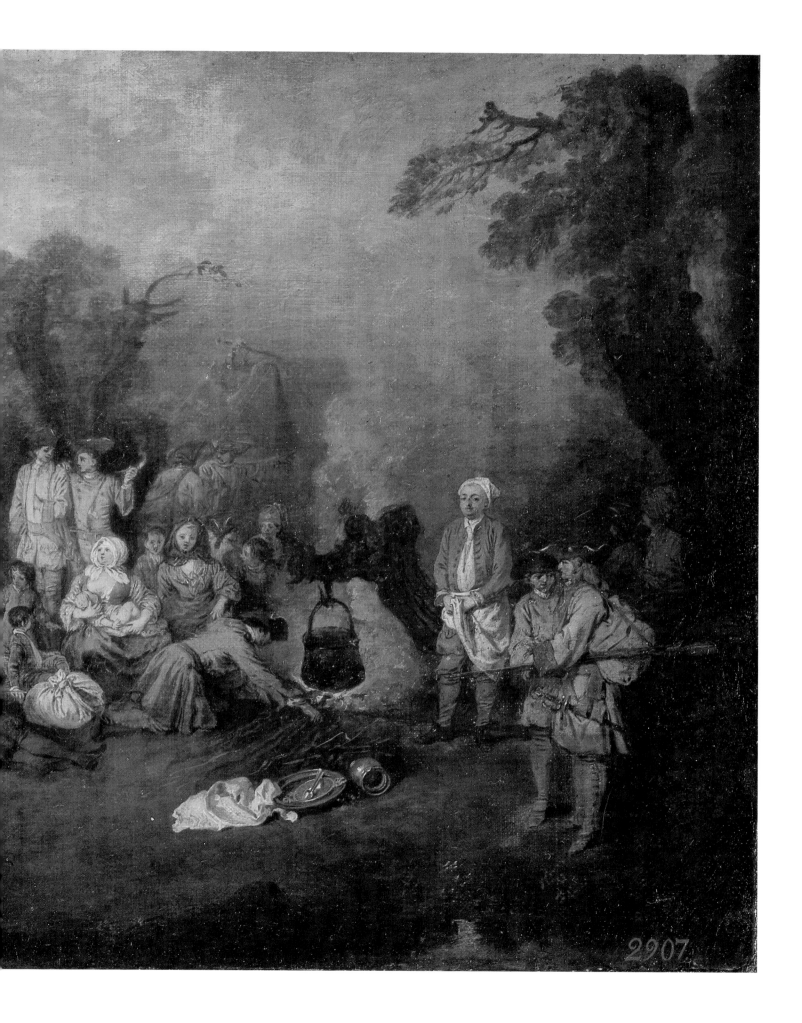

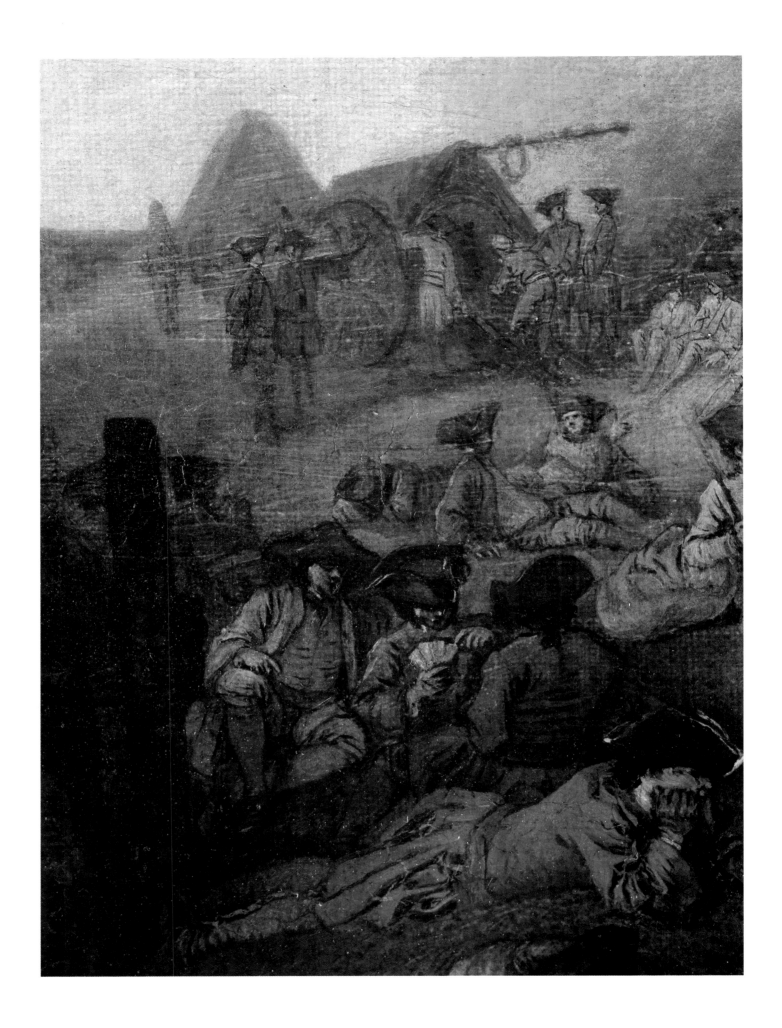

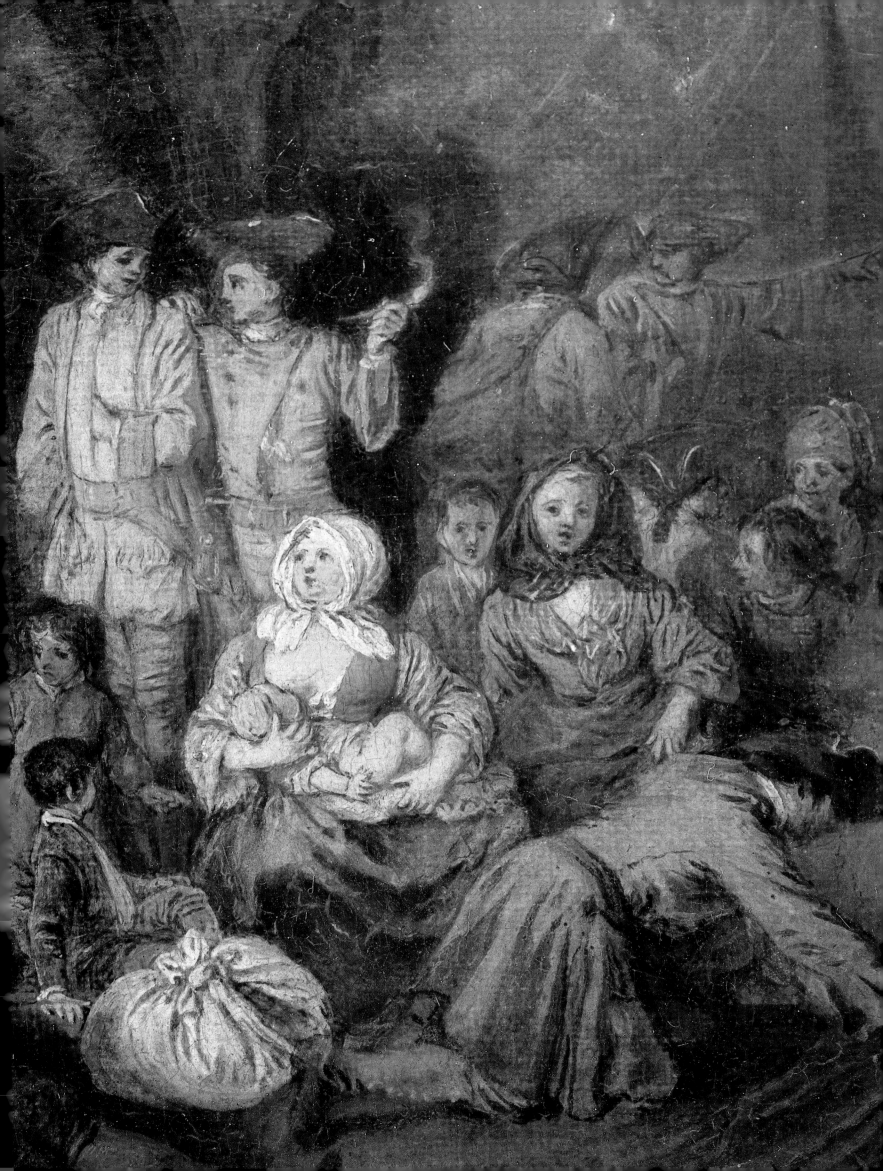

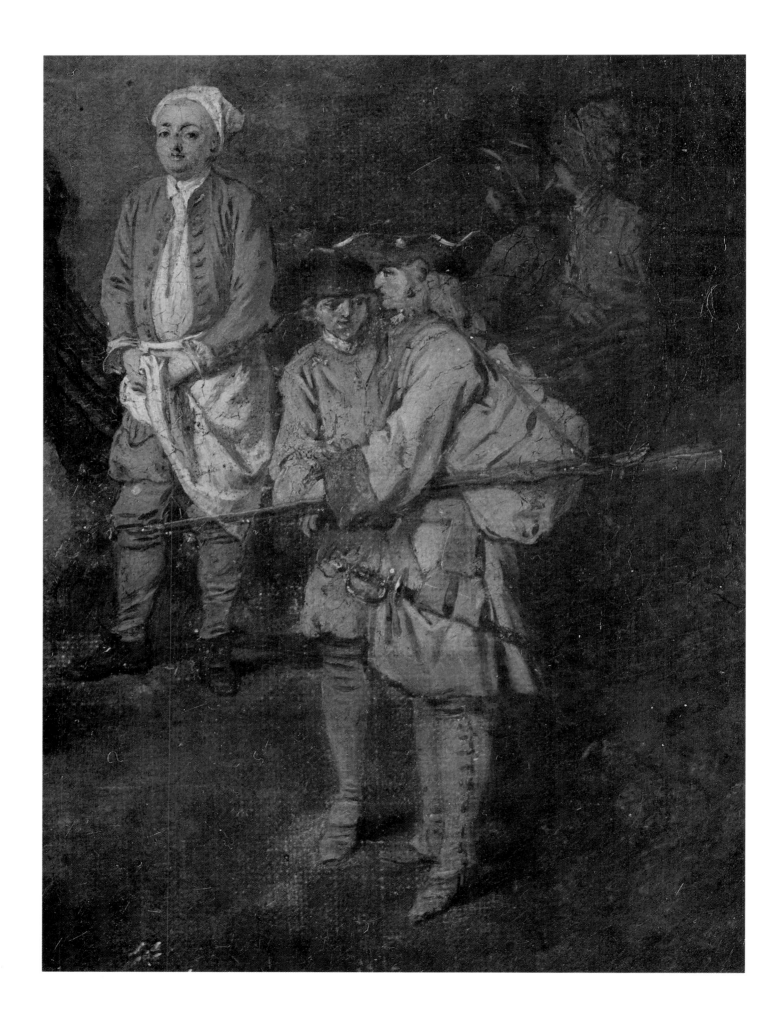

8. STUDY OF FOUR FIGURES

Red chalk on laid paper, 9.5 x 13.2 cm
The Pushkin Museum of Fine Arts, Moscow.
Inv. No. 4374

The drawing relates to the early period of Watteau's work, when he was apprenticed to Claude Gillot. The manner and the composition, where Gillot's influence is evident, have much in common with such drawings as the sheet in the Pierpont Morgan Library, New York (P.-M., I, No. 25). The figure at far right was used in the composition *Le Vendangeur*, engraved by J. Moyreau.

PROVENANCE

Svirskov-Golovkin collection, Moscow
Until 1890s : N. Mosolov collection, Moscow
Until 1927 : D. Shchukin collection, Moscow
1927 : The Pushkin Museum of Fine Arts, Moscow

EXHIBITIONS

1927.French Drawings : 16th to 19th Century. Moscow (Cat. No. 25)

REFERENCES

Zolotov, Nemilova 1973, p. 146, No. 12 ; Zolotov 1985, p. 7, No. 22.

Facing :
Le Vendangeur (The Grape Harvester). Etching by
J. Moyreau after Watteau's drawing..

Below : *Figures from the Theater.*
Pierpont Morgan Library, New York.

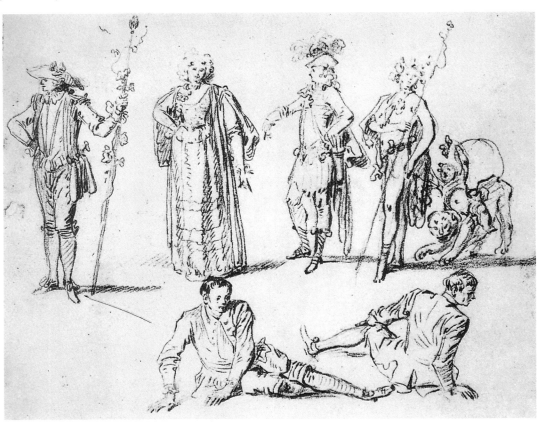

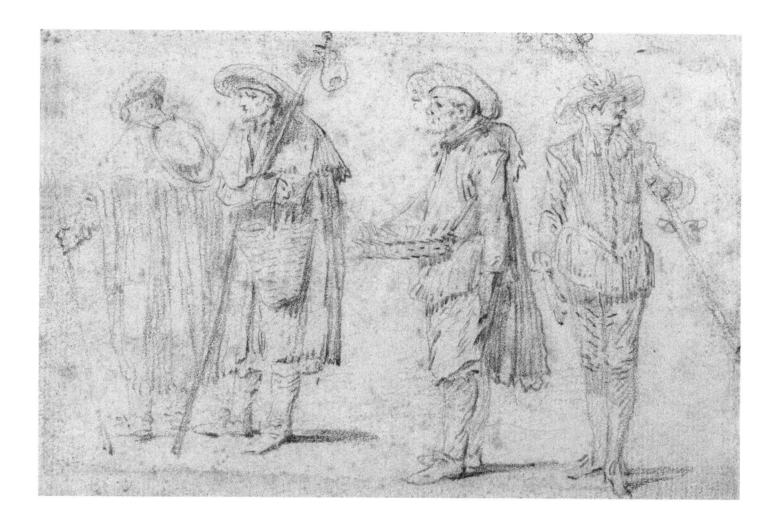

Étude de quatre personnages (Study of four figures) The Pushkin Museum of Fine Arts, Moscow.

9. THE HARDSHIPS OF WAR

Oil on copper plate, 21.5 x 33.5 cm
The Hermitage, St Petersburg.
Inv. No. 1159
(pair to *The Recreations of War*, see No. 11)

Minor paint losses filled with resin and painted over in the corners.
Engraved by G. Scotin in 1731 for Jean de Julienne's collection under the title *Les Fatigues de la guerre*.
Dated by H. Adhémar to 1712-15, by J. Mathey to 1712. An analysis of the painting's style and its original treatment of the subject furnish grounds for considering it a mature work of the "military genre" and dating it to 1715.

REFERENCES

E.-F. Gersaint, *"Annonce énumérant les 17 estampes d'après Watteau, publiées depuis deux ans"*, Mercure de France, June 1731, p. 1564; P.-J. Mariette, *Manuscrit du Cabinet des Estampes de la Bibliothèque Nationale*, vol. IX, fol. 192/24; E.-F. Gersaint, *Catalogue de la vente de La Roque*, Paris, 1745, No. 44; *Catalogue des tableaux du Cabinet de M. Crozat, Baron de Thiers....*, 1755, p. 58; Goncourt, No. 54; Josz, pp. 130-131; Zimmermann, p. 31; Dacier, Vuaflart, No. 138; Réau 1928, No. 42; Réau 1929, No. 412; Adhémar, No. 96, pl. 25, pp. 75, 99, 139; Catalogue 1958, p. 270; Nemilova 1964, pp. 42-52, 183; Stuffmann, p. 135, No. 185; Macchia, No. 97; Rosenberg, Camesasca, No. 97; Zolotov, Nemilova 1973, pp. 27, 132, 133, No. 2; Catalogue 1976, p. 189; Nemilova 1981, No. 48; Catalogue 1984, pp. 280-282, No. 15; Roland Michel 1984, pp. 113, 167, 169, 170, 229, 265, No. 152; Rosenberg 1984; Zolotov 1985, p. 7, Nos 23-27; Colloque Watteau 1987, p. 25, No. 31.

PROVENANCE

Gersaint collection, Paris
Until 1745: A. de La Roque collection, Paris (see catalogue of auction sale)
1745: Gersaint collection, Paris (bought for 1,680 francs)
Until 1772: P. Crozat, Baron de Thiers collection, Paris
1772: The Hermitage

EXHIBITIONS

1956 . French Art: 12th to 20th Century. Leningrad (Cat., p. 12)
1972 . Watteau and His Time. Leningrad (Cat. No. 7)
1972 . Meisterwerke aus der Ermitage, Leningrad, und aus dem Puschkin Museum, Moskau. Dresden (Cat. No. 49)

Overleaf:
The Hardships of War. details.

Pages 120 and 121:
The Hardships of War.
The Hermitage, St Petersburg.

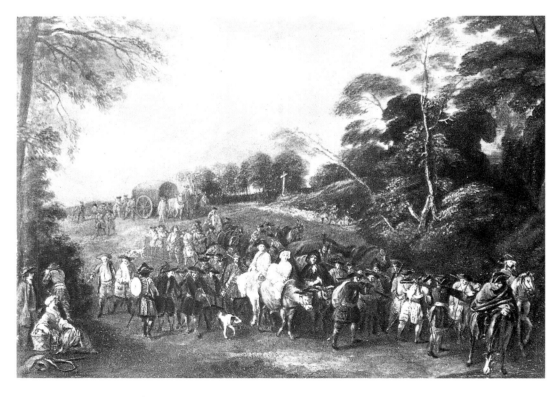

Retour de campagne. Edwards collection, Cincinnati.

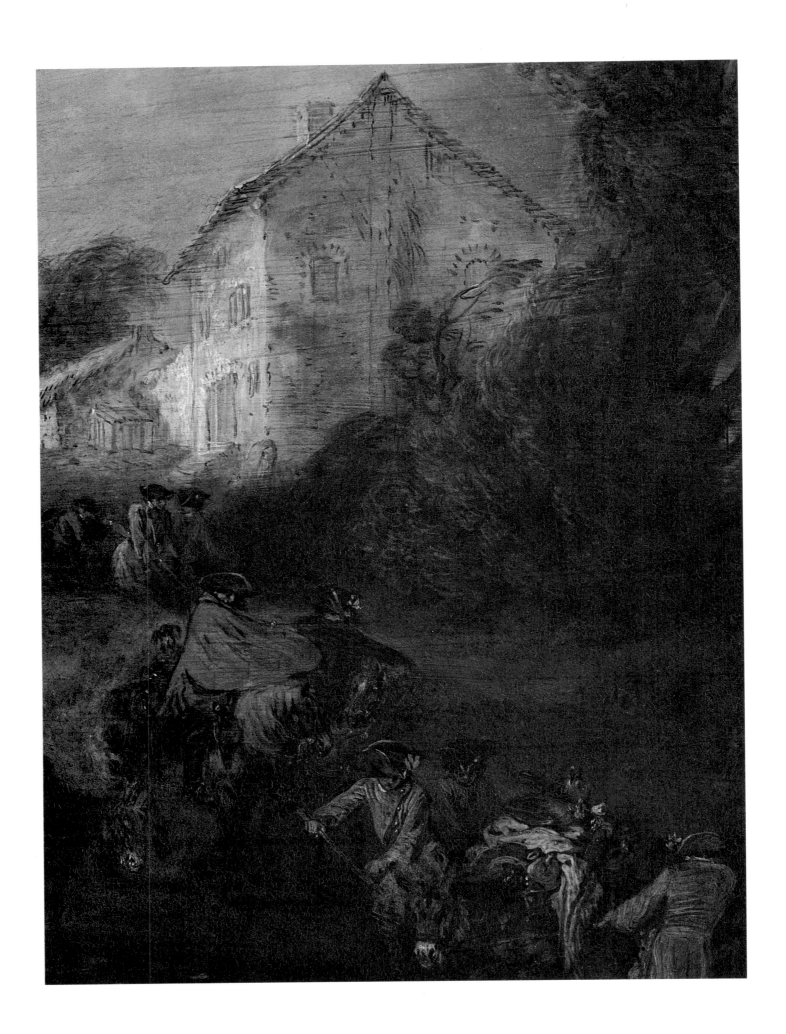

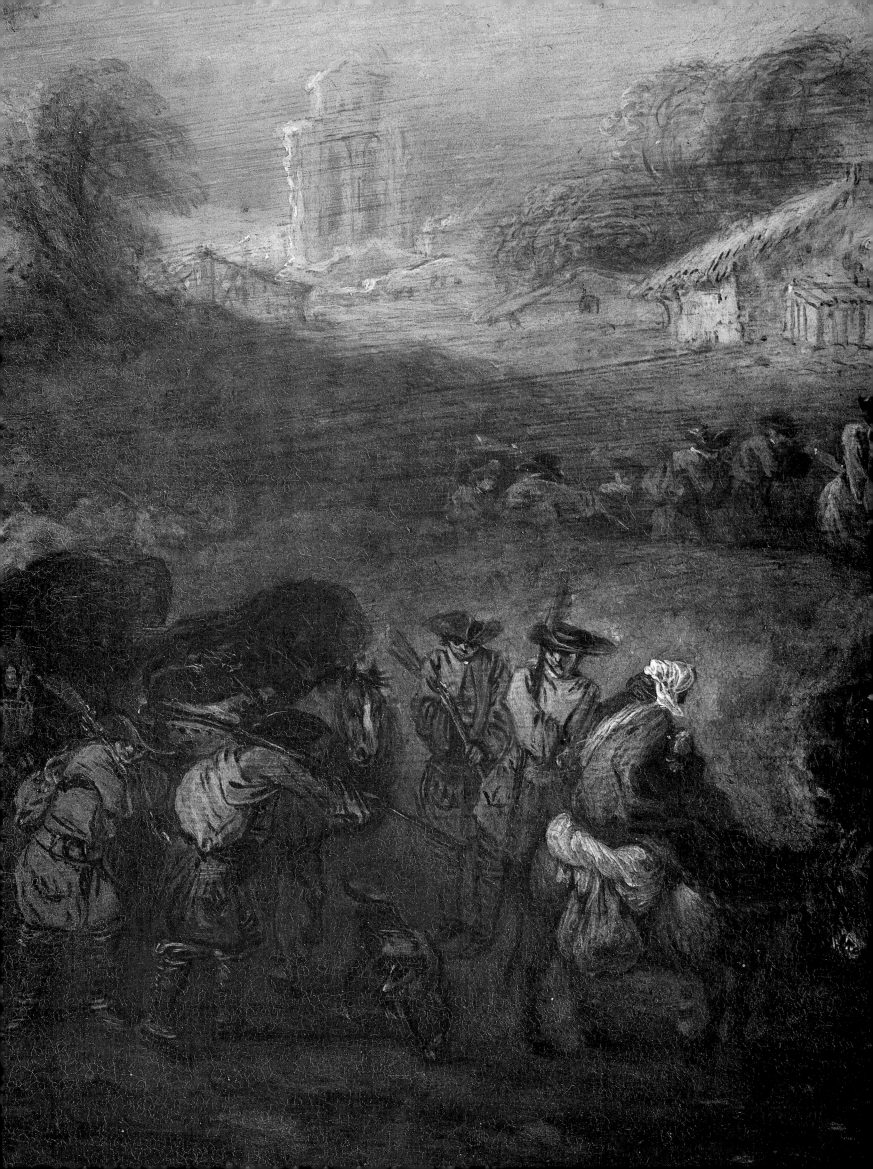

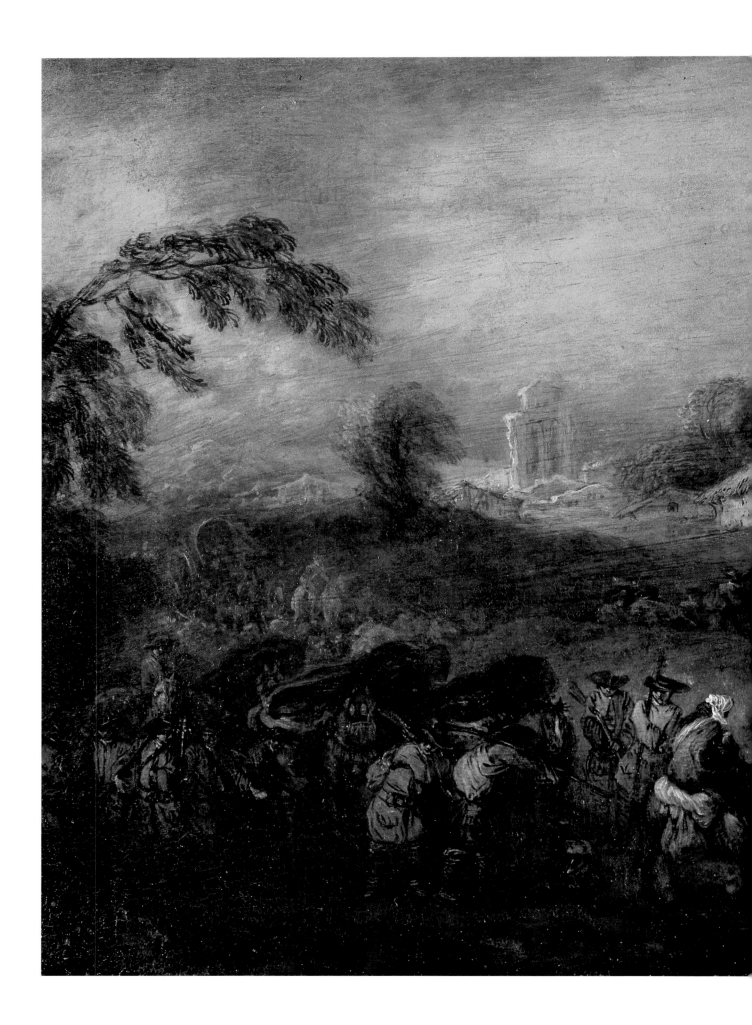

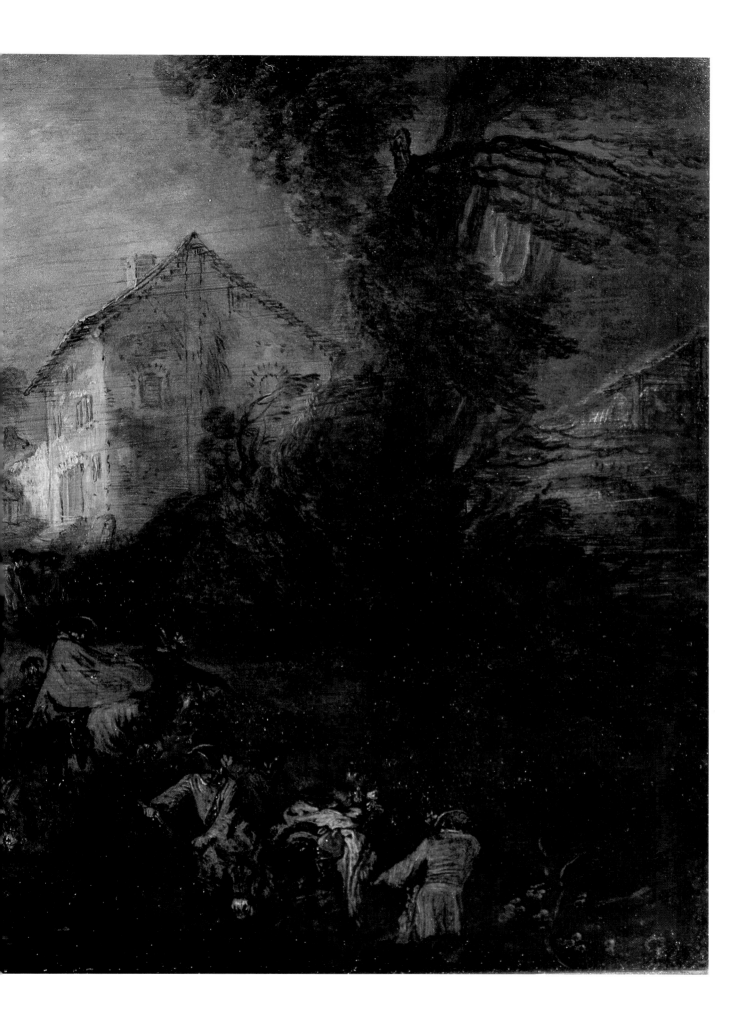

10. STUDY OF AN OLD WOMAN

Red and black chalk on light brown paper, 29.5 x 18.3 cm
The Hermitage, St Petersburg.
Inv. No. 6298

The drawing is mounted on another sheet of paper.
It was engraved by Caylus in *Figures de différents
caractères* (No. 3).
The drawing is a study for the figure of the old woman
in the painting *L'Occupation selon l'âge*, engraved by
Ch. Dupuis.
In the Julienne collection the study of the old woman
was on the same sheet as the figure of a young woman,
bent over her sewing. Later these two studies were sepa-
rated and now the drawing of the young woman is in the
Bordeaux-Groult collection, Paris (P.-M., II, No. 563).

PROVENANCE

E.-F. Julienne collection, Paris
Until 1768 : Count Cobenzl collection
1968 : The Hermitage

EXHIBITIONS

1926. Old Master Drawings. Leningrad
1972. Watteau and His Time. Leningrad (Cat. No. 60)

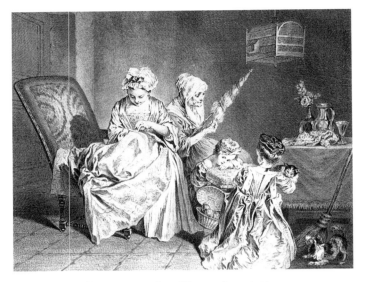

Etching by Ch. Dupuis after Watteau's painting
L'Occupation selon l'âge (Occupation according to Age)

REFERENCES

P. Remy, *Catalogue*, Paris, 1767, No. 801 ; *Ermitage Impérial. Collection
des dessins*, St Petersburg, 1860, No. 49 (2nd ed. 1867, No. 481); R.
Weiges, *Die Werke der Maler in ihren Handzeichnungen*, Leipzig, 1865, No.
8593 ; A. Klynder-Poettger, *Dessins des grands maîtres conservés au
Musée de l'Ermitage Imperial*, St Petersburg, 1868, No. 36 ; Dobroklonsky,
No. 244 ; Adhémar, No. 83 ; Nemilova 1964, p. 117, pl. 63, p. 191, No. 5 ;
Zolotov, Nemilova 1973, p. 149, No. 16 ; Zolotov 1985, p. 7, No. 36.

Overleaf :
Une vieille femme (an Old Woman)
The Hermitage, St Petersburg.

Opposite :
Etching by Caylus, after Watteau's drawing,
(from *Figures de différents caractères*).

11. RECREATIONS OF WAR

Oil on copper plate, 21.5 x 33.5 cm
The Hermitage, St Petersburg.
Inv. No. 1162
(pair to Les Fatigues de la guerre, see No. 9)

A large missing flake of the paint layer in the slightly warped left-hand corner has been painted in. A minor loss, at the lower edge, has been covered with paint and varnish, without resin.

Some preliminary sketches of soldiers at rest are in the Boymans-Van Beuningen Museum, Rotterdam. E. Dacier and A. Vuaflart believe that the first version of this painting is the drawing engraved by Boucher in Chéreau's *Figures de différents caractères* (No. 270). This composition is described by Mariette.

Engraved by L. Crepy in 1731.

Dated by H. Adhémar to 1712-15, by J. Mathey to 1712. An analysis of the painting's style and its original treatment of the subject furnish grounds for considering it a mature work of the "military genre" and dating it to 1715.

PROVENANCE

Gersaint collection, Paris
Until 1745: A. de La Roque collection, Paris (see catalogue of auction sale)
1745: Gersaint collection, Paris (bought for 1,680 francs)
Until 1772: P. Crozat, Baron de Thiers collection, Paris
1772: The Hermitage

EXHIBITIONS

1956. French Art: 12th to 20th Century. Leningrad (Cat., p. 12)
1965. La Peinture française dans les musées de l'Ermitage et de Moscou. Bordeaux (Cat. No. 45)
1965-66. Chefs-d'œuvre de la peinture française dans les musées de Léningrad et de Moscou. Paris (Cat. No. 43)
1972. Watteau and His Time. Leningrad (Cat. No. 6)

REFERENCES

E.-F. Gersaint, "*Annonce énumérant les 17 estampes d'après Watteau, publiées depuis deux ans*", Mercure de France, June 1731, p. 1564; P.-J. Mariette, *Manuscrit du Cabinet des Estampes de la Bibliothèque Nationale*, vol. IX, fol. 192/24, 196/62; E.-F. Gersaint, *Catalogue de la vente de La Roque*, Paris, 1745, No. 44; *Catalogue des tableaux du Cabinet de M. Crozat, Baron de Thiers...*, 1755, p. 57; Goncourt, No. 55; Josz, pp. 130-131; Zimmermann, p. 30; Dacier, Vuaflart, No. 216; Réau 1929, No. 413; Adhémar, No. 95, pl. 44, pp. 10, 99, 139; Parker, Mathey, No. 249; Catalogue 1958, p. 270; Nemilova 1964, pp. 47-51; Stuffmann, p. 135, No. 186; Macchia, No. 96; Rosenberg, Camesasca, No. 96; Zolotov, Nemilova 1973, pp. 27, 133, 134, No. 3; Nemilova 1975, p. 436; Catalogue 1976, p. 189; Nemilova 1981, No. 47; Catalogue 1984, pp. 282, 283, No. 16; Roland Michel 1984, pp. 113, 167, 169, 170, 265, Nos 79, 151; Rosenberg 1984; Zolotov 1985, p. 7, Nos 29-31; Colloque Watteau 1987, p. 25.

Pages 126 and 127:
Recreations of War,
The Hermitage, St Petersburg.

Pages 128 and 129:
Recreations of War, details

Étude de quatre soldats au repos et une femme debout.
(Study of four soldiers resting and a woman standing)
Boymans-Van Beuningen Museum, Rotterdam.

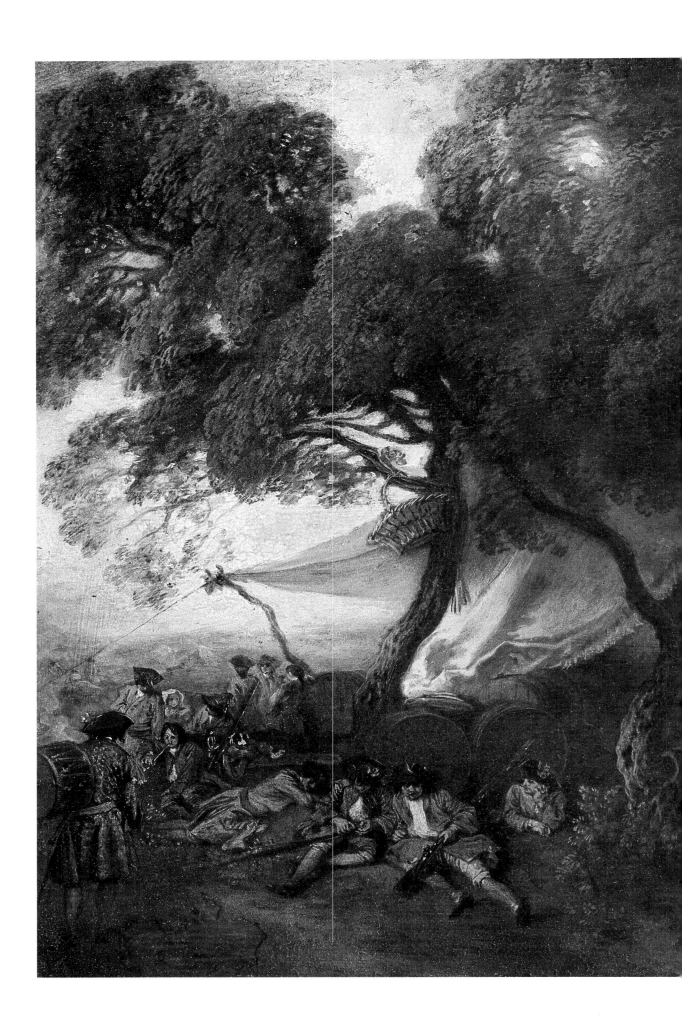

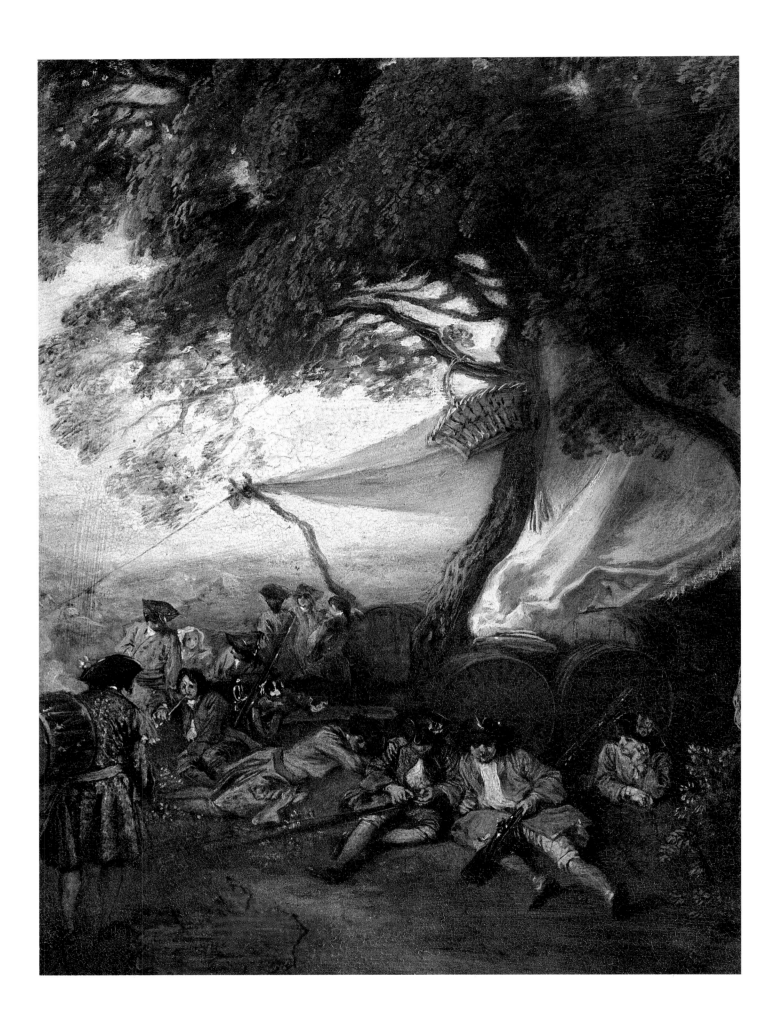

12. SAVOYARD WITH A MARMOT

Oil on canvas, 40.5 x 32.5 cm
The Hermitage, St Petersburg.
Inv. No. 1148

The drawings *Savoyard à la marmotte* (Musée des Beaux-Arts de la ville de Paris) and *Paysage de rivière et clocher d'église* (Teyler Museum, Haarlem) may have been preliminary works. Engraved by C. Audran in 1732, on the same sheet as its pair composition, *La Fileuse* (present whereabouts unknown).

The painting was previously believed to have been done in 1709-10 or earlier. E. Zimmermann dated it to 1707-8; V. Josz shares this opinion, while H. Adhémar suggests a more extended period, 1703-8. Ch. Sterling dates it to 1709-10, J. Mathey around 1713, I. Nemilova to 1716.

Early datings were based on the traces of Flemish influence and on the fact that *the Savoyard*, along with its pair *La Fileuse*, were part of the C. Audran collection. We do not find these points conclusive. Flemish influence can be found in later paintings as well *(Le Repos pendant la fuite en Egypte.* Hermitage). Even if the painting was in Audran's

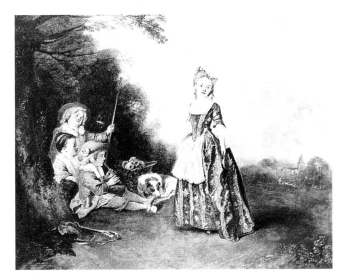

La Danse ou Iris. Staatliche Museen, Berlin.

collection, it does not prove that it was done during Watteau's apprenticeship years. We base our dating of *the Savoyard* to 1716 on an analysis of the technique of both the painting itself and of drawings related to *the Savoyard and La Fileuse*. The painterly manner of the Hermitage picture - gentle, unconstrained, reminiscent at times of a sketch - is typical of the master's mature period (1715-17). This is apparent above all in the painting's landscape background. Elements of this landscape reappear in such paintings as *Iris,* ou *La Danse* (Staatliche Museen, Berlin), *Les Bergers* (Schloß Charlottenburg, Berlin), and *Plaisir pastoral* (Condé Museum, Chantilly), all of which are usually dated between 1716 and 1718.

One of the figures on the reverse of the drawing for the *Savoyard* landscape (P.-M., I, No. 53) was used by Watteau for his *L'Accordée de village* (Soane Museum, London), which is dated by Mathey to 1715-16 and by H. Adhémar to 1716; we discover the second figure in *La Danse villageoise* (former Alwin Schmidt collection, Zurich) which bears the date 1716, and was apparently

produced in the same year as *the Savoyard.* A study of the drawings for *La Fileuse*, the companion painting to *the Savoyard*, leads to the same year. The first, *La Fileuse debout* (P.-M., I, No. 500), is sketched over a woman's head which Watteau repeated in three different positions on another sheet (P.-M., II, No. 786). One of these three head studies was later used for *Gamme d'amour* (National Gallery, London) and *Réunion en plein air* (Gemäldegalerie, Dresden). These paintings are convincingly dated by both H. Adhémar and J. Mathey to 1716-17.

An analysis of the second drawing for *La Fileuse. La Fileuse assise* (P.-M., I, No. 501) leads to the same date. The figure of the girl was used by the artist for *L'Indiscret* (Boymans-Van Beuningen Museum, Rotterdam), attributed to 1716. This dating is also confirmed by the fact that among the personages in the painting we recognize Sirois's son, who sat for Watteau in 1715 and 1716. The dating of *La Fileuse* to 1716 supports the same date for *the Savoyard.*

PROVENANCE

Until 1734: C. Audran collection, Paris
1774: The Hermitage

EXHIBITIONS

1937. Chefs-d'œuvre de l'art français. Paris (Cat. No. 226)
1955. French Art: 15th to 20th Century. Moscow (Cat., p. 24)
1956. French Art: 12th to 20th Century. Leningrad (Cat., p. 12)
1972. Watteau and His Time. Leningrad (Cat. No. 3)

REFERENCES

Goncourt, No. 85; *"Lettre du Baron Kniphausen"*, Archives de l'art français, 1888, p. 64; Josz, p. 98; Zimmermann, p. 1; Dacier, Vuaflart, No. 122; Réau 1928, No. 164; Réau 1929, No. 164; K.T. Parker, *The Drawings of Antoine Watteau*, London, 1931; Volskaya, p. 32; J. Mathey, *"A Landscape by Watteau"*, The Burlington Magazine, 1947, October, p. 6; Adhémar, No. 13, pl. 6, pp. 36, 50, 143, 144, 178; Parker, Mathey, No. 490; Catalogue 1958, p. 266; J. Mathey, *Antoine Watteau*. Peintures réapparues..., Paris, 1959, pp. 24, 67, 74, pl. 22; Nemilova 1964, pp. 101-113, 186; I. Nemilova, *"The Dating of the Hermitage Savoyard and the Problem of Different Phases in Watteau's Genre Painting"*, Papers of the Hermitage (in Russian), 8, Leningrad, 1965, pp. 84-98; *Splendeurs de l'Ermitage (Baroque et Rococo)*, Paris, 1965, No. 66; Macchia, No. 110; Rosenberg, Camesasca, No. 110; Zolotov, Nemilova 1973, pp. 10, 134, 135, No. 4; D. Posner, *"An Aspect of Watteau 'peintre de la réalité'"*, in *Etudes d'art français offertes à Ch. Sterling*, Paris, 1975; Nemilova 1975, p. 438; Catalogue 1976, p. 189; Nemilova 1981, No. 49; Catalogue 1984, pp. 319-321, No. 32; Roland Michel 1984, p. 156; Rosenberg 1984; Zolotov 1985, p. 7, Nos 32-35; Colloque Watteau 1987, pp. 59, 144, 181, No. 44.

Une Fileuse assise. Whereabout unknow.

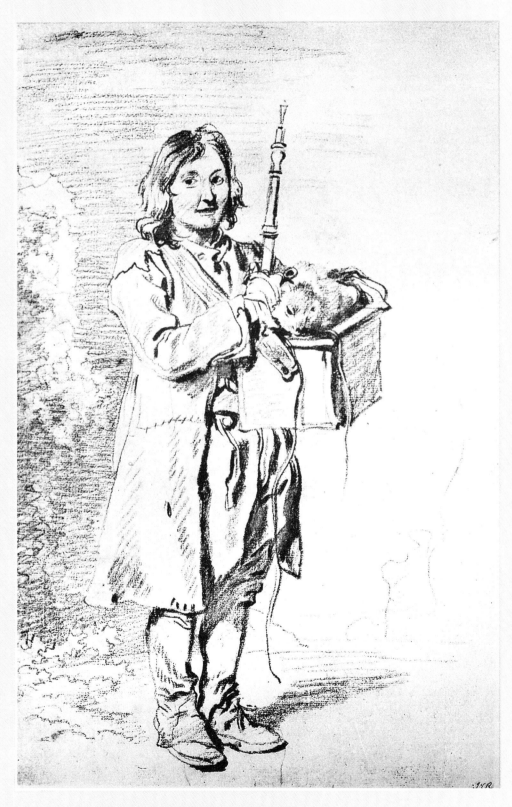

Savoyard à la marmote. Musée des Beaux-Arts de la Ville de Paris.

Trois études de tête.
Foryth Wickes collection, New York.

La Fileuse debout. Metropolitan Museum, New York.

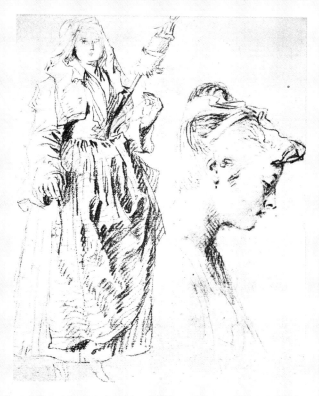

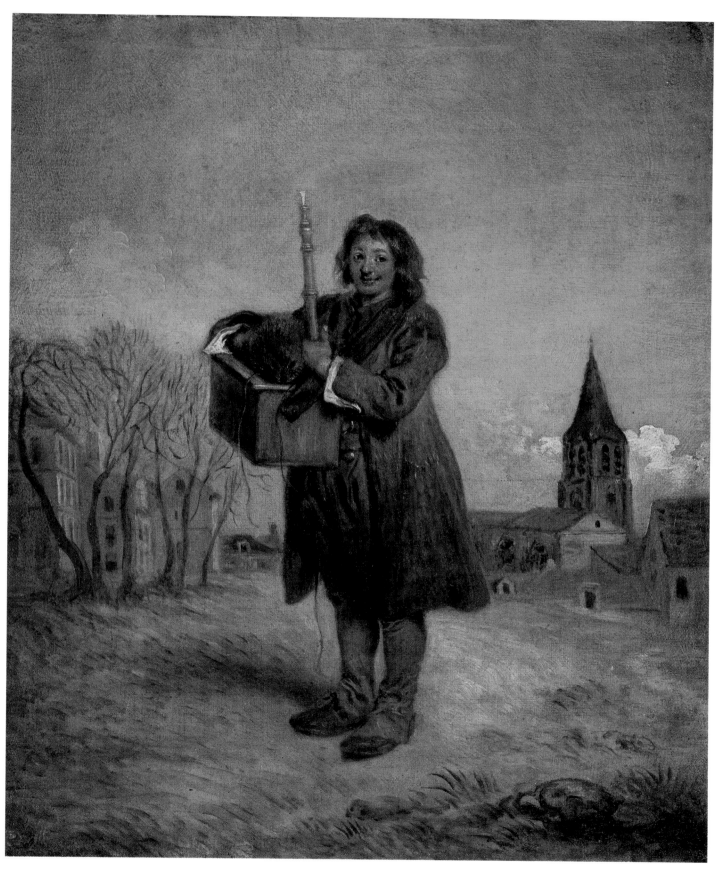

La Marmotte ou le Savoyard. The Hermitage, St Petersburg.

Opposite and overleaf:
La marmotte ou le Savoyard, details.

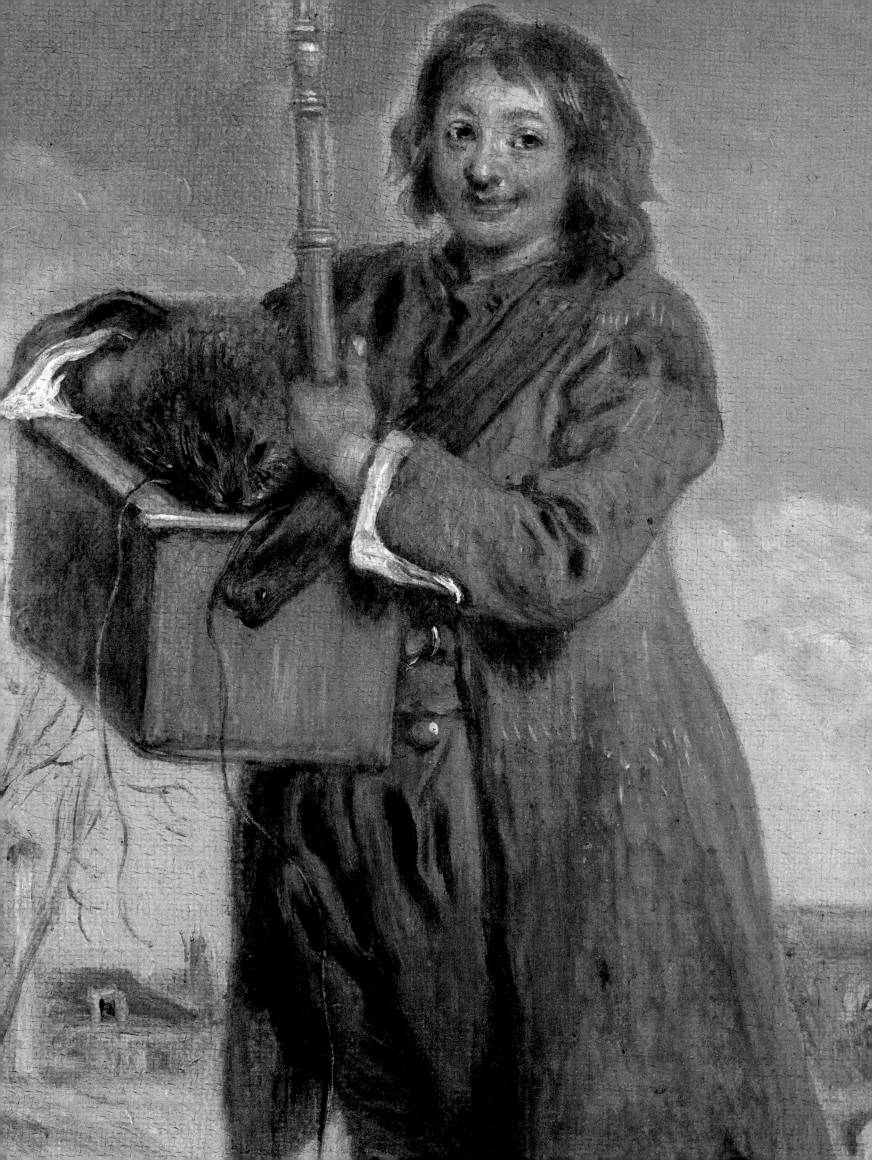

13. SHOE-BLACK

Sanguine on laid paper, 21.1 x 15 cm
The Pushkin Museum of Fine Arts, Moscow.
Inv. No. 4403

The drawing was engraved in reverse by Caylus for the collection *Figures de différents caractères* (No. 226). There is a similarity between this youth and *the Savoyard* from the drawing in the Boymans-Van Beuningen Museum, Rotterdam (P.-M., I, No. 499).

Deux études de cireur de cireur de chaussures.
Boymans – Van Beuningen Museum, Rotterdam.

The verso of the sheet bears a reverse proof of the black chalk drawing that served for the upper part of Watteau's etching *Les comédiens italiens*, retouched by Simonneau. Watteau's drawing for the final version of the etching has not survived; we know it only from an engraving by F. Boucher. In all probability, however, this was not the only drawing on that subject. Along with another sanguine drawing, a reverse proof of which was in the Earl of Rosebery collection (Mentmore, England), and has been preserved (P.-M., II, No. 870), an earlier drawing in black chalk must have existed; a reverse proof of this was made and part of it is in the Pushkin Museum of Fine Arts, Moscow. Apparently the artist was not satisfied with this version of the composition, although it was close to the final one; the drawing disappeared, while the reverse proof was cut in two by the artist. On the reverse of one of its parts he did the sanguine drawing *Le Cireur de chaussures*. The

reverse proof, which is unfortunately indistinct, is of interest in that it sheds light on the artist's creative process and allows one to date *Le Cireur de chaussures* no earlier than 1716-18.

PROVENANCE

Until 1918: Countess E. Shuvalova collection, St Petersburg/Petrograd
1918: The Shuvalova House-Museum, Petrograd
1924: The Pushkin Museum of Fine Arts, Moscow

EXHIBITIONS

1927. French Drawings: 16th to 19th Century. Moscow (Cat. No. 27)
1955. French Art: 15th to 20th Century. Moscow (Cat., p. 72)
1956. French Art: 12th to 20th Century. Leningrad (Cat., p. 85)
1959. Exhibition of Drawings and Watercolours. Moscow (Cat., p. 23)

REFERENCES

M. Konopliova, The Shuvalova House-Museum. Guide (in Russian), Petrograd, 1923, p. 45, No. 132; Goncourt, p. 287, No. 603; Parker, Mathey, No. 951; Zolotov, Nemilova 1973, p. 148, No. 15; Catalogue 1984, p. 108, No. 41; Roland Michel 1984, p. 285; Rosenberg 1984; Zolotov 1985, p. 29, No. 7.

Etching by Caylus, after Watteau's drawing,
(from *Figures de différents caractères*).

Opposite:
Le Cireur de chaussures.
The Pushkin Museum of Fine Arts, Moscow.

14. AN EMBARRASSING PROPOSAL

Oil on canvas, 65 x 84.5 cm
The Hermitage, St Petersburg.
Inv. No. 1150

The canvas is relined. A strip 0.5 cm in width has been added along the lower edge. Inpainting on the borders. Significant alterations are apparent. In the right-hand part there are grooves of differing depth and form under the paint layer. The painted surface around the head and neck of the woman in a terracotta dress is uneven. Similar uneven strokes are noticeable on the white skirt of the woman with the guitar and over the entire left-hand part of the picture. In addition to that, vertical, straight pleats show through the dress of the standing woman beneath the deep, curving folds of her slightly hoisted skirt. Daubs of colour are also visible through the terracotta dress of the woman seated in the centre, while here and there the impasto folds of the lady guitarist's white skirt can be discerned through the liquid strokes of the top layer and, similarly, one can trace the outline of the standing woman's crinoline. These features find their explanation in the X-ray photographs of the painting. The grooves must have appeared when the paint layer that covered the canvas prior to the painting of La Proposition embarrassante was scraped off by the artist. Watteau seems to have used a spatula-like instrument or a blade with a rounded point for the purpose and he cleaned the canvas so thoroughly that it is extremely difficult to determine what was originally depicted on it. The same procedure was repeated in the left-hand part. The deep scrapings that are so clearly evident in the X-rays sometimes even affect the priming and overrun the area where the young man and the lady guitarist are now seated. These scrapings change their character above the guitarist's head, covering a large area and spreading in different directions. The area now occupied by the seated youth was scraped with particular fervour and then heavily painted in so as to preserve the relief on which the present figure was depicted.

Underneath the network of grooves caused by the scrapings, the X-rays show, instead of the present lady guitarist, another woman also holding a guitar. But while the one in the painting has her back turned to us, the woman in the X-ray picture is seen in half-profile. One can clearly follow the line of her décolleté, the tight bodice with its elongated waist and the wide pleated skirt. The woman's right hand lies on the strings of the guitar, shown in full to the viewer, while her left hand supports the neck of the instrument. In the space between the musician's skirt and the guitar one can discern a rather large hand in a puffed sleeve, while higher up, amid a chaos of brushstrokes belonging to both the present painting and its scraped-off predecessor, one can glimpse the outlines of a man's head. The standing couple belong to the earlier painting. X-ray photographs show their original condition. The man's foot was damaged during the scraping procedure and was repainted. The lady originally wore a dress with straight, heavy folds. Two horizontal pleats and stripes are clearly distinguishable on the back of her bodice. The skirt was much narrower than in the present painting. The woman held a handkerchief in her hand. In the X-ray the man looks much heavier and stockier than now. In his outstretched hand he held a no longer discernible object, perhaps a mask. The X-rays allow us to conclude that the lady in terracotta dress was painted on top of earlier figures.

Thus, a basically complete composition already existed on the canvas prior to the painting of La Proposition embarrassante. The silhouette of the lady guitarist, clearly apparent in the X-rays, makes it possible to regard this composition as an early one. We were able to discover a drawing which apparently served for this woman's figure (P.-M., I, No. 57) and was not used in any other of the artist's paintings. It has a degree of affinity, but only in figure and posture, with heroines of two of Watteau's lost paintings: Arlequin amoureux, engraved by Cochin, and Les Jaloux, engraved by G. Scotin. Both of these paintings were undoubtedly early works; H. Adhémar dates the first to 1710 or 1711, and the second to 1712. The original composition of La Proposition embarrassante probably belongs to the same period. That composition apparently remained intact for about three years, since the Hermitage painting was produced in 1715 or early 1716. Traces of scrapings are proof of the fact that the original painting was only destroyed some time after it had been completed, for they cut through a dry paint layer and the priming.

Magnification furnishes interesting data about the painting. The naked eye discerns only the broad, soft strokes. When magnified from 6 to 12 times, all the details preserve their form and modelling, but where the eye saw only strokes of a uniform colour dozens of tiny, multicoloured strokes placed close to each other now appear.

The following drawings may be considered as preliminary sketches: Trois femmes assises (charcoal, sanguine, lead pencil; Louvre, Paris); Deux femmes assises (sanguine; Rijksmuseum, Amsterdam; Watteau used the reversed proof of this drawing for the seated woman in terracotta dress); Deux figures masculines (sanguine; Lyon collection, London). Engraved by N. Tardieu for the Julienne collection, with the caption La Proposition embarrassante, and by Michael Keyl for Recueil d'estampes gravées d'après les tableaux de la Galerie et du Cabinet de S.E.M. le Comte de Brühl à Dresde, 1754. The painting was executed around 1716. H. Adhémar dates it to 1716, J. Mathey to 1715.

PROVENANCE

Until 1769 : Count Brühl collection, Dresden
1769 : The Hermitage

EXHIBITIONS

1955. French Art : 15th to 20th Century. Moscow (Cat., p. 24)
1956. French Art : 12th to 20th Century. Leningrad (Cat., p. 12)
1972. Watteau and His Time. Leningrad (Cat. No. 4)

REFERENCES

Goncourt, No. 152 ; Zimmermann, p. XX ; Dacier, Vuaflart, No. 224 ; Réau 1928, No. 129 ; Réau 1929, No. 415 ; Volskaya, p. 32 ; Adhémar, No. 142, pl. 73, p. 144 ; Parker, Mathey, Nos 43, 636, 825 ; Catalogue 1958, p. 266 ; Nemilova 1964, pp. 130-138, 185 ; *Splendeurs de l'Ermitage* (*Baroque et Rococo*), Paris, 1965, No. 67 ; Macchia, No. 146 ; Rosenberg, Camesasca, No. 146 ; I. Nemilova, *"On the Evolution of Watteau's Art"*, in : Western European Art (in Russian), Moscow, 1971 ; Nemilova 1973, pp. 19-44 ; Zolotov, Nemilova 1973, pp. 17, 143, 144, No. 9 ; Nemilova 1975, p. 434 ; Catalogue 1976, p. 189 ; Nemilova 1981, No. 50 ; Catalogue 1984, pp. 340-342, No. 39 ; Rosenberg 1984 ; Zolotov 1985, p. 14, Nos 37-42 ; Colloque Watteau 1987, pp. 101, 158, 167, No. 12.

Below and pages 142 and 143 :
La Proposition embarrassante, detail.

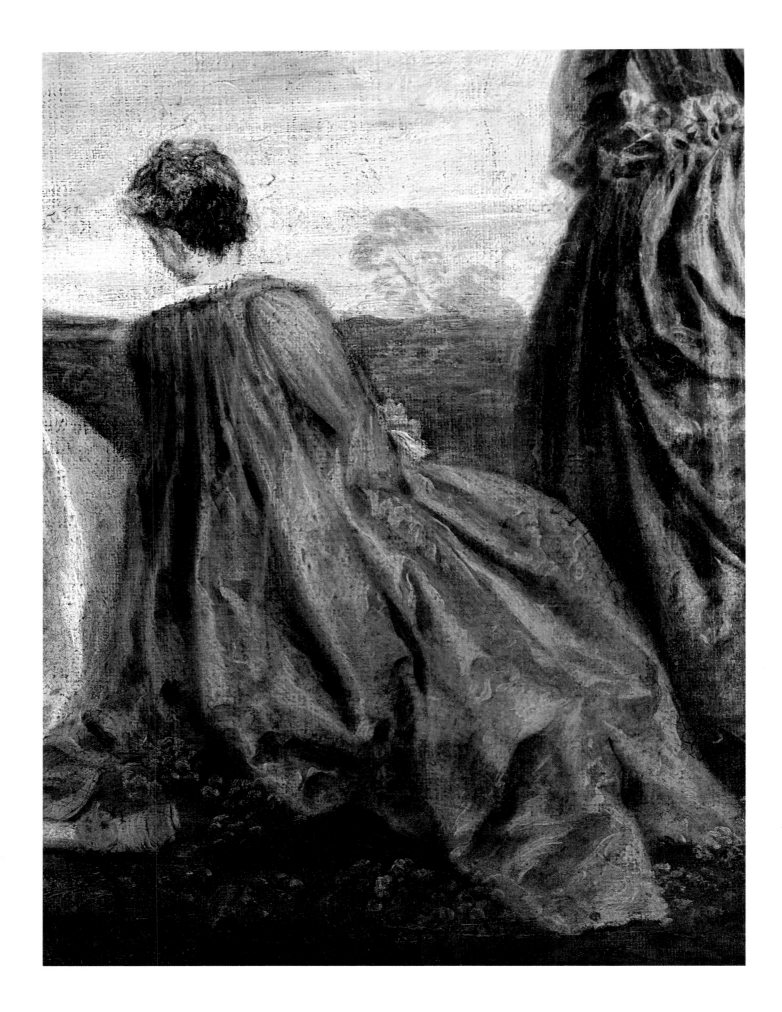

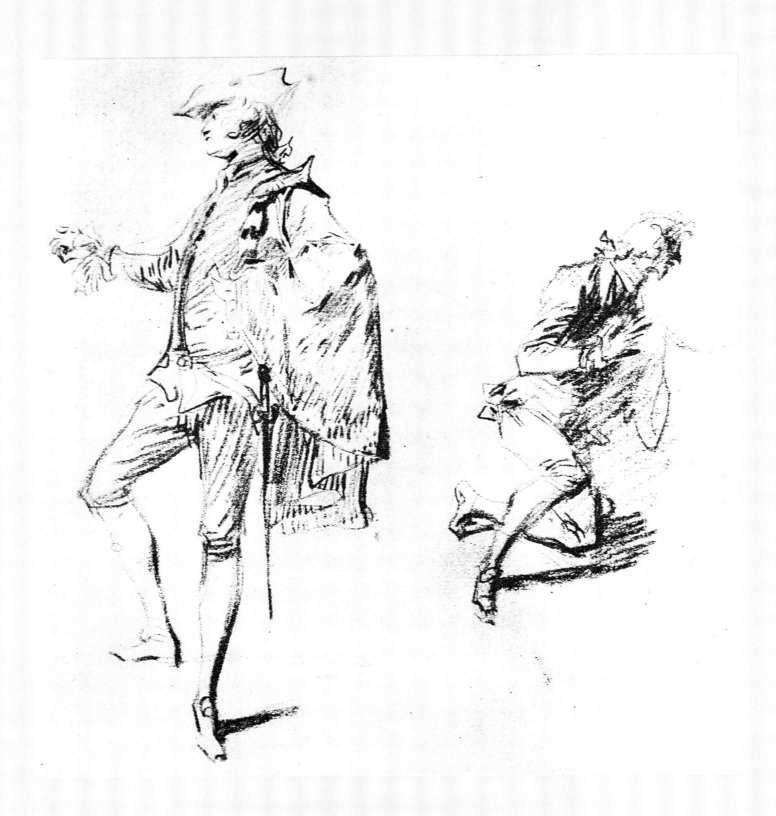

Deux figures masculines.
Lyon collection, London.

Deux femmes assises.
Rijksmuseum, Amsterdam.

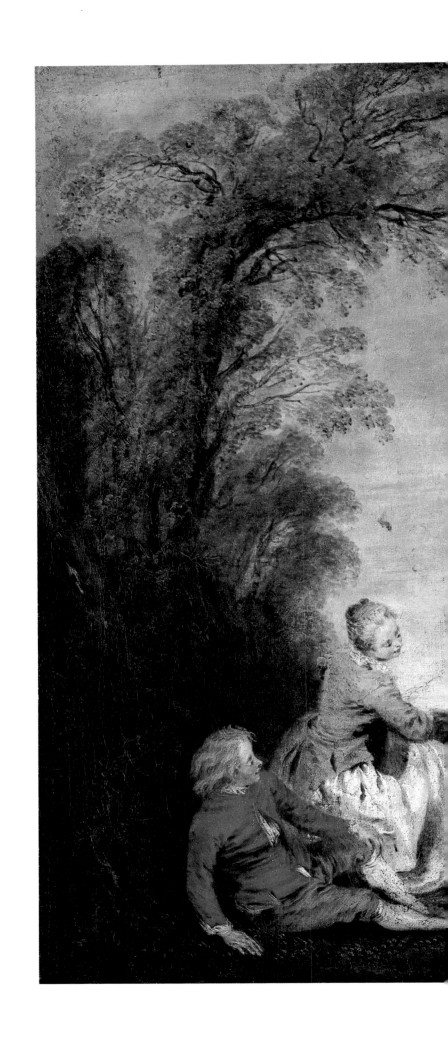

La Proposition embarrassante,
The Hermitage, St Petersburg.

Pages 148 and 149:
La Proposition embarrassante, details.

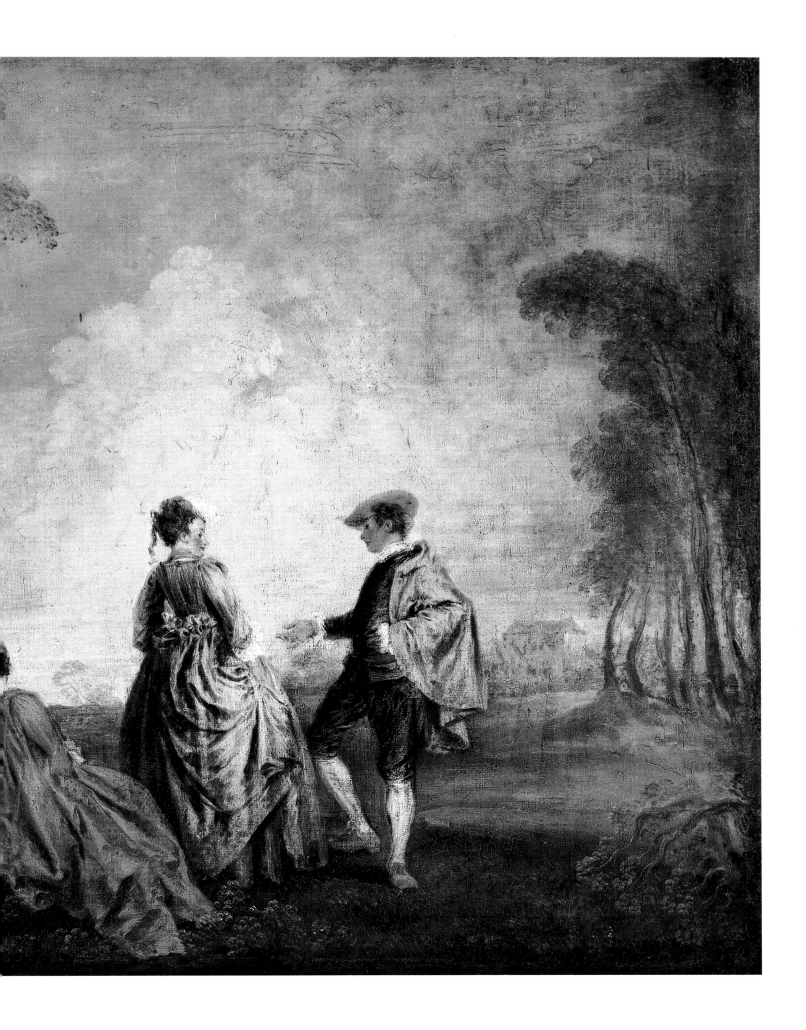

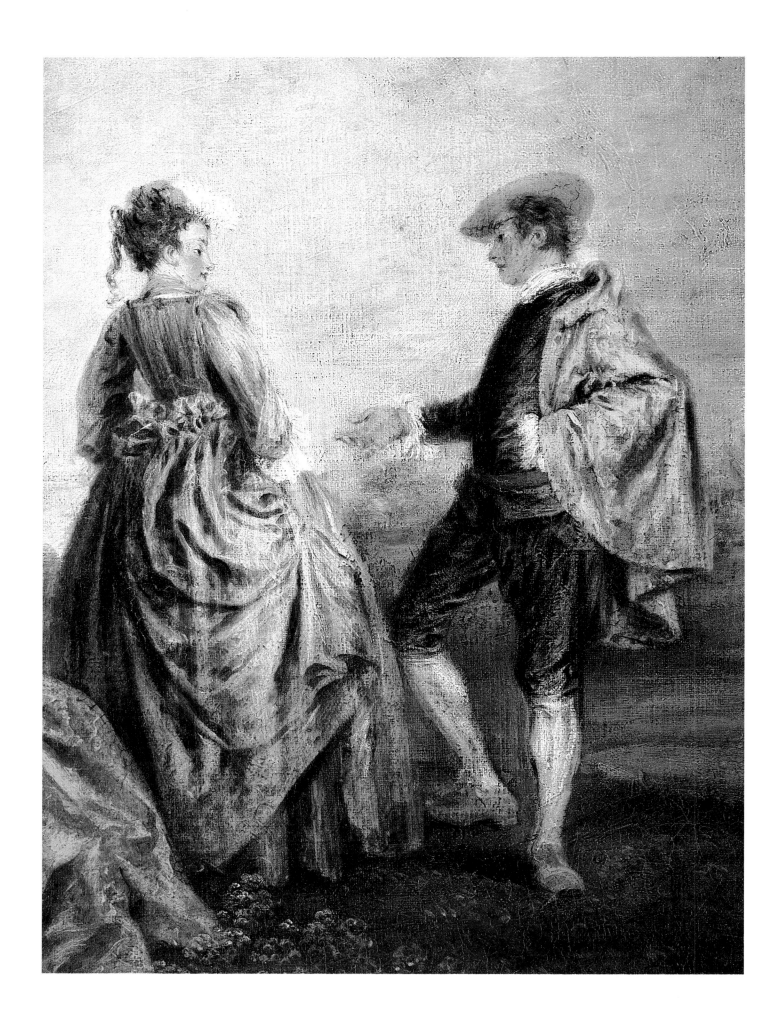

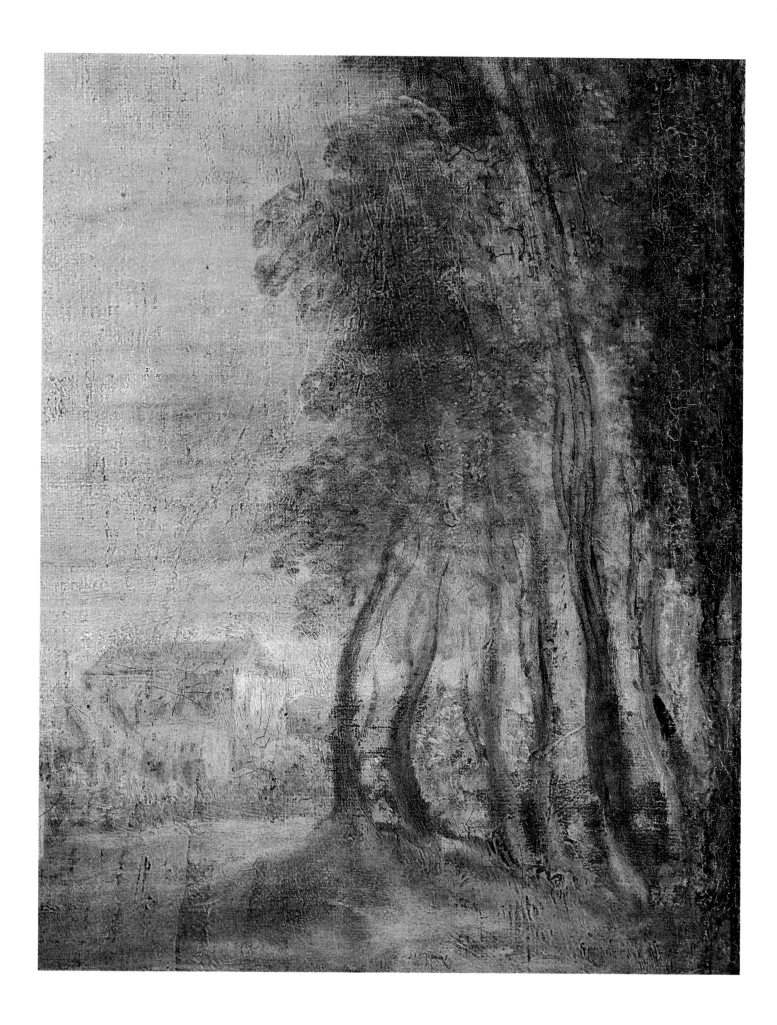

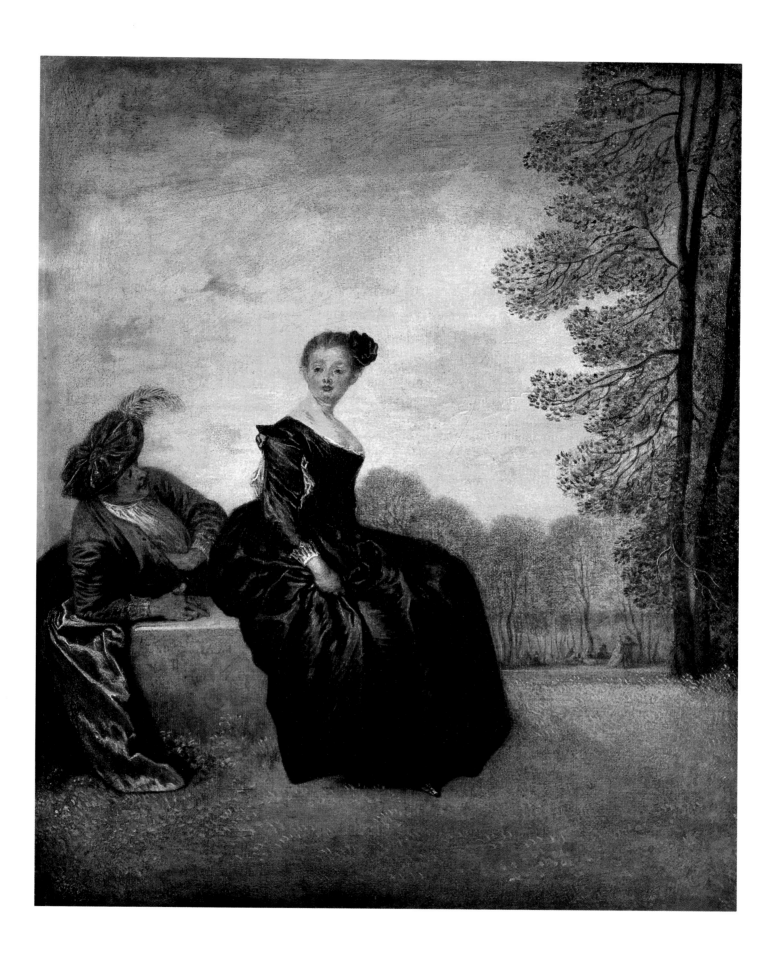

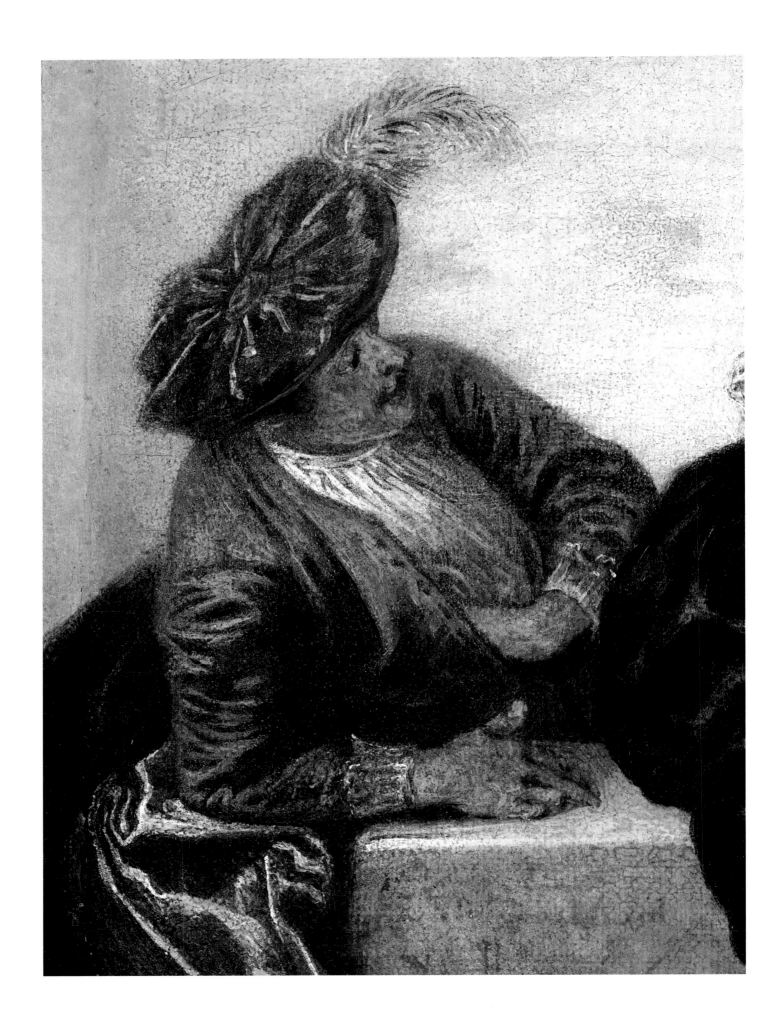

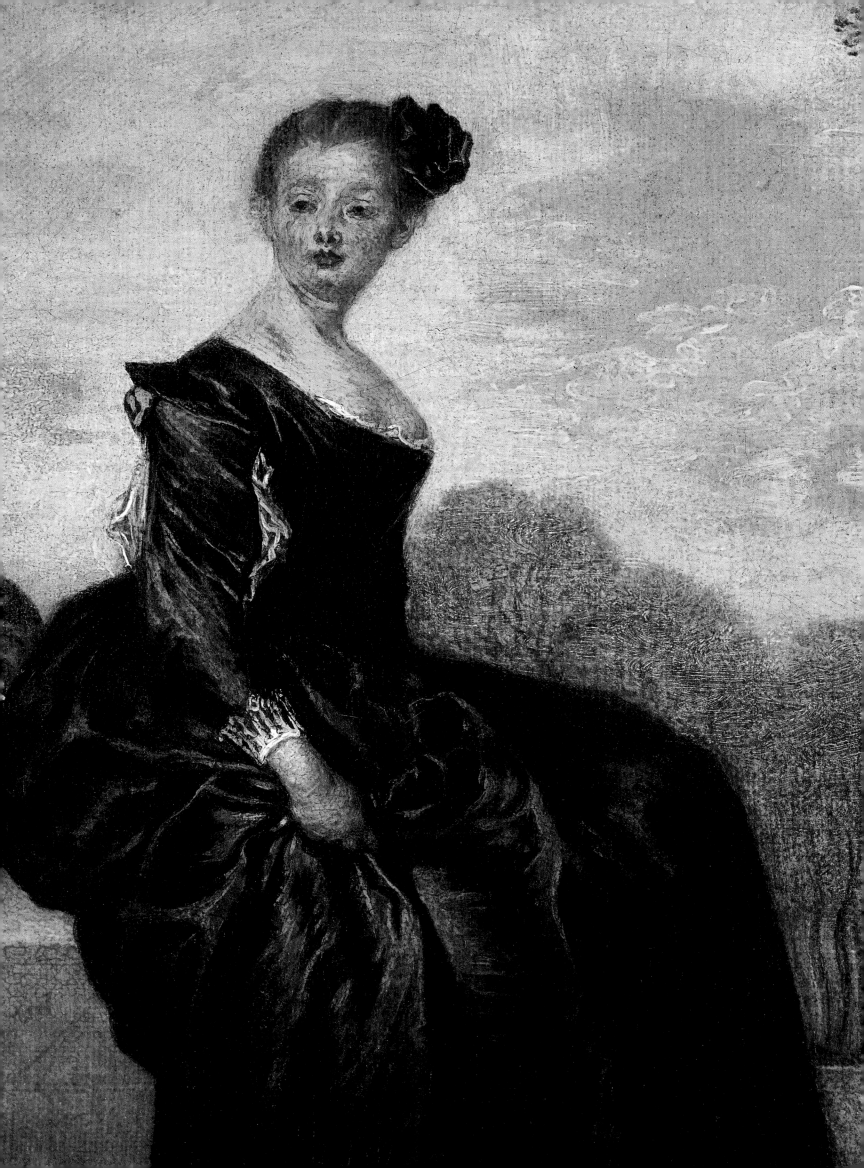

17. THE BIRTH OF VENUS

La naissance de Vénus,
The Hermitage, St Petersburg.

Sanguine, 29.5 x 17.5 cm
The Hermitage, St Petersburg.
Inv. No. 40764

The drawing was engraved by G. Huquier under the title *La Naissance de Vénus* on the same sheet as the composition *La Pluie*. Both subjects were included in *Les Quatre Saisons*.

PROVENANCE

1893 : A. Beurdeley collection
1905 : Baron Stieglitz School Library, St Petersburg/Petrograd
1923 : The Hermitage

EXHIBITIONS

1912. Exhibition of Drawings by French Artists of the Louis XIV and Regency Periods. St Petersburg, Baron Stieglitz Museum (Cat. No. 164)

REFERENCES

Nemilova 1964, pp. 33-36, 190, pl. 8 ; Zolotov, Nemilova 1973, pp. 28, 150, No. 18 ; Catalogue 1984, pp. 107, 108, No. 40 ; Roland Michel 1984, p. 285 ; Zolotov 1985, p. 29, No. 7.

Etching by G. Huquier after Watteau's drawing.

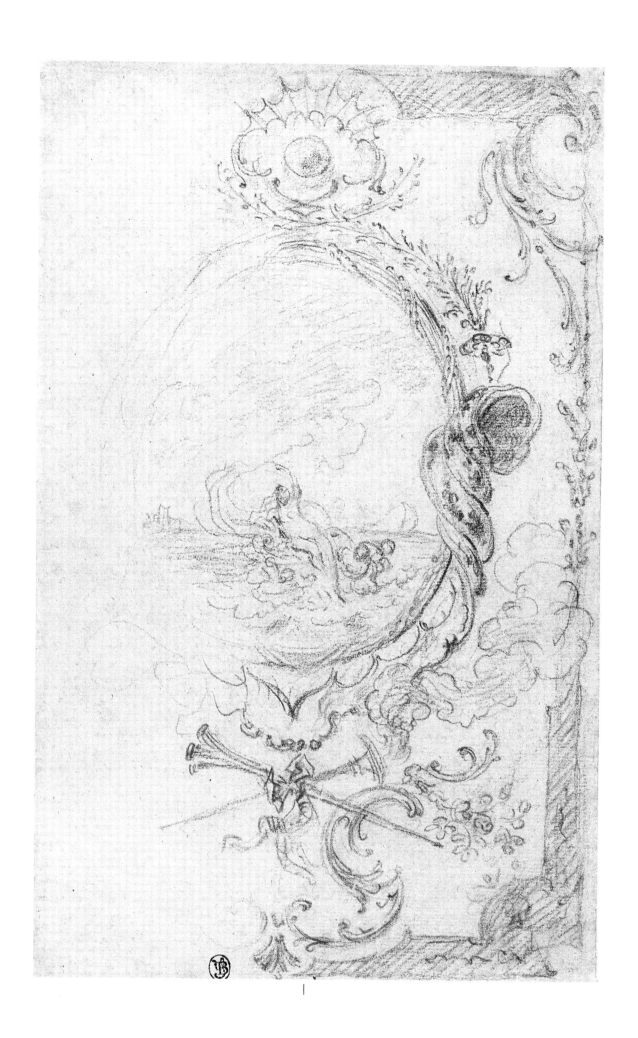

18. HEAD OF A YOUNG WOMAN IN PROFILE

Black and white chalk, sanguine, 37.7 x 23.3 cm
The Hermitage, St Petersburg.
Inv. No. 40424

Inventories of the Baron Stieglitz School Library list the drawing as a Rubens original. When received in the Hermitage, it was attributed to the eighteenth-century French school. M. Dobroklonsky thought it to be a Watteau copy of Rubens, while I. Nemilova later identified it as a copy of the Madonna's head from *Madonna with Saints* by Rubens (Church of St Jacob, Antwerp). We do not know whether Watteau ever visited that city; perhaps he did this copy from a Rubens drawing that could have belonged to the Crozat collection.

PROVENANCE

A. Polovtsev collection, St Petersburg
Until 1923 : Baron Stieglitz School Library, St Petersburg/Petrograd
1923 : The Hermitage

EXHIBITIONS

1956. French Art : 12th to 20th Century. Leningrad (Cat., p. 35)
1972. Watteau and His Time. Leningrad (Cat. No. 61)

REFERENCES

T. Kamenskaya, *"The Art of Rubens as Reflected in French Graphic Works of the Seventeenth and Eighteenth Centuries"*, in : Papers of the Hermitage. Department of Western European Art (in Russian), III, Leningrad, 1949, p. 125, pl. 9 ; T. Kamenskaya, *Un dessin inédit de Watteau d'après Rubens au Musée de l'Ermitage*, Brussels, 1949 ; Parker, Mathey, No. 291 ; M. Dobroklonsky, The Hermitage. Graphic Art (in Russian), Leningrad, 1961, pl. 112 ; Nemilova 1964, pp. 58, 191, pl. 19 ; Zolotov, Nemilova 1973, pp. 147, 148, No. 14 ; Zolotov 1985, p. 29, No. 49.

Tête d'une jeune femme vue de profil,
The Hermitage, St Petersburg.

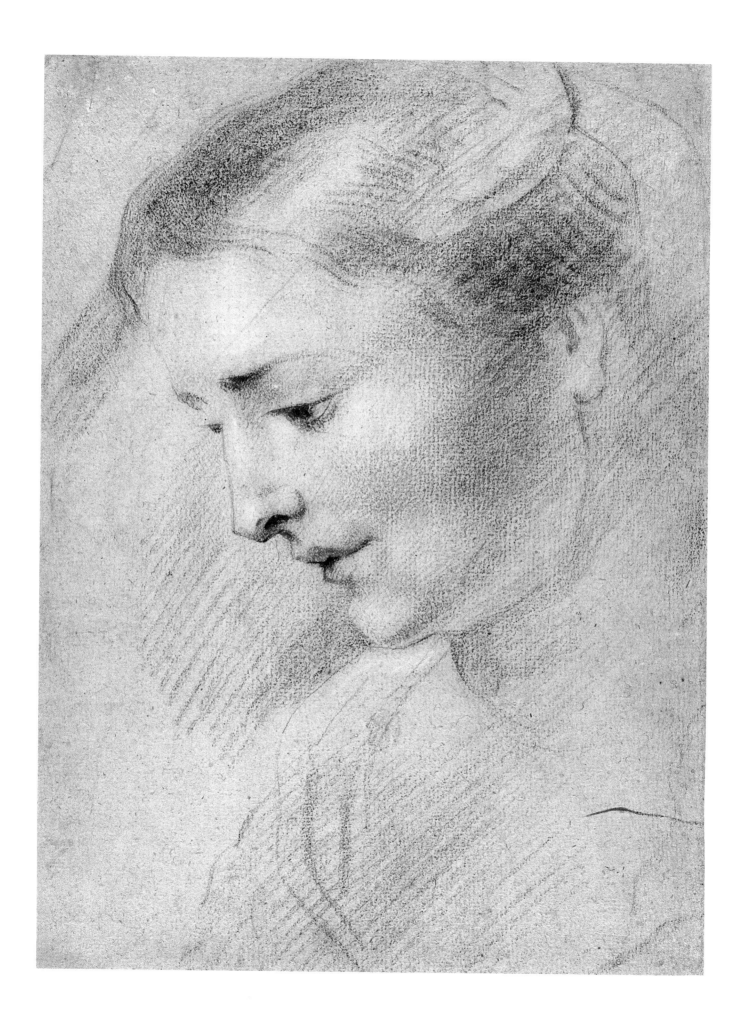

19. REST ON THE FLIGHT INTO EGYPT

Oil on canvas, 129 x 98 cm
The Hermitage, St Petersburg.
Inv. No. 1288

The canvas is relined, coloured strips of paper pasted over its edges. Traces of deep cracks in the upper right-hand corner. Inpainting covers paint losses along the borders. A large area of the upper right background has been painted in; there is also inpainting on the rock to the left. Traces of an earlier restoration are discernible on the Madonna's head and cloak. The paint layer on the cloak and white cloth has split in several places all the way down to the priming.

It can be assumed that the painting was not completed. While its colour scheme is well developed, its planes are out of order (the figure of St Joseph is placed in two planes simultaneously), the figures are depicted on different scales (the Madonna and the Child are larger than St Joseph), the perspective lacks consistency. Only the figures of Mary and Christ seem finished. Watteau mentions this painting in the letter to his friend Julienne, in which the artist asks him to convey his thanks to Abbot Noirterre for the Rubens painting the latter gave him - a gift that inspired him to paint La Sainte Famille for Noirterre.

Neither J. Mathey, nor E. Dacier and A. Vuaflart before him, identify the Hermitage painting with the one mentioned by Watteau in his letter to Julienne. J. Mathey believes that the letter refers to a painting on the same subject executed in 1711-12 and now belonging to the Paul Cailleux collection, Paris. E. Dacier and A. Vuaflart suggest that the Noirterre painting remains unknown as it was never engraved. Although Watteau's works on religious subjects are few, Mathey published four Saintes Familles, all of them showing the Old Masters' influence. Several imitations of this painting are known, including copies of engravings (in the Quimper and Anjou museums, the Bonn Palace, and the Denon collection). It was engraved by Marie-Jeanne Renard du Bos in 1732 for the Julienne collection and by C.-L. Wüst for Recueil d'estampes gravées d'après les tableaux de la Galerie et du Cabinet de S.E.M. le Comte de Brühl à Dresde, 1754 (No. 33). The painting is dated 1719 on the basis of stylistic analysis and the information in the artist's letter to Julienne. The letter has no date on it, therefore scholars of Watteau differ on this issue. J. Mathey's assumption that the letter refers to an earlier painting, done in 1711 or 1712, seems doubtful. Logic makes it hard to believe that anyone would present such a young and inexperienced painter with a work by Rubens (as indicated in the letter), or even a work attributed to him at the time. But a mature, famous and popular master could indeed have received such a gift. H. Adhémar dates Le Repos pendant la fuite en Egypte to 1716; J. Mathey believes it was done between 1714 and 1721. Yu. Zolotov suggests the date ca 1715, citing a number of documentary facts and analogies.

PROVENANCE

Until 1724: Hénin collection, Paris
1724: J. de Julienne collection, Paris
Until 1729: Count Brühl collection, Dresden
1769: The Hermitage
The Tauride Palace, St Petersburg
The Gatchina Palace near St Petersburg
1920: The Hermitage

EXHIBITIONS

1908. The World of Art Exhibition. St Petersburg (Cat. No. 296)
1956. French Art: 12th to 20th Century. Leningrad (Cat., p. 12)
1965. La Peinture française dans les musées de l'Ermitage et de Moscou. Bordeaux (Cat. No. 46)
1965-66. Chefs-d'œuvre de la peinture française dans les musées de Léningrad et de Moscou. Paris (Cat. No. 44)
1972. Watteau and His Time. Leningrad (Cat. No. 9)

REFERENCES

P. Chennevières, "Lettre de Watteau à Jean de Julienne", Archives de l'art français, 1852-53, II, p. 207; Goncourt, No. 31; N. Wrangel, "Art and Emperor Nicholas I", The Old Years (in Russian), 1913, 3, p. 102; Zimmermann, No. 64; Dacier, Vuaflart, No. 26; Réau 1928, No. 416; Réau 1929, No. 416; Adhémar, No. 181; Catalogue 1958, p. 270; Ch. Sterling, Musée de l'Ermitage. La peinture française de Poussin à nos jours, Paris, 1957, p. 42; J. Mathey, Antoine Watteau. Peintures réapparues...., Paris, 1959, pp. 30-31, 75; Nemilova 1964, pp. 71-73, 188; Macchia, No. 194; Rosenberg, Camesasca, No. 194; Zolotov, Nemilova 1973, pp. 29, 30, 142, No. 8; Nemilova 1975, p. 434; Catalogue 1976, p. 190; Nemilova 1981, No. 52; Catalogue 1984, pp. 313-316, No. 30; Roland Michel 1984, p. 151; Rosenberg 1984; Zolotov 1985, pp. 29, 30, Nos. 50-52; Colloque Watteau 1987, pp. 60-63, No. 64; Yu. Zolotov, "Watteau: iconosphère et personnalité d'artiste", in: Antoine Watteau (1684-1721), Le peintre, son temps et sa légende, Paris-Geneva, 1987.

Le Mariage mystique de sainte Catherine et la Sainte Famille. Seilern collection, London.

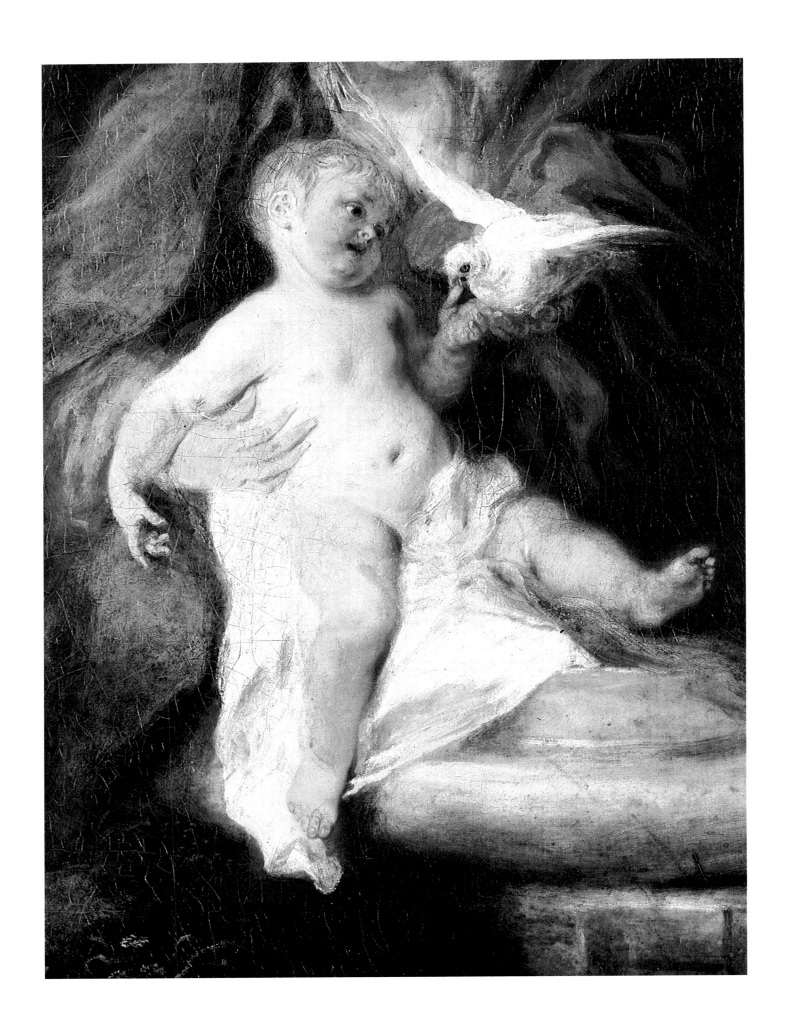

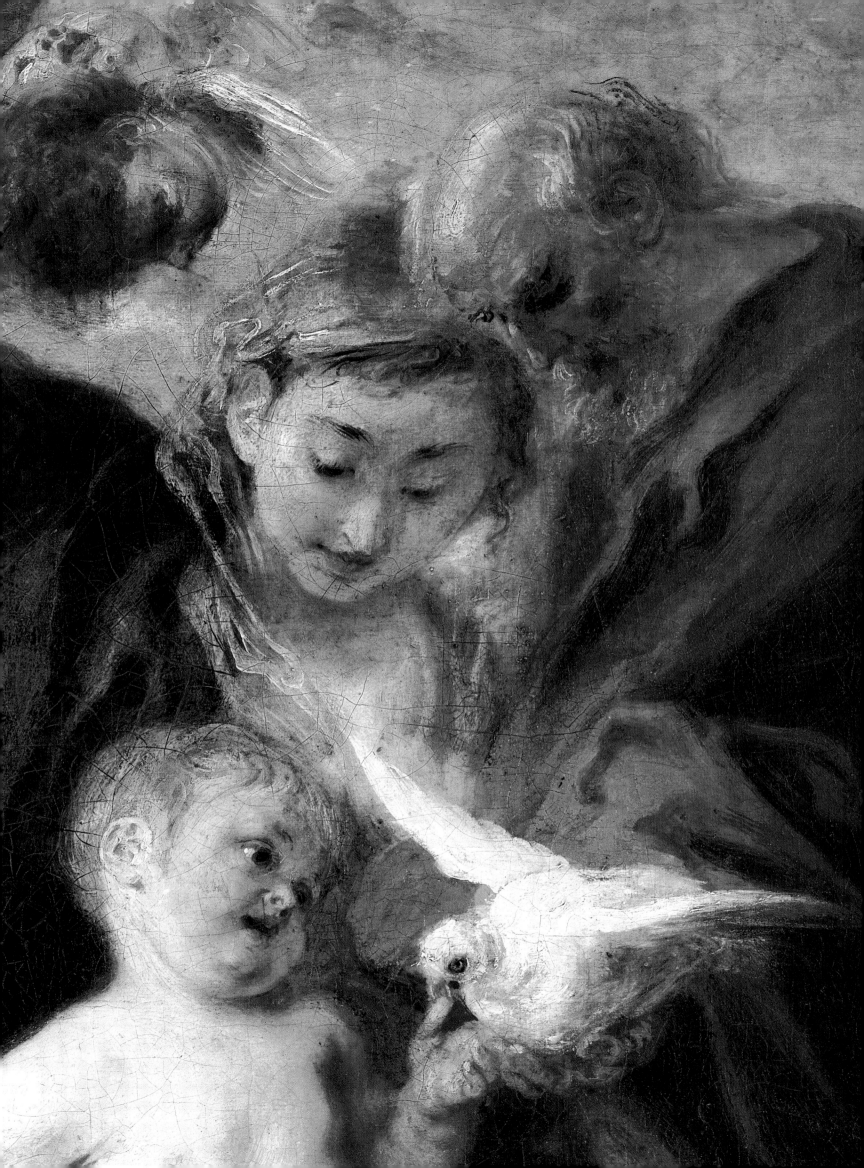

Preceding page and above:
Le Repos pendant la fuite en Égypte, detail.

Overleaf:
Le Repos pendant la fuite en Égypte,
The Hermitage, St Petersburg.

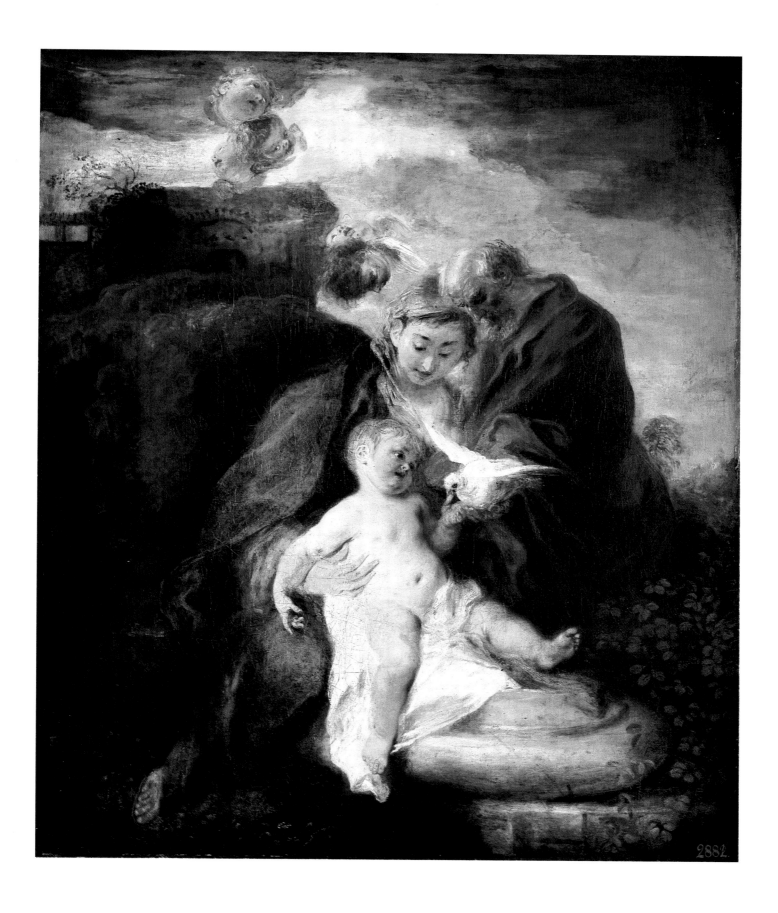

20. AUTUMN

Sanguine, 29 x 18.5 cm
The Hermitage, St Petersburg.
Inv. No. 40783

This still-life motif of a wickered wine-bottle was used by Watteau for his painting *Les Amoureux heureux* (see J. Mathey, Antoine Watteau. *Peintures réapparues...,* Paris, 1959, p. 46, No. 111), while the transparent goblet appears in the composition *L'Occupation selon l'âge*, known thanks to the engraving by Ch. Dupuis.
The drawing was engraved by G. Huquier in the series *Les Quatre Saisons.* It can be dated to 1707-8, i.e. to the time when Watteau worked with Claude Audran. The faun mask, also found in the engraving by his teacher Claude Gillot, *Bacchanale* (Bibliothèque Nationale, Paris), seems to be a reminiscence of Watteau's early period.

PROVENANCE

1893 : A. Beurdeley collection
1905 : Baron Stieglitz School Library, St Petersburg/Petrograd
1923 : The Hermitage

EXHIBITIONS

1912. Exhibition of Drawings by French Artists of the Louis XIV and Regency Periods. St Petersburg, Baron Stieglitz Museum (Cat. No. 163)
1955. French Art : 15th to 20th Century. Moscow (Cat., p. 73)
1972. Watteau and His Time. Leningrad (Cat. No. 57)

REFERENCES

K.T. Parker, *The Drawings of Antoine Watteau*, London, 1931, p. 19, pl. 15 ; Parker, Mathey, No. 197 ; M. Dobroklonsky, *The Hermitage*. Graphic Art (in Russian), Leningrad, 1961, pl. 111 ; *Mästerteckningar från Ermitaget*, Leningrad. Nationalmuseum, Stockholm, 1963, No. 39 ; Nemilova 1964, pp. 35, 36, 190, pl. 10 ; Zolotov, Nemilova 1973, pp. 28, 149, 150, No. 17 ; Zolotov 1985, p. 7, No. 28.

Overleaf:
L'Automne, The Hermitage, St Petersburg.

Opposite:
Etching by G. Huquier after Watteau's drawing.

Biographical
Bibliography
Key to abreviated
literature

BIOGRAPHICAL OUTLINE

Actual information being scarce, many recently furnished dates are based on guesswork. Here we cite only fully documented dates.

1684, October 10

Jean-Antoine Watteau, the son of the roofer Jean-Philippe Watteau and Michèle Lardenois, is baptized in Valenciennes.

1702 (?)

Watteau arrives in Paris. The following years include work for an obscure merchant, then apprenticeship to Claude Gillot and Claude Audran. Studies the works of Rubens (his Life of Marie de'Medici series) in the Luxembourg Palace.

1709

April 6: The Académie Royale de Peinture et de Sculpture permits Watteau to participate in the Prix de Rome competition.
August 31: The Académie awards Watteau second prize for his painting Retour de David après la défaite de Goliath. Abigaïl apporte des vivres à David. Watteau takes a trip home to Valenciennes. Paints his first "military subjects".

1712

July 30: The Académie accepts Watteau as an agréé

1715

June 13: The Swedish collector Carl Tessin pays a visit to Watteau's studio on the Quai de Conti, near the Pont-Neuf, and comments on the artist's interest in Van Dyck.

1716

Watteau makes the acquaintance of the Italian painter Sebastiano Ricci.

1717

August 28: Upon having presented Le Pèlerinage a l'île de Cythère, Watteau is accepted as a member of the Académie.
September 4 and December 31: Participates in Académie meetings. According to the Almanach Royal, Watteau lives in the home of the collector and patron of the arts Pierre Crozat, in the Faubourg de Richelieu.

1718

Watteau leaves the Crozat residence and, together with the painter Nicolas Vleughels, moves to the home of Le Brun in the Rue des Fossés-St-Victor.

1719

September 20: Watteau leaves Le Brun's house and travels to London.

1720

Watteau returns to Paris.
August 21: Meets the female Italian painter, Rosalba Carriera, in Paris.
Watteau lives at "Au Grand Monarque" (the art-dealer Gersaint's shop) on the Pont Notre-Dame. Paints L'Enseigne de Gersaint.

1721

February 9: Rosalba Carriera visits Watteau in Paris.
July 18: Watteau dies in Nogent-sur-Marne.

SELECTED BIBLIOGRAPHY

E. et J. de Goncourt, *L'Art du XVIIIe siècle*, vol. 1, Paris, 1860

E. de Goncourt, *Catalogue raisonné de l'œuvre peint, dessiné et gravé d'Antoine Watteau*, Paris, 1875

P. Mantz, *Antoine Watteau*, Paris, 1892

V. Josz, *Antoine Watteau*, Paris, 1905

A. Benois, *The History of Painting*, vol. 4, St Petersburg, 1912 (in Russian)

E. Pilon, *Watteau et son école*, Brussels, Paris, 1912

E.H. Zimmermann, *Watteau*, Stuttgart, 1912

P. Champion, *Notes critiques sur les vies anciennes d'Antoine Watteau*, Paris, 1921

L. Gillet, *Un grand maître du XVIIIe siècle: Antoine Watteau*, Paris, 1921

E. Hildebrandt, *Antoine Watteau*, Berlin, 1922

E. Dacier, A. Vuaflart, *Jean de Julienne et les graveurs de Watteau au XVIIIe siècle*, Paris, 1924

M. Eisenstadt, *Watteaus Fêtes galantes und ihre Ursprünge*, Berlin, 1930

V. Volskaya, *Antoine Watteau*, Moscow, 1933 (in Russian)

M. Florisoone, *Le Dix-huitième siècle*, Paris, 1948

H. Adhémar, *Watteau. sa vie - son œuvre*, Paris, 1950

Antoine Watteau och andra franska sjuttonhundratalsmästare i Nationalmuseum, Stockholm, 1953

Ch. de Tolnay, "*Embarquement pour Cythère de Watteau au Louvre*", Gazette des Beaux-Arts, 1955, February

K.T. Parker, J. Mathey, *Antoine Watteau. Catalogue complet de son œuvre dessiné*, 2 vols, Paris, 1957-58

M. Gauthier, *Antoine Watteau*, Paris, 1959

J. Mathey, *Antoine Watteau. Peintures réapparues inconnues ou négligées par les historiens. Identification par les dessins. Chronologie*, Paris, 1959

M. Levey, "*The Real Theme of Watteau's Embarkation for Cythera*", The Burlington Magazine, 1961, May

A.-P. de Mirimonde, "*Statues et emblèmes dans l'œuvre d'Antoine Watteau*", La Revue du Louvre et des Musées de France, 1962, 1

M.V. Alpatov, *Essays on the History of Western European Art*, Moscow, 1963 (in Russian)

A.D. Chegodayev, *Antoine Watteau*, Moscow, 1963 (in Russian)

I.S. Nemilova, *Watteau and His Works in the Hermitage*, Leningrad, 1964 (in Russian)

H. Adhémar, "*L'Enseigne de Gersaint par Antoine Watteau. Aperçus nouveaux*", Bulletin du Laboratoire du Musée du Louvre, 1964

H. Bauer, "*Wo liegt Kythera? Ein Deutungsversuch an Watteaus Embarquement*", in: *Probleme der Kunstwissenschaft*, vol. 2, Berlin, 1966, pp. 251-278

R. Huyghe, *L'Univers de Watteau*, Paris, 1968
L'Opera completa di Watteau (presentazione di G. Macchia), Milan, 1968

J. Cailleux, M. Roland Michel, *Watteau et sa génération*, Paris, 1968

Tout l'œuvre peint de Watteau (introduction par P. Rosenberg, documentation par E. Camesasca), Paris, 1970

Antoine Watteau. Old Texts (introduced by Yu.K. Zolotov), Moscow, 1971 (in Russian)

Antoine Watteau (compiled and introduced by Yu. Zolotov; catalogue by I. Nemilova, I. Kuznetsova, T. Kamenskaya and V. Alexeyeva), Leningrad, 1973 (in Russian)

I. Nemilova, *The Enigmas of Old Paintings*, Moscow, 1973 (in Russian)

J. Cailleux, "*A Strange Monument and Other Watteau Studies*", The Burlington Magazine, 1975, April, pp. 246-249

M. Roland Michel, *Watteau. Un artiste au XVIIIe siècle*, London-Paris, 1984

Vies anciennes de Watteau (textes réunis et presentés par Pierre Rosenberg), Paris, 1984

Watteau. 1684-1721. Catalogue, Paris, 1984

Antoine Watteau (1684-1721). Le Peintre, son temps et sa légende, Paris-Geneva, 1987

KEY TO ABBREVIATED LITERATURE

Adhémar
H. Adhémar, *Watteau, sa vie - son œuvre*, Paris, 1950

Catalogue 1948
The Pushkin Museum of Fine Arts. Catalogue of the Picture Gallery, Moscow, 1948 (in Russian)

Catalogue 1957
The Pushkin Museum of Fine Arts. Catalogue of the Picture Gallery, Moscow, 1957 (in Russian)

Catalogue 1958
The Hermitage, Leningrad. Catalogue of Western European Painting, vol. 1, Leningrad, Moscow, 1958 (in Russian)

Catalogue 1961
The Pushkin Museum of Fine Arts. Catalogue of the Picture Gallery, Moscow, 1961 (in Russian)

Catalogue 1976
The Hermitage, Leningrad. Catalogue of Western European Painting, vol. 1, Leningrad, 1976 (in Russian)

Catalogue 1984
Watteau. 1684-1721. Catalogue de l'exposition, Paris, 1984

Colloque Watteau 1987
Antoine Watteau (1684-1721). Le peintre, son temps et sa légende, Paris-Geneva, 1987

Dacier, Vuaflart
E. Dacier, A. Vuaflart, *Jean de Julienne et les graveurs de Watteau au XVIIIe siècle*, vol. III (Catalogue), Paris, 1922

Dobroklonsky
M. Dobroklonsky, *Musée de l'Ermitage. Dessins des maîtres anciens. Exposition de 1926*, Leningrad, 1927

Goncourt
E. de Goncourt, *Catalogue raisonné de l'œuvre peint, dessiné et gravé d'Antoine Watteau*, Paris, 1875

Josz
V. Josz, *Antoine Watteau*, Paris, 1905

Macchia
L'Opera completa di Watteau (presentazione di G. Macchia), Milan, 1968

Nemilova 1964
I. Nemilova, *Watteau and His Works in the Hermitage*, Leningrad, 1964 (in Russian)

Nemilova 1973
I. Nemilova, The Enigmas of Old Master Paintings, Moscow, 1973 (in Russian)

Nemilova 1975
I. Nemilova, *"Contemporary French Art in Eighteenth-century Russia"*, Apollo, 1975, June

Nemilova 1981
I. Nemilova, *Eighteenth-century French Painting in the Hermitage. Catalogue raisonné*, Leningrad, 1981 (in Russian)

Parker, Mathey (P.-M.)
K.T. Parker, J. Mathey, *Antoine Watteau. Catalogue complet de son œuvre dessiné*, 2 vols., Paris, 1957-58

Réau 1928
L. Réau, *"Watteau"*, in: *Les Peintres français du XVIIIe siècle* (sous la rédaction de L. Dimier), vol. 1, Paris, Brussels, 1928

Réau 1929
L. Réau, *Catalogue de l'art français dans les musées russes*, Paris, 1929

Roland Michel 1984
M. Roland Michel, *Watteau. Un artiste au XVIIIe siècle*, Paris, 1984

Rosenberg, Camesasca
Tout l'œuvre peint de Watteau (introduction par P. Rosenberg, documentation par E. Camesasca), Paris, 1970

Rosenberg 1984
Vies anciennes de Watteau (textes réunis et présentés par Pierre Rosenberg), Paris, 1984

Stuffmann
M. Stuffmann, *"Les Tableaux de la collection de Pierre Crozat..."*, Gazette des Beaux-Arts, 1966, July-September

Volskaya
V. Volskaya, *Antoine Watteau*, Moscow, 1933 (in Russian)

Zimmermann
E.H. Zimmermann, *Watteau*, Stuttgart, 1912

Zolotov, Nemilova 1973
Antoine Watteau (compiled and introduced by Yu. Zolotov; catalogue by I. Nemilova, I. Kuznetsova, T. Kamenskaya and V. Alexeyeva), Leningrad, 1973 (in Russian)

Zolotov 1985
Antoine Watteau. Paintings and Drawings from Soviet Museums, Leningrad, 1985